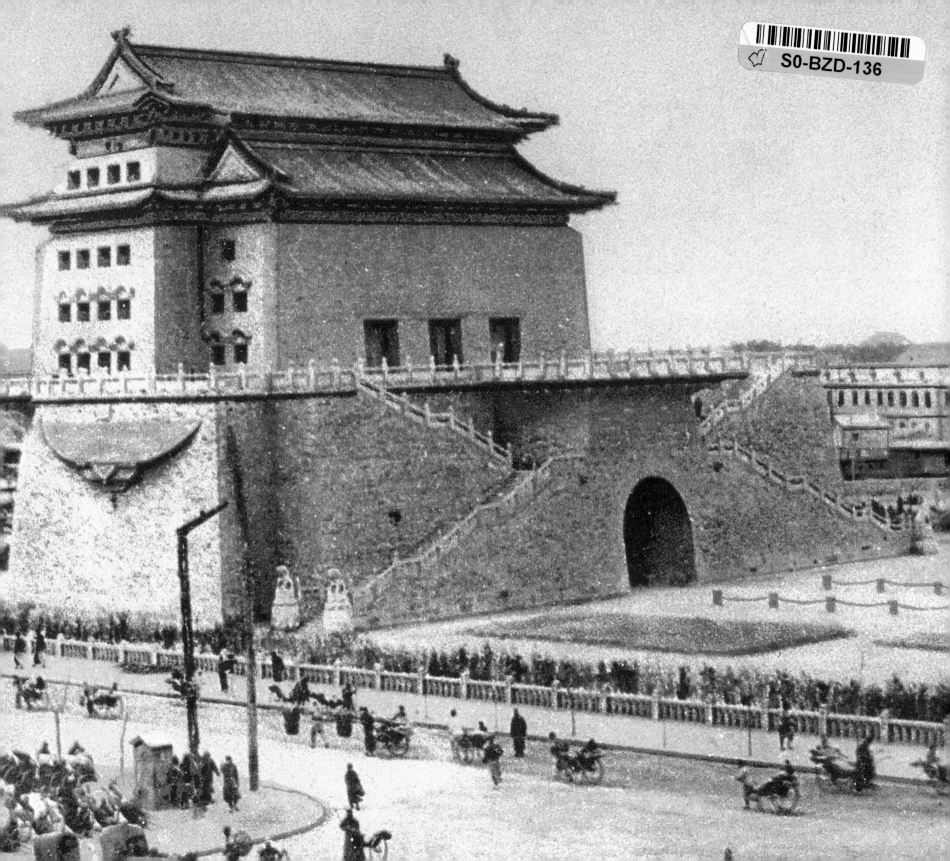

Published by Tuttle Publishing, an imprint of Periplus Editions
(HK) Ltd.
www.tuttlepublishing.com

Library of Congress Cataloging-in-Publication Data

Titus, Felicitas.
 Old Beijing : postcards from the Imperial City / Felicitas Titus ;
foreword by Susan Naquin. —1st ed.
 p. cm.
 Includes bibliographical references.
 ISBN 978-0-8048-4185-6 (hardback)
1. Postcards—China—Beijing. 2. Beijing (China)—Pictorial
works. 3. Titus, Felicitas—Art collections. 4. Postcards—Private
collections—United States. I. Naquin, Susan. II. Title.
 NC1878.7.C6T58 2012
 951'.156040222—dc23
 2011042469

ISBN 978-0-8048-4185-6

Distributed by
North America, Latin America & Europe
Tuttle Publishing
364 Innovation Drive
North Clarendon, VT 05759-9436 U.S.A.
Tel: 1 (802) 773-8930; Fax: 1 (802) 773-6993
info@tuttlepublishing.com
www.tuttlepublishing.com

Asia Pacific
Berkeley Books Pte. Ltd.
61 Tai Seng Avenue #02-12
Singapore 534167
Tel: (65) 6280-1330; Fax: (65) 6280-6290
inquiries@periplus.com.sg
www.periplus.com

First edition
15 14 13 12 10 9 8 7 6 5 4 3 2 1

Printed in Singapore 1201 TW

TUTTLE PUBLISHING® is a registered trademark of Tuttle
Publishing, a division of Periplus Editions (HK) Ltd.

*To my mother, Eva Titus, who never
stopped kindling the flames of fascination
and respect for the old Chinese culture—
one of the greatest in the world*

The Tuttle Story: "Books to Span the East and West"

Most people are surprised to learn that the world's largest publisher of books on Asia had its
beginnings in the tiny American state of Vermont. The company's founder, Charles E. Tuttle,
belonged to a New England family steeped in publishing. And his first love was naturally
books—especially old and rare editions.

Immediately after WW II, serving in Tokyo under General Douglas MacArthur, Tuttle was
tasked with reviving the Japanese publishing industry, and founded the Charles E. Tuttle
Publishing Company, which thrives today as one of the world's leading independent publishers.

Though a westerner, Charles was hugely instrumental in bringing knowledge of Japan
and Asia to a world hungry for information about the East. By the time of his death in 1993,
Tuttle had published over 6,000 books on Asian culture, history and art—a legacy honored
by the Japanese emperor with the "Order of the Sacred
Treasure," the highest tribute Japan can bestow upon
a non-Japanese.

With a backlist of 1,500 titles, Tuttle Publishing is
more active today than at any time in its past—inspired
by Charles's core mission to publish fine books to span
the East and West and provide a greater understanding
of each.

Old Beijing

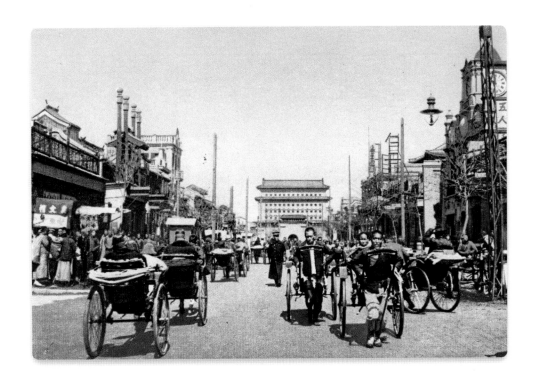

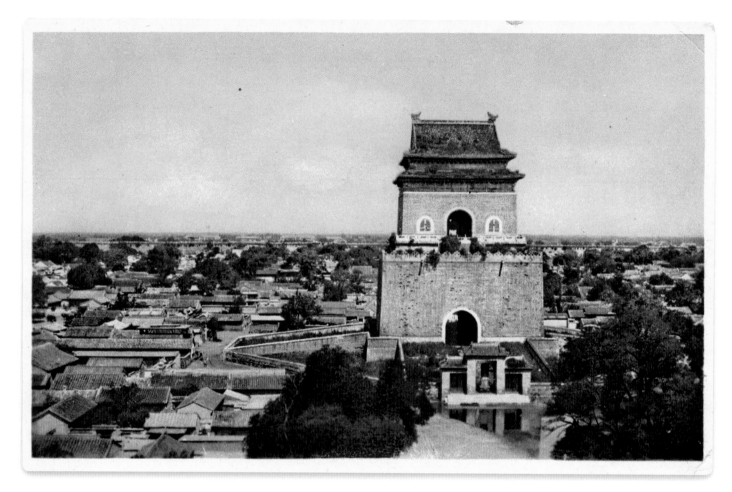

Bell Tower, rising
above Old Beijing.
*Hartung's Photo Shop
ca. 1920*

"He who looks back to the old and knows the new is
worthy to be a scholar." —Confucius, *Analects, Book II*

"He who exercises government by means of his virtue
may be compared to the north pole star, which keeps its
place while all other stars turn toward it." —Confucius, *Analects, Book II*

Old Beijing

Postcards from the Imperial City

Felicitas Titus

Foreword by Susan Naquin

TUTTLE Publishing

Tokyo | Rutland, Vermont | Singapore

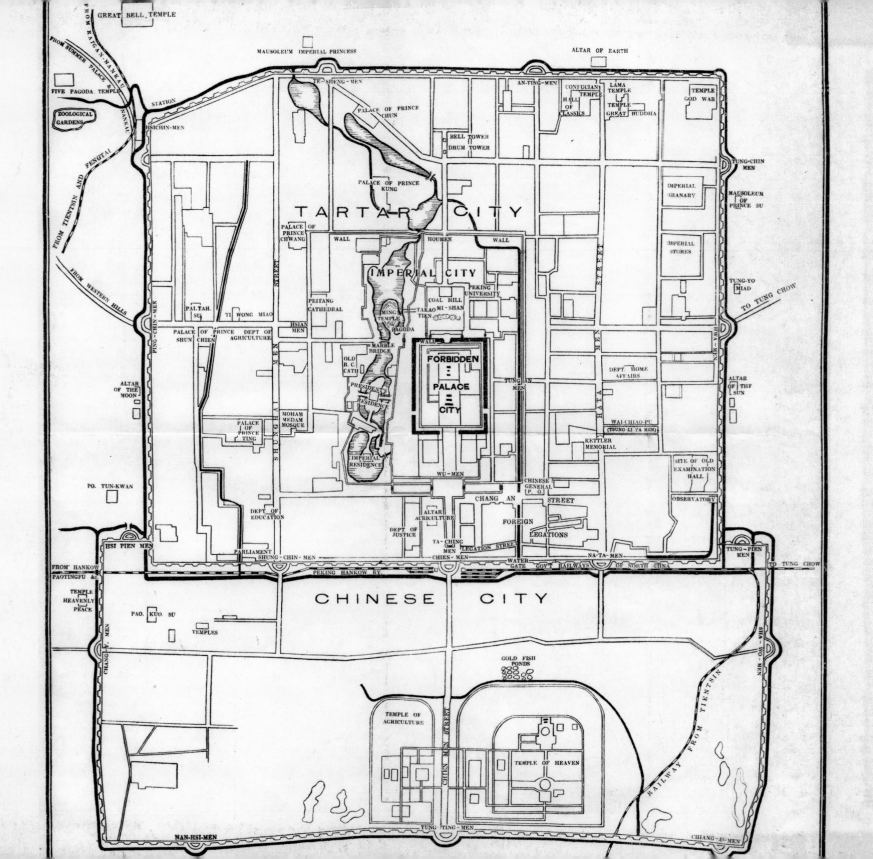

contents

Foreword

The period from the 1890s to the 1930s was a golden age for both postcards and tourism to China. As foreigners traveled for business and pleasure, they bought these handy cards, with their pictures of a distant land, to keep as souvenirs and to send home to family and friends. In those years, Beijing (Peking, as it was called by foreigners) was still the preeminent tourist destination in China. As the seat of the Qing dynasty before its collapse in 1911, the city retained its lingering imperial identity boasting a multitude of fabulous palaces, temples, tombs, and pleasure gardens not to be seen elsewhere.

Thousands of postcards picturing not only these unrivaled landmarks but also scenes of street life were printed, sold, saved, sent, and received. Initially treasured, most have since been stashed away in closets and attics or lost altogether. Nostalgia stimulated some collectors to preserve these small peculiar objects, philatelists wanted the stamps, and an international, Web-based postcard market has increased their value thousands of times over. More recently, scholars have started to investigate their history and analyze their meanings.[1] Books are being published that use postcards to illustrate the vanished past and the natural wonders of places all over the world. Other compilations have brought together picture postcards on all kinds of topics: wars and revolutions, famous people, early trains, planes, and cars. Of these, amazingly few deal with China, none is in English, and none concentrates on Beijing.[2]

Felicitas Titus gives us an unusually accessible account of Beijing through its postcards, together with a special vantage point on the city's history. From a German family, she grew up in China and was educated there, studying its language, literature, and history. This insider's knowledge has guided the ways that, over a period of many years, she acquired and organized her remarkable postcard collection. The 350 postcards that you have before you are thus enhanced with a commentary that combines historical background with private memories from the days of fading imperial splendor in the 1930s and 1940s. Here, we can not only see Old Beijing through the eyes of postcards but also have the pleasure of meeting and learning from a long-term foreign resident who knew and loved the city.

There have been visitors to Beijing since it first became a dynastic capital in 938. As ruling house succeeded ruling house, the city residents became a cosmopolitan mixture of peoples from northern and central Asia, Chinese from all over the empire, and annual embassies from the surrounding kingdoms that came to trade and pay their respects. The list of the capital's renowned sights became longer and longer.[3] But China controlled its borders, and it was only in the late nineteenth century that, defeated in war, Qing emperors agreed to allow a far larger number of long-term residents and unlimited numbers of tourists. In 1900, the xenophobic attack on Beijing's foreign community by self-styled Boxers led to a two-year foreign occupation of the city. Moreover, the forbidding imperial palaces—which only formal embassies had previously been invited to enter— were forced open, and from that time forward the desires of non-Chinese and Chinese alike to penetrate these secret compounds could finally be gratified. After 1911, access to China was even less controlled. Dramatic changes in transportation technology had brought Asia much closer to Europe and the Americas, Western governments became more involved in Pacific affairs, and China and Japan became ever more popular destinations for people with money and leisure.

In the twentieth century, when travelers arrived in Beijing by steamship or railroad, they could be reasonably well prepared and looked after. Hotels catered to them, and a range of guidebooks told them what to see in two, or four, or six days, and proposed excursions for a more extended stay. There were, however, remarkably few souvenirs such as we might expect to find today. There was plenty of shopping—for useful items (fur coats, carpets), antiquities (bronzes, porcelain), and interesting curios (snuff bottles, purses). These were all famous Chinese products, but none illustrated the sights of the capital. If you wanted to show your friends at home what Beijing looked like, choices were few. You could sketch or paint—if you had the talent of Carl Wuttke (1849–1927), whose lovely paintings you can see here for the first time—or you could take black-and-white photographs to develop after you returned.

And so, the postcard. This convenient alternative to the letter had burst onto the European world in the 1870s, and as the Universal Postal Union made it possible for existing national postal systems to connect reliably with one another, the postcard became a safe and inexpensive form of international communication. The simultaneous development of photography and the techniques of coloring pictures helped create the picture postcard, and in this book you will find examples of the many different techniques used to recapture something of the magic of the gleam and shine and rich tones of imperial Beijing.

As you can also see from the postcards in this book, printing and using them was a multinational affair. Nearly two dozen different publishers from almost as many countries made the cards that visitors bought. And as the numbers on some of the cards indicate, they were printed in comprehensive sets, some with familiar images of the famous sites (the wonderful walls), others with unexpected scenes (Tibetan Devil Dancers). For American, British, French, Japanese, Italian, Russian, and German visitors, buying postcards was a way of preserving their memories of the places they had visited (the Altar to Heaven) and the sights they had seen (haircuts given on the street!), and sharing their pleasure with those who could not be there with them. Inexpensive, convenient to buy and send (hotels helped), and much easier to write than a proper letter, the postcard compressed the exoticism of Beijing into a simple package, at once intimate and boldly public. Once these cards had become established, moreover, they became expected, and travelers knew that a certain circle of their friends would be upset if they did not receive one. Writing postcards became a responsibility for the traveler, while recipients saved and treasured theirs.

In China, after the dark decade of the 1940s, as the county reconstituted itself as the People's Republic, the government took charge of printing postcards for the more limited numbers of tourists from "friendly countries." In the 1990s, with the boom of the post-Mao era, travel to China surged, and postcards entered a twenty-year second golden age. At the same time, Beijing itself was dramatically rebuilt as a twenty-first century capital. Today, even though travel to the city by millions of Chinese as well as foreigners continues to increase, cheap global phone communications and the World Wide Web have made it possible to send words and pictures instantly across any distance. The impulse behind the postcard—to share the thrilling experience of a new place—can now be gratified immediately and satisfyingly. Does this not signal an end to the age of postcards?

A proper global history of the postcard is still unwritten. Properly done, it would show how the development of this humble card was intertwined with the histories of stationery and letter writing, postal systems, visiting cards, stamp collecting, mechanical printing, graphic design, and the tourist and souvenir industry. What we know of the postcard in China is still even less, and postcard and stamp collectors have an important role to play in preserving this vanishing phenomenon. Felicitas Titus's wonderful book not only brings us the sights of a city now greatly changed, it will help future generations understand the pleasure and excitement caused by the sending and receiving of a few words scribbled on a small, bright picture from a faraway place.

SUSAN NAQUIN
PRINCETON UNIVERSITY

[1] I recommend chapter 4 in Esther Milne, *Letters, Postcards, Email: Technologies of Presence* (New York: Routledge, 2010).

[2] The best collection I have seen is Chen Shouxiang, *Jiu meng chong jing* (Nanning: Guangxi Meishu Chubanshe, 1998). It shows both sides of the cards and makes a serious attempt to date them. The text is in Chinese. Another, *Lao mingxinpian: Jianzhu pian/Old Postcard: Building* (Shanghai: Shanghai Huabao Chubanshe, 1997) is good and more typical. It devotes 22 out of 160 pages to Beijing and has brief captions in Chinese.

[3] For more on earlier tourism and tourist sights: Susan Naquin, *Peking: Temples and City Life 1400–1900* (Berkeley: University of California Press, 2000), chapters 8, 13, and epilogue.

The throne in the Throne Hall in the Forbidden City *Graphische Gesellschaft, Berlin hand-dated March 20, 1916*

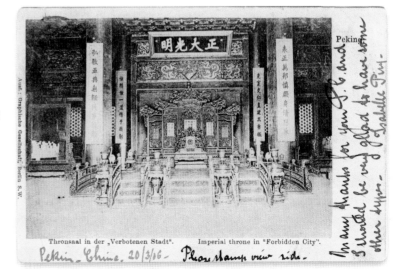

Introduction

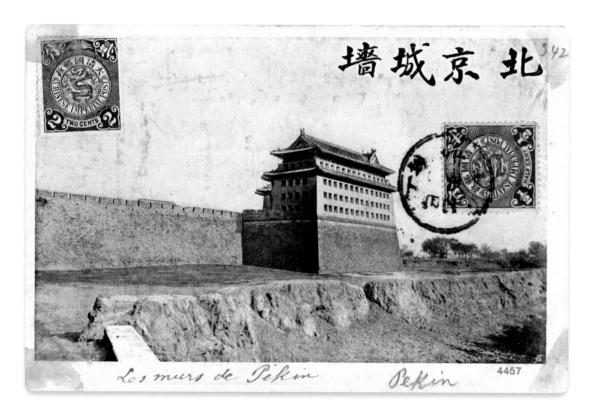

The outer city wall of Old Beijing
no publisher ca. 1930

To hold a postcard from old Beijing in one's hand was a sensation once and still is today. This small paper souvenir of the Imperial Palace, Temple of Heaven, or Summer Palace never loses its luster. Even now, old cards may be found in the attics of many households, thanks to the large volume of views produced between the 1890s and the 1930s, the heyday of Western travel to what was known as Peking. With more than 350 rare and vintage cards, this postcard history of old Beijing will bring amazement to the eyes of new beholders.

History left some grandiose and some sad traces upon Beijing. The city has undergone many trials and tribulations, like China itself, and the changes that have taken place must be faced head on, like history itself. To retrace those changes is not easily done for one born in China and who cherishes memories of a happy childhood in that country among the Chinese. Yet, turning the pages of an album of vintage postcards such as this lets one take a walk through the bygone days, and see again the vanished city.

Early photography triumphs in these contrived and candid shots of a fabled city and a people much admired for the onetime glories of their culture. Postcards even add charm and intensity to their subject because of their constrained space. The beginnings of photography go back to 1839, and "postal cards" appeared in Europe about thirty years later. The postcards shown here date from the 1890s to the late 1930s, when the freelance production of postcards in China stopped owing to the invasion of the country by the Japanese. Postcards can be lithographic prints, gravures, and so-called Real Photo postcards of an actual black-and-white photograph. Many are in color, though color film was not developed until the 1930s. The colored cards were produced from black-and-white photographs using existing lithographic color printing methods, or printed black-and-white cards were hand-colored by artists using translucent oil paints. This charming but cumbersome technique began in

"China is so full of things to see, it's impossible to find time to write; the magnificence that was once China's is here on every side & I wish to see it all."

—FROM THE BACK OF A POSTCARD HAND-DATED 4/10/24

Europe before World War I. A thin wash of oil paint would be applied to a black-and-white print on fiber-based paper that let the image shine through. The artist determined the density of the application depending on the look of the real object. The European artists worked at tables in an assembly line, each one having been assigned a color. This art soon faltered in Europe, whereas postcards continued to be hand-colored in Beijing throughout the 1940s by accomplished Chinese artists hired by photo shops in Beijing. The grandchildren of Max Hartung, a leading German photographer and photo shop owner located in the Legation Quarter, recall their mother telling them of Chinese artists seated at tables in the basement of Max Hartung's shop meticulously adding color tints to black-and-white cards.

Both the printed color cards and the hand-tinted cards did ample justice to the crimson columns and golden roofs of Beijing's palaces and temples, as well as the city's renowned translucent blue sky. Both types can be seen in this collection, although they are difficult to distinguish from one another without assistance. Unquestionably, the hand-tinted cards are works of art and an example of perfectionist labor. Sold as souvenirs by the thousands to tourists, these cards have now turned into vintage collectibles as well as part of the historical record.

The Beijing brought to life in these pages is a city of golden-roofed palaces, imperial gardens, temples, altars, hefty walls, and giant gates built by the Ming emperor Yongle in 1420 and expanded and embellished by the Manchu emperors Kangxi and Qianlong, who also were avid builders and lovers of the arts. The postcards are organized around different themes, such as the imperial family, the imperial palace and its architecture, the diverse temples in and around Beijing, the street life of the Chinese, native means of transportation, country life outside the city, the Great Wall, and, last but not least, the Manchus, whose rule was on the verge of

collapse, while China and Beijing itself experienced the bitter inroads of Westerners, who had destroyed parts of the summer palaces during the Second Opium War in 1860.

The imperial rules and regulations allowed no building to be higher than those of the Forbidden City. Today, Beijing is beset by giant high-rises, examples of a Western-type architecture that has been implemented in huge gulps to house its vast population. The city now is a technologically driven metropolis of mega-buildings, highways, overpasses, streams of automobiles, buses, bicycles, cell phones at the ears of the multitudinous pedestrians, airplanes overhead, and several encircling highway rings, the contemporary city's pride and joy. It is no longer the home of the Son of Heaven, who ruled the Middle Kingdom from the golden throne in the Forbidden City and performed august rites and rituals. These rites and rituals are long since forgotten, which makes such postcards as these even more meaningful.

A special highlight of the collection is a set of nine cards from the estate of Amalie Bigony, the niece of Mrs. Hartung and a friend, that came to me through Bruce A. and Vicky Bigony Peters, Amalie's son and daughter. These cards represent engravings executed from the drawings of palaces and gardens that the Jesuit priest Giuseppe Castiglione made in the 1740s for the Qianlong emperor for what would become the Old Summer Palace. Max Hartung took photographs of original engravings brought to him by Chinese acquaintances and made cards of them. (This provenance is indicated on the card packet.) They are a collector's true delight.

I had the good fortune to have been in Old Beijing once as a girl, with my mother and my brother in 1936, when it was a hushed, storybook city behind a series of forty-foot-high ramparts lying on the wind-swept northern Chinese plain below the Great Wall. We visited the Forbidden City, where the emperors once

dwelled with their retinue of wives, concubines, and a team of eunuchs. My mother described them ambling through the maze of the golden-roofed palaces, courtyards, and gardens dressed in brilliantly embroidered brocade gowns with dragon and phoenix motifs. Later, at the end of World War II, I lived in the city for three years as a student of Chinese language, literature, and history at the College of Chinese Studies and at the Catholic Fu Jen University.

China was my homeland, I knew none other. I was born and raised in the foreign concessions of Hankou (then known as Hankow) on the mid-Yangtze River where my father was a leading businessman. My father's export firm dealt in the main in tea, silk, silk cocoons, and tung oil, the typical colonial export articles of that era. I had a Chinese girl companion, Yulan (Green Jade), with whom I explored Chinese life. We spent time in the Chinese City next to the foreign concessions, bought onion buns, and watched a scribe at a table writing a letter with a brush for an illiterate woman standing there. We saw the farmers bringing in their squealing pig from the villages in shoulder baskets as well as Taoist priests and Buddhist nuns in robes on the way to monasteries.

China early got under my skin, so that after I had immigrated to the United States in 1950, I came to miss the intricacies of Chinese life. To assuage my nostalgia, I began to look for Chinese mementos after teaching college. My first postcard encounter came when I stumbled upon one in a box of vintage cards in an antique store in San Francisco. Looking at a picture of the golden-roofed Forbidden City, I felt my heart beat faster. I experienced the power of a postcard. After that, I hunted down all the postcard shows in the Bay Area and accumulated six albums of vintage cards of China that brought back to me the country where I had once lived. From them, this collection of Beijing images is now available for your enjoyment.

Notes on the History of Beijing

The emergence of modern Beijing began when Kublai Khan, the grandson and heir of Genghis Khan, moved the Mongol capital from Karakorum in Outer Mongolia to a site near the ruins of Zhongdu, the central capital of the Jurchen Jin dynasty that was destroyed by the Mongols in 1215. As the third Great Khan, Kublai had inherited his grandfather's vast empire, reaching to the gates of Vienna. He himself completed the conquest of China and proclaimed the Yuan dynasty. The city that Kublai built as the capital of his empire was named Khanbalic, "City of the Khans." The Chinese appellation, Dadu, meant "Great Capital."

An enlightened ruler, Kublai adopted the ways of the Chinese and their advanced administrative system, while adhering to his Mongol identity. His capital city incorporated traditional Chinese principles in its layout along a north-south axis, with the imperial palace along its center. A prescribed number of gates pierced the earthen walls on each side and were connected by broad avenues themselves linked by narrower streets. Kublai drained the lakes around the present Forbidden City and built his palace there. The merchant Marco Polo described "Cambulac" and the imperial palace in glowing terms in the travelogue he is said to have dictated upon his return to Venice. His voyage with his father and uncle to the world's then most cosmopolitan city took place along the trading routes known as the Silk Road, which led from the Mediterranean area through Persia and across the Hindu Kush into China and was protected by intermittent Mongol military garrisons. Marco and his father and uncle arrived in Cambulac in approximately 1275. Kublai Khan, who was an outgoing ruler, welcomed them and, according to Marco, made use of him as his official emissary on various assignments.

Kublai Khan repaired parts of the Grand Canal, the singular engineering feat of earlier Chinese dynasties that linked the capital with Hangzhou in the south. He fostered science, drama, and the arts. He rebuilt the observatory that had been established in the area by the Jurchen Jin, star-watching being an age-old Chinese preoccupation. Mongols, Chinese, Tibetans, Uighurs, Nestorian Christians from Persia, Buddhists from India, and many other nationals met freely in the Great Capital, where many different religions were practiced and promoted.

The Mongolian Yuan dynasty lasted only one hundred years. Rebellions occurred; the empire began to disintegrate. The first Ming emperor, a Han Chinese commoner whose reign took the name Hongwu, established his court in the southern city of Nanjing. His tomb and spirit path are located in the mountains above that city and can still be seen today. His son, the third Ming emperor, moved the capital back to Dadu. Known since the time of the Ming conquest as Beiping (Northern Peace), it now took on the name Beijing (Northern Capital). Yongle ruled from 1403 to 1428 and started afresh, laying out a new city over a period of fifteen years, using foreign architects and "a million laborers" to do the work. The streets followed the precepts of a north-south geomantic axis and were surrounded by heavy protective city walls and watchtowers, legacies of the Yuan but much grander and more solid. Most of all, within the walled Imperial City, he tore down the ruins of Kublai's palace and built a fabulous new palace to a new design in 1420, with golden roofs, red columns, and marble balustrades all within a quadrangular compound surrounded by a crimson wall. The centerpiece was the Throne Hall, surrounded by lesser ceremonial halls and the emperor's domicile. The complex was referred to as the Purple Forbidden City—"purple" referring to the imperial residence and "forbidden" signifying that the palace was closed to outsiders.

Yongle also erected the now world-renowned Temple of Heaven as the emperor's supreme religious sanctuary. Sited to the south of the Imperial City, the Temple of Heaven is part of an extended dynastic complex, along with the Ming Tombs, the imperial burial grounds in the north. Yongle was an avid patron of Chinese art. Polychrome porcelain, painting, and architecture achieved a high degree of refinement during his reign and throughout the Ming dynasty. The Ming emperors conducted trade with the outside world. Yongle also sponsored the general Zheng He's maritime expeditions, which reached the Indian Ocean and the Persian Gulf well before Columbus or Vasco de Gama made their voyages. The dynasty crumbled under later weak and profligate emperors, during whose rules corrupt eunuchs abused their power and enriched themselves unduly. Once again, internal rebellions contributed to the dynasty's fall. The Ming dynasty lasted for three hundred years, from 1368 to 1644.

The horse-mounted Manchu tribesmen of the north became the next rulers of China. Their national hero, Nurhaci, had fought long wars on the border with the Chinese. He consolidated the Jurchen tribes and established the Manchu empire and Jin, or Latter Jin, dynasty, with a palace in the city of Mukden (Shenyang) in Manchuria. He also invented an alphabet for the Manchu language, a script that can be seen today on the framed notices outside the buildings of the Forbidden City, next to Chinese characters.

In 1644, as a peasant rebellion threatened Beijing, the last Ming emperor hanged himself in shame on Coal Hill. The rebellion's leader, Li Zicheng, proclaimed himself emperor of China. Meanwhile another aspirant to the throne, the Chinese general Wu Sangui, needing

allies to achieve his ends, opened the gates of the Great Wall at Shanhaiguan on the coast and invited the Manchus to help suppress the rebels. They poured in on their horses, rode to Beijing, ousted Li Zicheng's forces, and seized the throne, proclaiming the Qing dynasty.

The Manchus, too, adopted Chinese ways, including the long-standing bureaucracy, Confucianism, and the examination system by means of which to recruit and select civil servants. On the other hand, they also adhered to their own identity as the Mongols under Kublai Khan had done. They placed viceroys and bannermen in the provinces to secure the vast empire. Besides the age-old rites of Confucianism, they practiced those of Buddhism and Lamaism, the Tibetan form of Buddhism. The two enlightened Manchu emperors, Kangxi (r. 1661–1722) and Qianlong (r. 1735–1796), in turn, brought Chinese decorative arts as well as literature and architecture to another high point. Among religions, they favored Lamaism and maintained a Lama temple inside the city walls. They built numerous Tibetan-style temples outside the city for Tibetan visitors and residents. Qianlong in particular is credited with leaving his mark on Beijing through many new buildings and the renovation of old ones. During the eighteenth century, elaborate "summer palaces" were built outside the city, near the cooler mountains.

Since the mid-sixteenth century, the pope had sent out missions to Christianize the peoples of the world. Jesuit priests and mendicant friars accompanied explorers and traders east via the sea route, first stopping at the Portuguese colony of Goa on the Indian coast and then in Macao, on the southern coast of China. The late Ming and Manchu emperors, being the preservers of the lunar calendar, were much interested in the Jesuits because of their advanced knowledge of science and astronomy. Just as Arab astronomers had

previously been invited to sojourn at the court, the Jesuits were now invited to the palace to take part in making accurate calculations. The Jesuits perfected the astronomical instruments that had been used by the Chinese for centuries and assisted in other ways.

Under later ineffectual emperors, decadence set in, and the power of the eunuchs rose unduly again. This decline in imperial power coincided with greater pressure from Western states to engage in new forms of trade and state relations. Since the sixteenth century, first the Portuguese and then the Dutch and English arrived in Guangzhou (Canton) in the south. They established a foothold there to trade with the Chinese. While the West avidly sought tea, silk, porcelain, nankeen, and spices, the Chinese had little interest in Western goods, apart from precious metals, such as silver. When the English gained supremacy over other Western trading nations, they resorted to importing opium to China from their colony in India, to offset their trade imbalance. Though the Manchu court prohibited the importation of this narcotic, the English ignored the ban, and this triggered the Opium War in the waters of Guangzhou in 1839. On their victory, the English sailed up the coast to Nanjing and forced the signing of the Unequal Treaty of Nanjing in 1842, which opened up four ports on the coast of China and ceded Hong Kong to Great Britain.

The British also insisted on official representation at the capital, and to exert pressure sent 2,000 troops to Tianjin under the command of Lord Elgin, who had been designated High Commissioner of Northern China. The so-called Second Opium War followed a provocation in 1856; once again the weakened Manchus capitulated. The Tianjin Treaty of 1859 granted Britain, France, the United States, and Russia their desired representation and residence in Beijing, leading to the

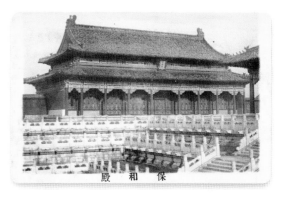

Marble balustrades of the Baohedian, Hall of the Preservation of Harmony, the rearmost great hall of the Forbidden City *no publisher 1930s*

building of the Legation Quarter. The treaty also opened up all of China to Christian missionaries.

The Manchu dynasty, further weakened, met its final demise in 1911, when a republic was proclaimed in Guangzhou by a group of revolutionaries under the leadership of Sun Yat-sen. After years of struggle to reunify the country, the Chinese Nationalists began to rule in Nanjing in 1927. The Japanese militarists occupied Manchuria in 1931 and staged an invasion in Shanghai in 1937. Beijing came under Japanese rule until the end of World War II in 1945, after which it was first retaken by the Chinese Nationalists under Chiang Kai-shek and then in 1949 by the Chinese Communists under Mao Zedong, after a four-year-long fratricidal civil war between the two groups. Mao Zedong proclaimed the People's Republic of China, while Chiang Kai-shek moved the Nationalist government to Taiwan, taking some of the palace treasures with them and preserving the old culture and hallowed written characters.

I

Beijing
City of Walls, Gates, and Watchtowers

THE MAGNIFICENT

RAMPARTS OF

FORMER TIMES

Threatened from time immemorial by the nomadic tribes of the north, Beijing arose as a city of walls, gates, and watchtowers. The Great Wall was built to hold the nomadic tribes at bay, just as the *limes* was the Roman Empire's first line of defense. Beijing enclosed itself within a huge city wall, forty feet high, with sixteen openings and intermittent watchtowers as well as long rows of crenellated battlements for archers. Ch'ien Men (pinyin: Qianmen) and Hatamen (Chongwenmen) were the two most prominent gates. Four huge watchtowers presided over the four corners of this main city wall, which under the Qing dynasty became known as the Tartar Wall.

The Tartar Wall enclosed three separate walled enclaves, one within the other. Within the Tartar City was the Imperial City, and within the Imperial City lay the Forbidden City. The imperial family lived in the Forbidden City, while the residences of the Manchu noblemen, bannermen, and the eunuchs were located in the Imperial City. They occupied so-called saddleback houses behind walled compounds with big red wooden gates along secluded alleyways called *hutong*—a Mongol word still in use today. These dwellings were situated among minor palaces, temples, lakes, gardens, and official buildings. Ordinary Manchus occupied the Tartar City. In turn, the Chinese lived to the south in the Chinese City, also referred to as the Outer City. This too was enclosed within a wall and included the Temple and the Altar of Heaven. The activities of the Chinese of Beijing were limited to their

city, which from the Tartar City was reached mainly through the openings of the Ch'ien Men and Hatamen Gates.

The Tartar City wall, the tallest and heaviest one of all, was faced with brick. The top was wide enough for two carriages to pass, and its gates were bolted at night. To walk or travel in Beijing, residents had to know the names of the most important gates when giving directions to a rickshaw puller or taxi driver. These gates, and especially the huge, impressive Ch'ien Men and Hatamen, were a photographer's constant target as landmarks and emblems of Beijing.

Outside of the main wall, in the Chinese City, a whole separate world unfolded. Here forbidden fruit could be savored. There were theaters, restaurants, mahjong parlors, opium dens, and all kinds of markets—among them the notorious "thieves market," where one could retrieve one's lost objects. Here things could be bought that could not be found elsewhere. Camel caravans rested languidly near the Chinese City wall after a long journey across the desert, masticating food they had ingested long ago, their long lashes veiling their eyes. These respected and proud animals always were a heartwarming sight. The world out here was more real and truer to life than the affected ways of the Manchus and Chinese inside.

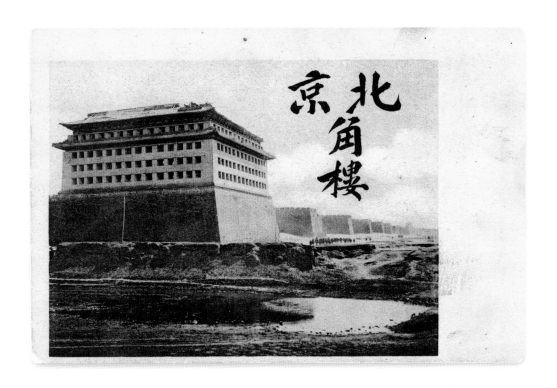

Early Cards

Left Corner tower and wall, emblems of Old Beijing, in a view much favored by photographers *no publisher pre-1907*

Left bottom Beijing city wall and camel train carrying bags of coal *O. Ludwig hand-dated February 10, 1908*

Below Before a Beijing corner tower, two-humped Bactrian camels coming and going as they had done for centuries *no publisher ca. 1919*

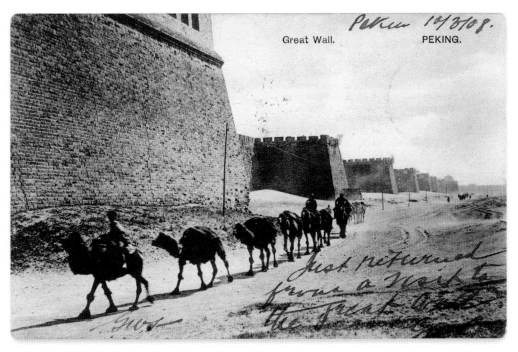

Great Wall. PEKING.

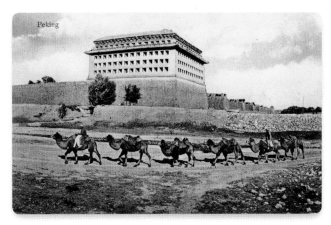

Peking

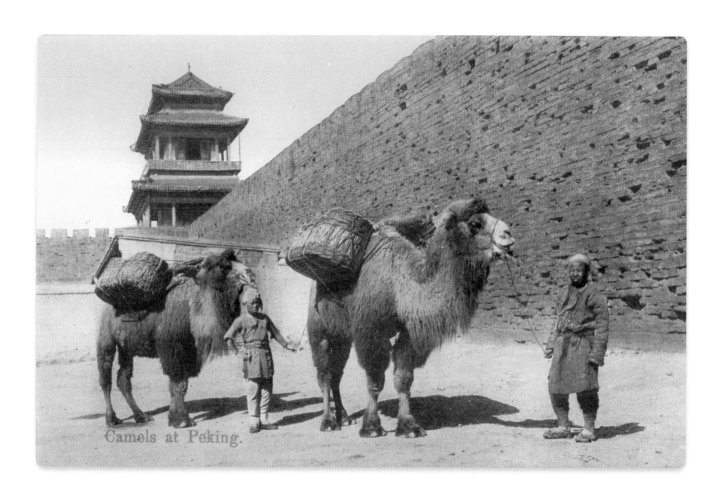

Camels at Peking.

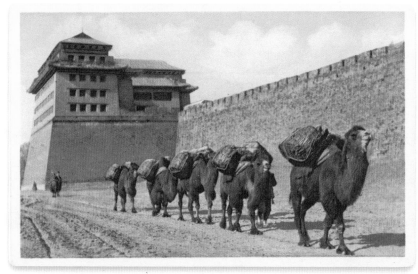

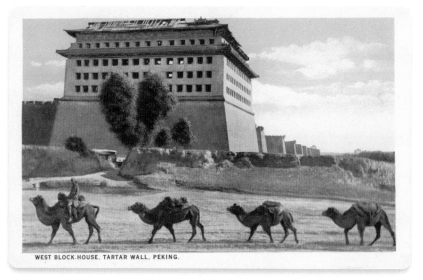

WEST BLOCK-HOUSE, TARTAR WALL, PEKING.

Outside the City Ramparts

Opposite top Camels below the wall near Hatamen Gate, posing for the photographer *Universal Postcard ca. 1907*

Opposite bottom left Camel train below the wall near Ch'ien Men Gate, carrying heavy bags of coal *Hartung's Photo Shop ca. 1920*

Opposite bottom right A damaged corner tower, with camels in steady gait *Camera Craft ca. 1920*

Right Corner tower and wall in silent majesty *no publisher pre-1907*

Below Beijing city wall and moat, with dwellings below *S. Yamamoto pre-1907*

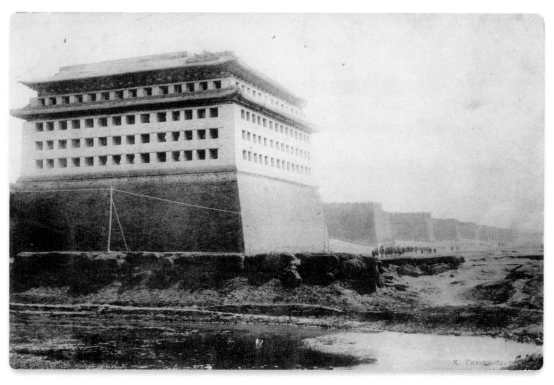

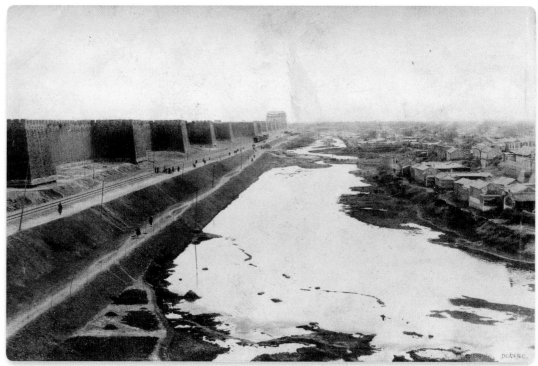

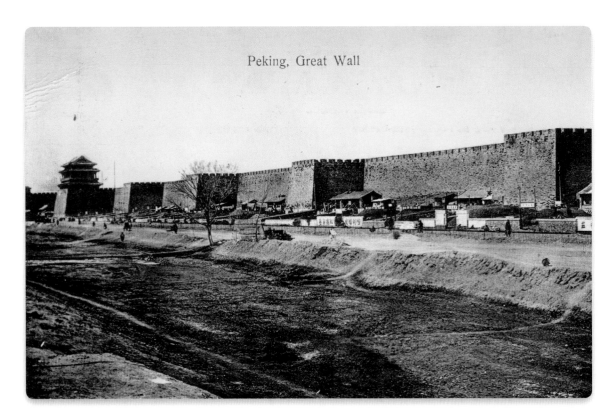

Peking, Great Wall

Ch'ien Men Gate and Environs

Opposite top left Traffic pressing through Ch'ien Men Gate
Kingshill (Qing dragon flag) ca. 1920

Opposite top right Ch'ien Men Gate repaired after Boxer
Uprising *no publisher ca. 1910*

Opposite bottom left A man with a queue rides a donkey,
with a city gate in the distance. *no publisher pre-1907*

Opposite bottom right Zhengyangmen, the archery tower
at Ch'ien Men, side view *Hartung's Photo Shop ca. 1920*

Above Beijing exterior city wall, with
dwellings below and dry moat
no publisher ca. 1910

Right Near the railway station beyond the
Tartar City wall, Chinese at work
S. Yamamoto ca. 1920

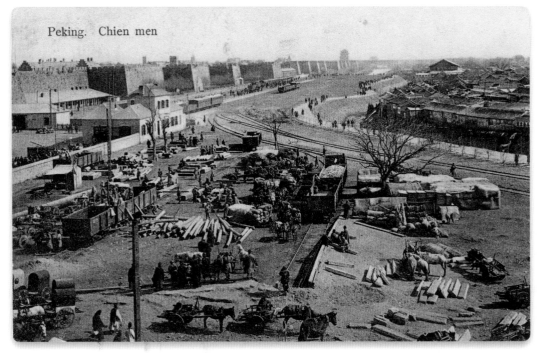

Peking. Chien men

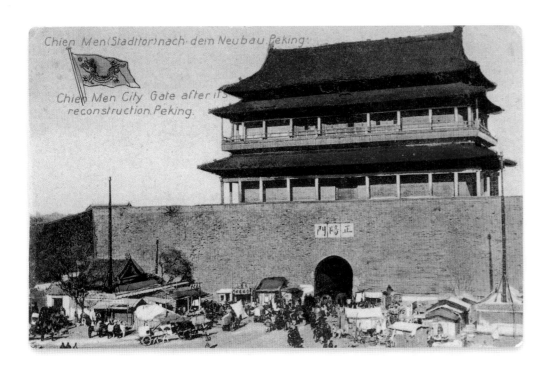

Chien Men (Stadttor) nach dem Neubau Peking.

Chien Men City Gate after its reconstruction. Peking.

正陽門

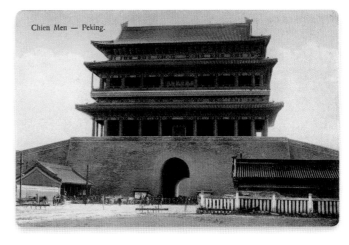

Chien Men — Peking.

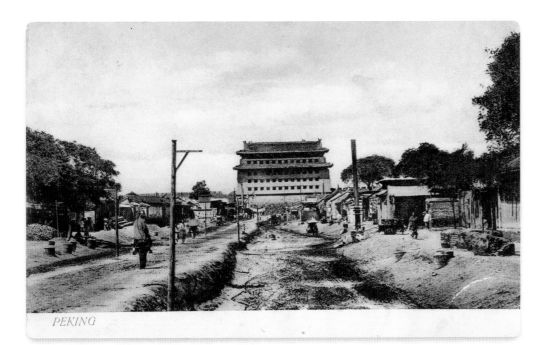

PEKING

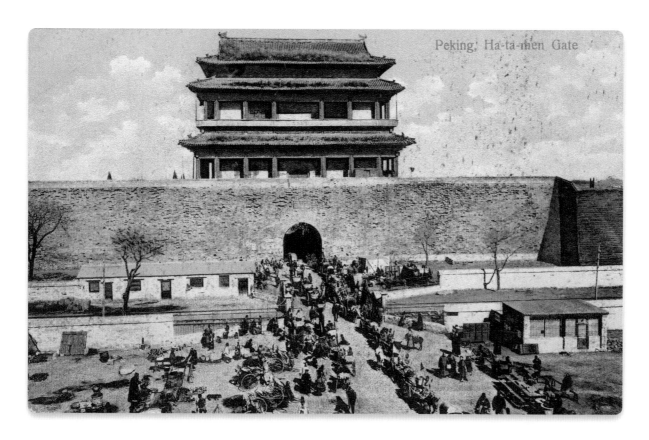

Peking, Ha-ta-men Gate

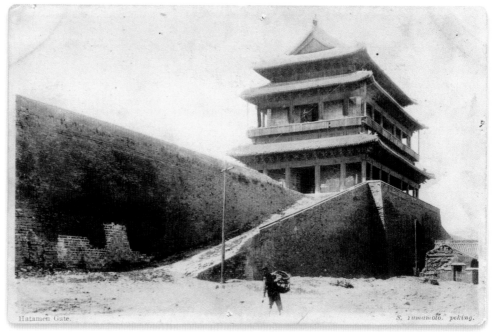

Hatamen Gate. S. Yamamoto, peking.

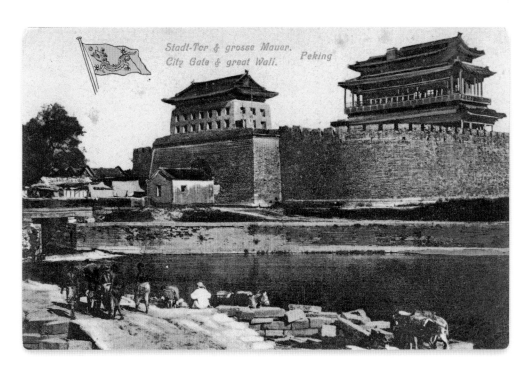

Hatamen Gate, the "Old Faithful"

Left Gate and guardhouse, with moat and cart stop *Kingshill (Qing dragon flag) ca. 1910*

Below Hatamen and life near the gateway *Kingshill (Qing dragon flag) ca. 1910*

Opposite top Traffic at Hatamen Gate, moving between the Chinese City and the Tartar City *no publisher ca. 1920*

Opposite bottom Hatamen side view and rag picker *S. Yamamoto pre-1907*

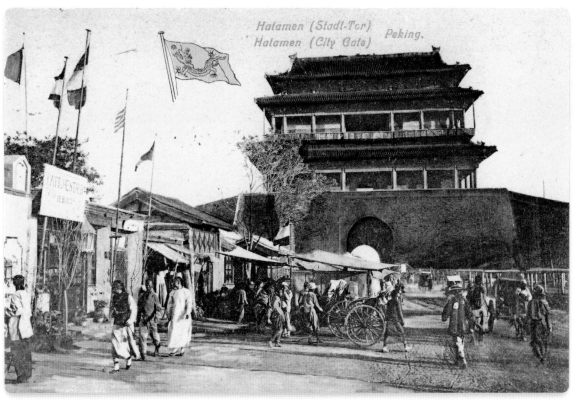

2

The Forbidden City

The Forbidden City, with its centerpiece, the grand Throne Hall (or Hall of Supreme Harmony) and the many lesser ceremonial halls and residences for the emperors, represents an all-time architectural masterpiece. It was from here that the Son of Heaven, dressed in elaborate robes, ruled the Middle Kingdom from the Dragon Throne.

"Forbidden City" was the name Westerners used in my time for the imperial palace, because its hermetically closed gates protected the secret lives of the emperors and their retinue within. It derives from the Chinese term *Zijincheng*, meaning "Purple Forbidden City," which was apparently introduced in the Yongle emperor's day in 1420, when the palace was completed.

After the conquest of Kublai Khan's capital city and the destruction of his palace, Yongle laid out a new city on a north-south axis, embodying a geomantic concept of old. Along this axis, in the heart of Beijing the Forbidden City was established, with the Throne Hall (Taihedian) at the geomantic center. This city is entered by the hefty Wumen Gate, sometimes called the Meridian Gate. Six large golden-roofed Great Halls succeed each other on the inside. All the buildings stand on white marble platforms adorned with intricately carved balustrades. The emperors of the Ming (1368–1644) and Qing (1644–1911) dynasties held court here with their ministers, issuing edicts, making proclamations, and planning military expeditions. In a smaller banquet hall, the Manchu emperors held feasts to as many as a thousand princes

and nobles at a time. The Forbidden City was surrounded by a rose-colored wall with four charming corner watchtowers and was protected by a moat covered with pink lotus flowers when in season. Today, we still see remnants of all these.

The Manchu emperors Kangxi and Qianlong continued to embellish and renovate Beijing. Qianlong in particular stands out. He built five pavilions on Prospect Hill (Jingshan, also called Coal Hill) and the Pavilion of Purple Brightness (Ziguangge) in the Imperial City as well as several gardens; and the gardens of Yuanmingyuan became what was later known as the Old Summer Palace. In the Forbidden City, the Qianlong Garden complex, with its lavish buildings and decor, was intended for his retirement, even though he continued to rule until his death. He also built the Hall of Pleasurable Old Age (Leshoutang) for his elderly mother, the Pavilion of Literary Profundity (Wenyuange), and the Palace of Established Happiness (Jianfugong), and in the Chinese City he renovated the Temple of Heaven. Kangxi, his son Yongzheng (r. 1723–1735), and Qianlong, through their patronage and imperial workshops, brought the decorative arts to an all-time high level of achievement. Exquisite porcelain vases, carvings, cloisonné pieces, embroideries, paintings, and furniture filled the nine hundred rooms of the Forbidden City. Kangxi commissioned the famous many-volume dictionary known by his name, while Qianlong's poems were engraved on stone far and wide. The emperors improved roads,

repaired the Grand Canal, and filled the granaries.

When decline set in with subsequent emperors, the palaces and temples suffered physical decay as described by early Western travelers in books about Beijing. The city lingered unkempt for many years. It was not until the Nationalist Government came to power in 1927 that substantial efforts were made to reverse the dilapidation. Recognizing the importance of this unique city and its heritage, Yuan Liang, the new mayor, requested funds for its restoration in the 1930s. Chiang Kai-shek personally arranged for the money to be allocated so that the Forbidden City and all of Beiping (Northern Peace), as the city was then called, might be returned to their onetime glory, as the colored postcards of that era show. It was during those years that I was able to enjoy the great emperor Yongle's capital in its restored brilliance during a visit with my mother and brother in 1936.

The People's Republic restored the name Beijing, but twice during the Cultural Revolution of the 1960s the Forbidden City was stormed by Red Guards bent on carrying out Mao's dictum to "Destroy the Past." He had issued the slogan as part of a power struggle within the Communist Party, and it signified his desire to purify the party. The palace was saved once by the palace guards and then through the repeated intervention of the premier, Zhou Enlai—just in time for the historic visit of President Richard Nixon, who strode expeditiously through its confines in 1972. On my own visit to Beijing in 1981, the communist government had already torn down the city walls and was building functional apartment houses on its grounds, recycling its bricks as building material for walls of a different nature.

Architectural Symmetry and Harmony

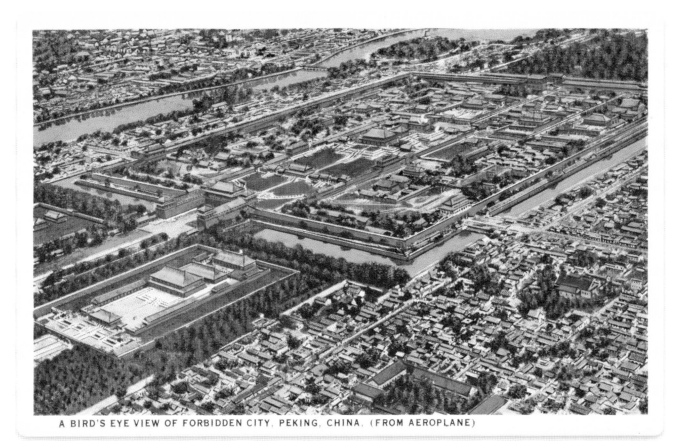

"From Aeroplane":
a bird's-eye view of the Forbidden City *Camera Craft ca. 1930*

A BIRD'S EYE VIEW OF FORBIDDEN CITY, PEKING, CHINA. (FROM AEROPLANE)

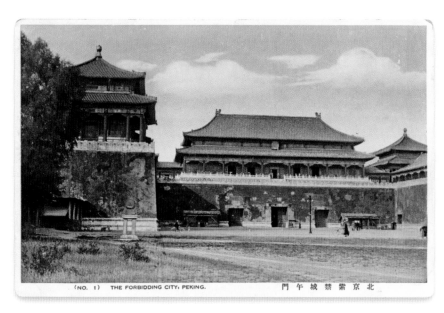

(NO. 1) THE FORBIDDING CITY, PEKING. 北京紫禁城午門

Wumen—main entrance to the Forbidden City,
showing side pavilions *Graphische Gesellschaft, Berlin ca. 1910*

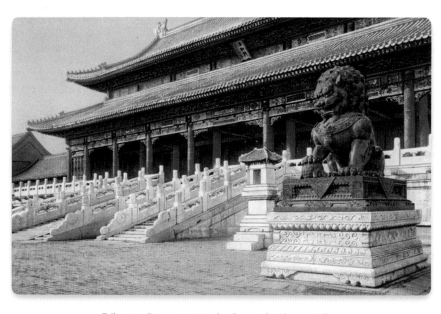

Taihemen Gate, great gate leading to the Throne Hall
Hartung's Photo Shop ca. 1920

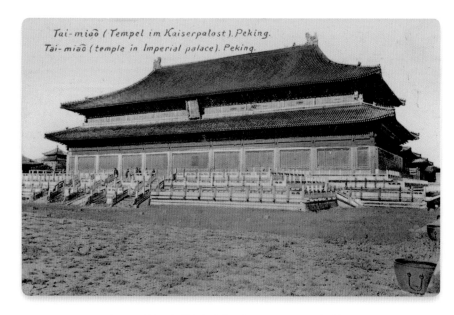

Tai-miaō (Tempel im Kaiserpalost). Peking.
Tai-miaō (temple in Imperial palace). Peking.

Ancestral Temple (Taimiao), housing emperors' soul tablets,
located just outside the Forbidden City *no publisher ca. 1910*

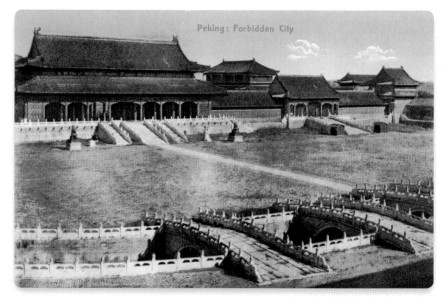

Peking: Forbidden City

Gate of Supreme Harmony (Taihemen), with canal and
marble bridges *no publisher ca. 1920*

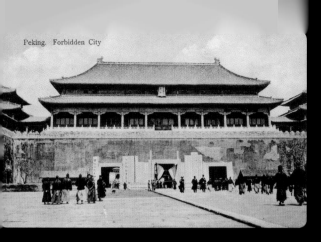

Peking. Forbidden City

Wumen, main entrance: three Westerners emerge from doorway, Chinese with queues looking on *no publisher pre-1907*

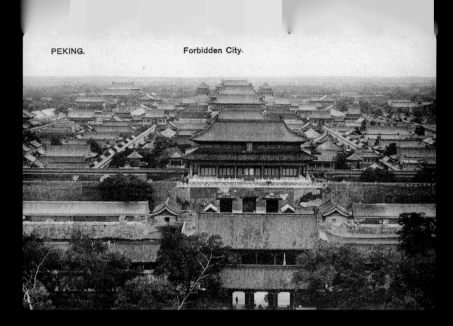

PEKING. Forbidden City.

Looking south over the Forbidden City
O. Ludwig, Peking
pre-1907

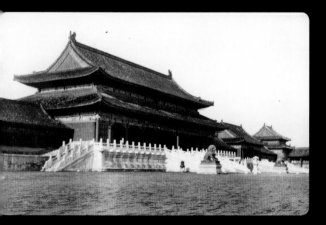

Taihemen Gate: empty courtyards, awaiting the emperor
no publisher Real Photo postcard, pre-1907

Hall with dragon path, over which the emperor's chair was carried *no publisher pre-1907*

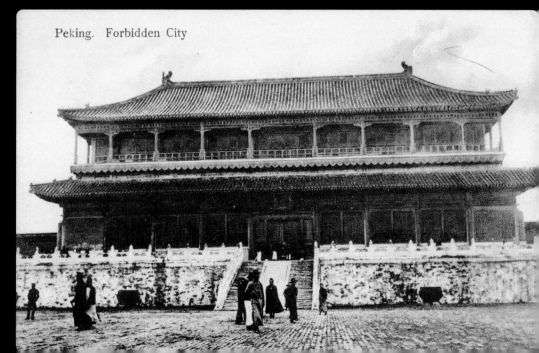

Peking. Forbidden City

Views of the Forbidden City in Color

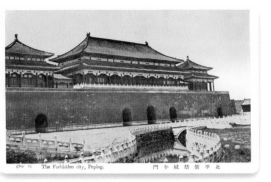

Court inside Wumen, with playful canals
and marble balustrades
no publisher ca. 1920

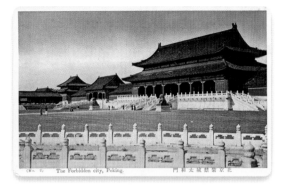

Gate leading toward the Throne Hall,
with bronze heavenly lions
no publisher ca. 1920

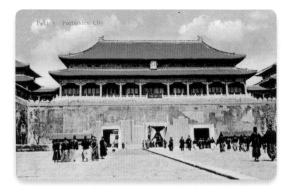

The main gate, Wumen, and two side pavilions
no publisher ca. 1920

Brilliant Gold-Tiled Roofs

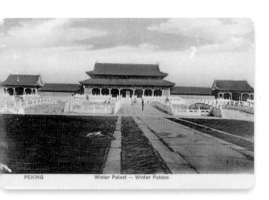

Panoramic view of Forbidden City courtyards
Hans Bahlke 1910–1920

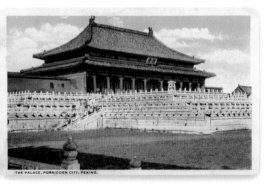

Throne Hall on triple marble terrace
Camera Craft 1930s

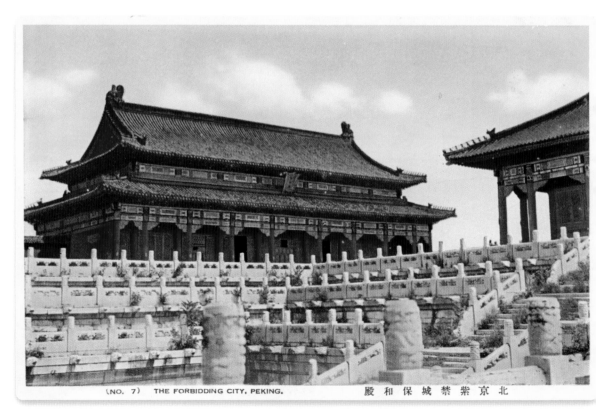

View of Throne Hall emphasizing the triple marble terrace
no publisher 1930s

The Golden Throne and the Empress Dowager's Residence

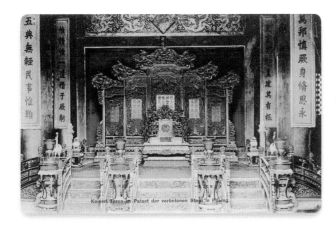

The golden throne
Hans Bahlke hand-colored, 1910–1920

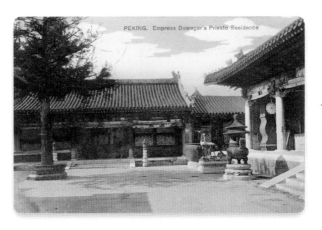

The Empress Dowager's private residence, with incense burner and Western clock
Hans Bahlke 1910–1920

The Imperial Procession and Return

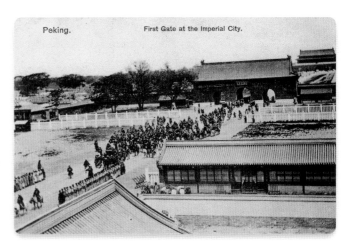

Imperial procession leaving from First Gate, with Manchu bannermen
O. Ludwig ca. 1910

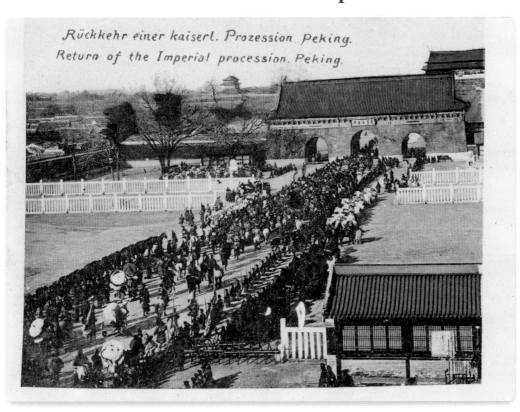

Return of imperial procession, with military and white horses lined up at the sides
no publisher ca. 1910

Entrances to the Forbidden City

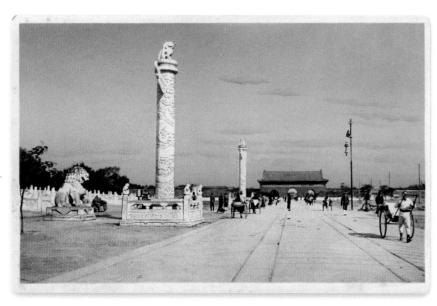

Heroic marble columns and rickshaw on Tiananmen Square, looking east
Librairie Française, Peking ca. 1920

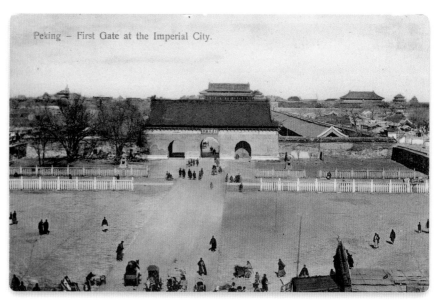

First Gate to the Imperial City
no publisher ca. 1920

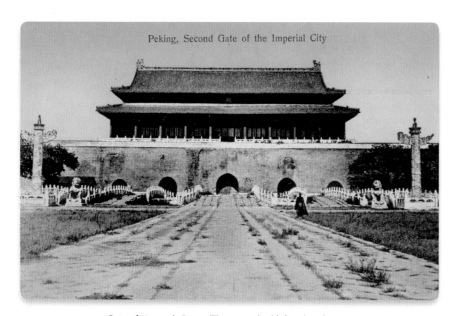

Gate of Heavenly Peace (Tiananmen) with heroic columns
no publisher ca. 1910

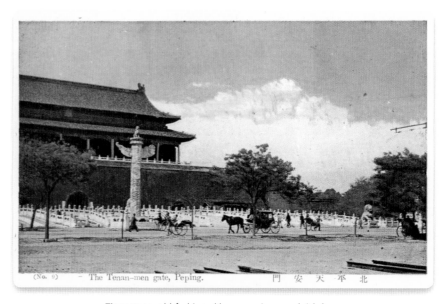

Tiananmen, old-fashioned horse carriage, and rickshaws
no publisher ca. 1910

Hall of Perfect Harmony, an audience hall
Japanese publisher ca. 1910

Back of card below. The hand-written notation reads: "This shows a corner of the Forbidden City . . . There is several thousand Chinese soldiers in there and some of the High officials and Know body can get in—if they would they would never get out."

Playful tower at corner of the crimson wall surrounding the Forbidden City. Lotus flowers fill the moat
Japanese publisher ca. 1910

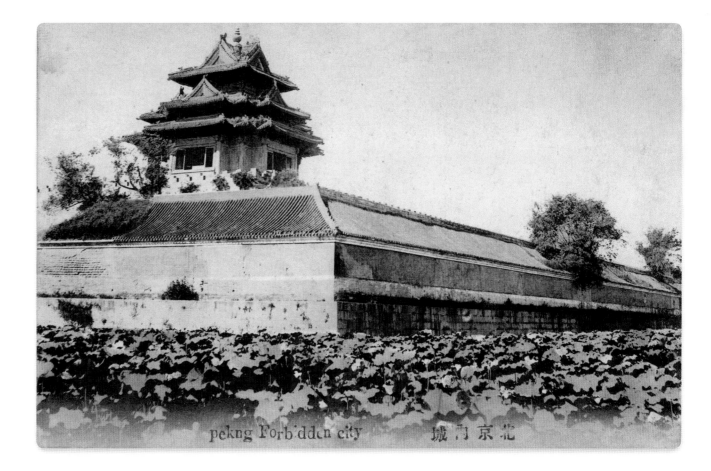

3

The Temple of Heaven and Altar of Heaven

ALTAR OF HEAVEN,

MOST SACRED PLACE

FOR SUPPLICATION

TO SHANGDI, THE

LORD OF HEAVEN

TEMPLE OF THE

MOON AND ALTAR

OF AGRICULTURE

The Temple of Heaven and the circular, marble Altar of Heaven were the most sacred structures in all of China. The design of the two edifices expresses a profoundly spiritual concept. The triple-roofed pavilion of the Temple of Heaven is considered one of the most perfectly proportioned buildings in the world; its azure-colored roofs represent Heaven. The temple was built under the emperor Yongle and completed in 1420, and the Altar of Heaven was added in 1530. The emperor worshiped here once a year at winter solstice as the Son of Heaven. In doing so, he upheld a primeval monotheistic faith based on the patriarchal relationship between the ancestor and his descendants, a faith that predated Confucianism, Taoism, and Buddhism. The Temple of Heaven was also called the Hall of Prayer for Good Harvests. It was intended for the prayers that were liturgically uttered by the emperor and the members of the Board of Rites. Located to the south in the Chinese City, it was in fact an extension of the imperial palace and lay along the geomantic axis. Set on a three-tiered marble terrace with surrounding marble balustrades, it is supported by twelve red columns on the outside as well as the inside and is ornately decorated on the ceiling. Burned down once, it was rebuilt. It was a favorite subject of the photographers and is shown over and over again on postcards.

The Altar of Heaven, or Round Altar, next to the Temple of Heaven, is perhaps even more sacred in its concept and function. It is a circular three-tiered open terrace with three rows of nine steps. The top terrace serves as the sole location for the performance of the most sacred ritual of all. In his capacity as the Son of Heaven and intermediary between his people and the Lord of Heaven, Shangdi, the emperor would supplicate once a year for the protection of his people from floods, famine, and drought, all of which plagued China periodically. After the required fast, the emperor would be carried here in a closed sedan chair in the early hours of dusk, dressed in sackcloth and accompanied by his retinue. He would prostrate himself in complete submission on the round center slab of the altar and recite hymns and prayers. Animals were sacrificed as burnt offerings in bronze urns that stood beside the altar. Specially chosen breeds of white deer, oxen, and sheep were raised on the temple grounds for the occasion. Smaller temples were provided for the emperor for an overnight stay and as repositories for sacrificial vessels and appurtenances. Surrounded by high-rises today, these architectural treasures are hidden in among taller buildings and are flanked by an intense flow of traffic rushing by—a token of how man's materialistic activities have taken over from a formerly profoundly contemplative world.

Beijing has in addition many altars going back to antiquity. The Altar of Agriculture, also called the Altar of the First Farmer, lies on the opposite side of the Temple of Heaven on Ch'ien Men Street. It was dedicated to Shennong, the

The Temple and Altar of Heaven: China's Supreme Sanctuaries

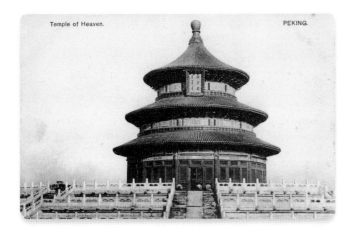

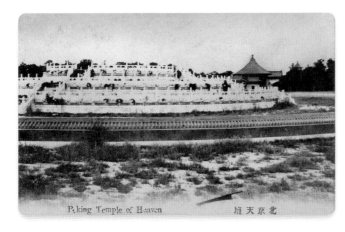

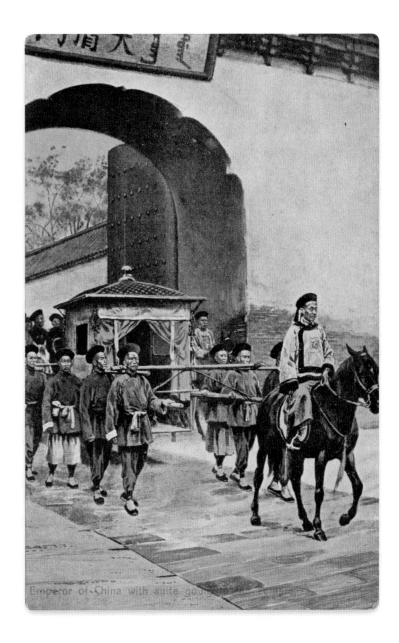

mythological emperor of husbandry who invented the plow. After making sacrifices to Shennong's tablet, the emperor would walk over to a yellow plow that stood in readiness for him to plow three double furrows at the end of a small field to welcome in the spring. This was an important ritual, for the farmer came second to the scholar in China. Each of the princes who accompanied him took a subsequent turn until the field was plowed.

There are also altars outside the city walls to the north, east, and west dedicated to the sun, the planets, and the stars. The Chinese were an intensely nature-oriented people. At the Temple of the Moon, bird lovers still hang their cages in cypress trees along the avenue toward these sacred structures, while having a chat with a neighboring bird aficionado.

Above The emperor in a sedan chair en route to the Temple of Heaven, from an oil painting *Kingshill ca. 1910*

Left top Temple of Heaven, the most perfect building in the world and a favorite of Western photographers *no publisher 1910–1920*

Left bottom Altar of Heaven, the most sacred spot in the empire, where the emperor addressed Shangdi, the Lord of Heaven *Japanese publisher 1920s*

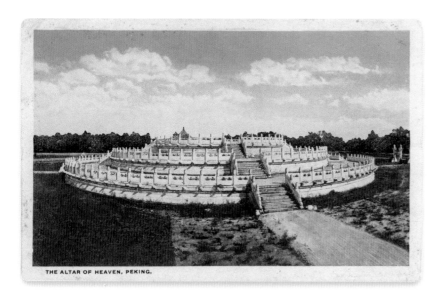

Altar of Heaven—or Round Altar—a round open-air marble terrace with triple stairs
Camera Craft, Peking ca. 1920

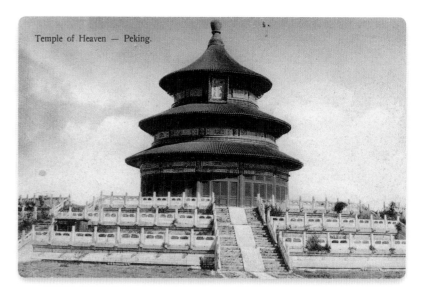

Temple of Heaven
no publisher 1920s

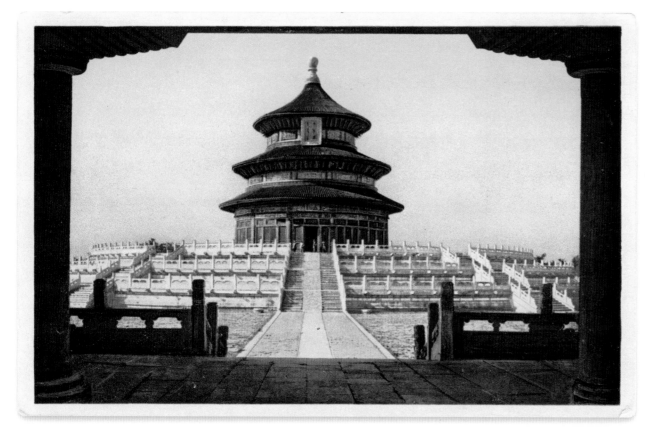

Temple of Heaven, or Hall of Prayer for Good
Harvests, a hall for imperial prayers
Hartung's Photo Shop 1920s

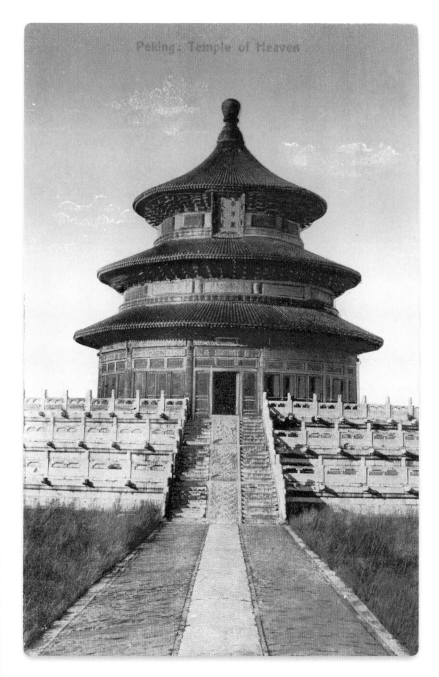

Temple of Heaven on triple marble terrace
no publisher 1920–1930s

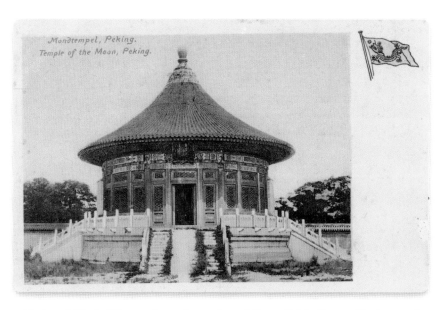

The Imperial Vault of Heaven, Huangqiongyu, housed the sacrificial tablets used in the annual rites (the identification on the card is incorrect). *Kingshill (Qing dragon flag) ca. 1910*

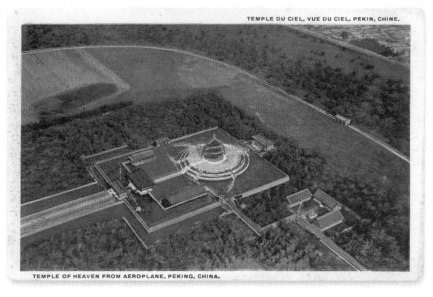

Temple of Heaven complex viewed from an airplane
Camera Craft, Peking ca. 1920

4

The Imperial Family

LAST DAYS

OF THE MANCHU

QING DYNASTY

CIXI'S TRIALS

The postcards in this collection depict notables of the Manchu court, including Cixi, the Empress Dowager, in different poses and in different royal robes. There is a picture from the funeral of the emperor Guangxu, whose regent she was, as well as cards for his three-year-old successor, Puyi; Puyi and his consort Wanrong (or Xiaokemin); two Manchu grand statesmen; and a Manchu general and short-lived self-styled emperor, Yuan Shikai.

Cixi, who ruled for fifty years at the end of the Qing dynasty, is shown sitting in or standing next to the imperial throne in black-and-white photographs and in color photographs that predate the arrival of Kodachrome film. Cixi always dressed in richly embroidered robes, of which she is said to have owned a large collection, having been an impassioned lover of beauty. One of her robes is supposed to have comprised the twelve royal emblems intended only for an emperor, making her equal to a man. The horse-hoof sleeve was a symbol of the Manchu equestrian heritage and can be seen on traditional Manchu gowns, but she chose to remove them from hers. Cixi spoke Chinese fluently, as well as Manchu. She was born with sharp native intelligence. An educated woman, she had mastered the Chinese classics thoroughly and could quote from them by memory.

Cixi was painted twice by Westerners: once by Miss Katharine Carl, an American portraitist, and once by Hubert Vos, a Dutch painter who traveled around the world. When Vos arrived in Beijing, he was asked to do a painting of her and devised a handsome background of bamboo reeds. He reported that the dignitaries and eunuchs who stood nearby directed him to leave the wrinkles and lines out of her face.

Cixi's favorite residence was a new Summer Palace on Kunming Lake, west of the walled city, where she lived in retirement. She loved to amble in the gardens, walk in the snow, and seek cover under the famous Long Colonnade with her ladies in waiting. After the destruction wrought by the Anglo-French troops in 1860, she had avidly rebuilt and expanded the fabulous lakeside palaces. She also built what some consider an outrageous marble pleasure boat set on the shores of the lake, using funds said to have been earmarked for a modern navy.

A member of the Manchu Yehonala clan, she was selected as an adolescent to be one of the concubines of the effete emperor Xianfeng, and she gave him an only son. Early on, she is said to have begun to assist the emperor with administrative affairs, displaying a bright intellect and a high level of managerial ability to run the state.

Her first political test occurred in 1860 after the signing of the Treaty of Tianjin with the Western nations to end the Second Opium War. On their way to ratifying the treaty in Beijing, two British envoys and their entourage were seized and imprisoned, and one of the envoys was tortured to death. This so incensed Lord Elgin, the British commander of Northern China, that he ordered his troops to burn down the

The Empress Dowager

Old Summer Palace, which had become the alternate residence of the ruling Manchus. Xianfeng and his concubine Yehonala were forced to flee to Jehol, the Manchu emperors' Tibetan-style mountain resort in the north. When Xianfeng died in 1861, Cixi showed her political skills, and with her eunuch accomplices installed her five-year-old son as successor, with the reign title Tongzhi, beginning her long rule from behind the imperial throne, most of it as Empress Dowager.

Her nephew Guangxu succeeded Tongzhi, who died young. When Guangxu befriended youthful reformers and began the Hundred Days' Reform in 1898, Cixi had the radicals killed. Only Kang Yuwei, the leader, managed to flee to Japan, while she imprisoned the emperor in the Winter Palace for life. The moderates at the imperial court, such as the two Grand Councilors Li Hongzhang and Zhang Zhidong, counseled modernization in the technical realm but retention of China's heritage and the teachings of Confucius as China's moral base.

The so-called Boxers were a secret society named the "Righteous and Harmonious Fists" that was once anti-Manchu but turned anti-Western. During the Boxer Uprising in 1900, Cixi ordered them to burn down the Legation Quarter inside Hatamen and issued an order to kill all Christian missionaries and converts in China to stop the continued encroachment by Westerners upon her land. As a Manchu patriot, she fiercely defended her dynasty, turning just as fiercely anti-Western. Had the confrontation turned personal? It was said by Westerners in her day that she was the only real man in China.

In the besieged Legation Quarter, the foreigners resisted the attack for seven weeks during the summer of 1900. During the siege, the wives asked to be shot dead by embassy aides if in danger of capture by the Boxers. However, the Empress Dowager lost this second war against the Western powers. She was forced to flee to Xi'an, a former capital of China. She is said to have traveled on foot with her retinue, supposedly in the disguise of a peasant woman with a scarf wound around her head—so the story went in Beijing.

Once again, she overcame excruciating humiliation in her stoic way. After a two-year exile in the former capital, she returned to Beijing with a spirit of conciliation toward the Western barbarian. The Western powers had rebuilt more luxurious legations in compliance with the Boxer Protocol of 1901, which affirmed the rights of representation and residence in Beijing that they had fought so vehemently to maintain, turning China into a near colony. Cixi now held audiences for the ambassadors and their wives, while the foreign women invited Manchu noblewomen to their legation homes in return. Sarah Pike Conger, the wife of the American ambassador and an outgoing woman who was deeply interested in Chinese ways, held a tiffin (lunch) for the leading imperial princess. She writes in her book *Letters from China* (1909) that the Imperial

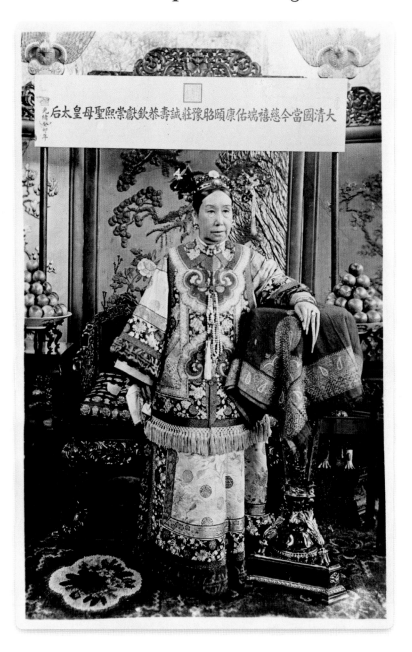

Cixi, the Empress Dowager (1835–1908), in her late sixties, in regal gown lacking horse-hoof sleeves, with her long fingernail protectors *no publisher Real Photo postcard, pre-1908*

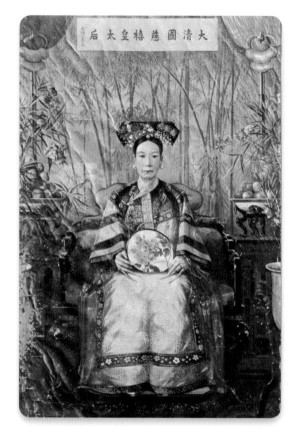

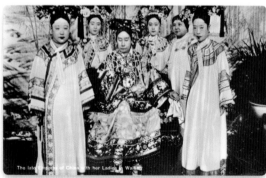

Above Empress Dowager with ladies-in-waiting. Cixi is wearing her favorite 2,500-pearl vest. At left is Princess Der Ling, at right Princess Rongling (the later Madame Dan). *A. Feng photograph, Universal Postcard ca. 1880s*

Top Empress Dowager sitting, with bamboo background. From oil painting by Dutch painter Hubert Vos. *no publisher ca. 1906*

Princess arrived in a sedan chair borne by a team of eunuchs accompanied by her retinue and brought Mrs. Conger the empress's greetings. The guests were served Western meals.

Mrs. Conger arranged for Miss Katharine Carl, an American portraitist for the International Exposition in St. Louis who happened to be passing through Shanghai, to paint a portrait of the Empress Dowager. Miss Carl describes her subject during the sittings in detail in her book *With the Empress Dowager of China* (1906) and quotes the Empress Dowager saying, " 'There is just a little crease down there in the skirt on the painting that must be remedied.' " Both Mrs. Conger and Miss Carl were so charmed by the empress's exquisite manners that they refused to believe the reports in the Western newspapers that she was "the evil lady of the Manchu Court." Her charm was known to be devastating, but her cruelty toward opponents equally so.

Elisabeth von Heyking, the wife of the German ambassador, describes in her book *Memoirs of Four Continents, 1886–1900*, "a special meeting" with all the ambassadors' wives granted by the empress. The embassy ladies were carried to the audience hall at South Lake in sedan chairs by teams of eunuchs. They found the empress seated on a dais, with the young Guangxu sitting next to her, having been let out of his imprisonment for the day. Cixi reached out her hand to each one of the ladies as they filed by, heretofore an unknown act. The dominant color in the palace was a dazzling pink, since the many Manchu princesses wore gowns of that color, and their Manchu butterfly hairdos were adorned with pink flowers as they stood in readiness to escort the embassy ladies to their seats. Innumerable eunuchs rushed to and fro, to the annoyance of Mrs. von Heyking.

Elisabeth von Heyking's memoirs further portray the political atmosphere of the time, with envoys shuttling between the Manchu Foreign Office, the Zongli Yamen, and their own legations, wrangling over spheres of influence and railway franchises with which she didn't always agree. Some of the deals were "too big a bite"—like the Bay of Jiaozhou, which the German emperor tried to gain for Germany. She recounts that the reform-minded Guangxu had previously been caught wearing Western clothes brought to him by the reformer Kang Youwei and his group. The clothes were another cause for his imprisonment in the Winter Palace and were torn off his body, the writer says. Most histories call Guangxu's death on November 14, 1908, "mysterious." In her account, *Two Years in the Forbidden City* (1925), Princess Der Ling depicts the principal eunuch standing at Guangxu's deathbed, while the Empress Dowager had already selected the two-year-old child Puyi as the next emperor, counting on being his regent.

She died the day after Guangxu. Her life had been a spectacular rise to power, from the condition of a simple Manchu girl in an environment of the tightest of sequestrations, where she could neither do nor move as she pleased. Her only option to carry out her ambitions was to

The Emperor Guangxu's Funeral Following His "Mysterious" Death

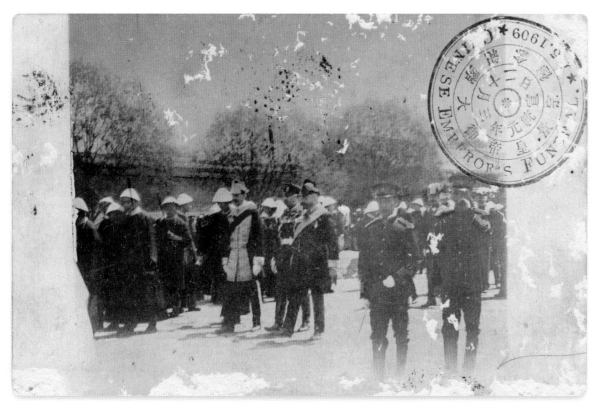

Guangxu's 1909 funeral procession with foreign ministers and Manchu cortège
Japanese publisher damaged postcard with commemorative stamp, 1909

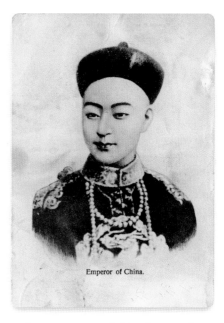

Guangxu, emperor of China, in court robe
and hat *O. Ludwig retouched image, hand-dated
June 20, 1910*

resort to ruse and intrigue and the help of the eunuchs. She rose to power not once but twice. She ruled the empire from the Golden Throne in the Forbidden City with an iron fist and became nothing less than a hero of her own kind. China was left in an uncontrollable miasma, beset by rebel groups who were successors to the Taipings and Boxers, the new revolutionaries, rising warlords, and, last but not least, the ever more encroaching Westerners. Cixi was interred in the

Eastern Tombs of the Qing emperors near her Manchu homeland.

Guangxu's Untimely Funeral as the Victim of Regency

The funeral procession of the unhappy reform-minded Guangxu emperor is portrayed on a damaged commemorative postcard that depicts foreign dignitaries walking alongside and white-hatted Manchu guards bearing the low sarcophagus. The scene represents a sad slice of history. The

three rings of the stamp placed on this postcard describe the date of Guangxu's funeral on May 1, 1909, on the outermost ring; the Chinese date, the twelfth day of the third lunar month of the first year of Xuantong's (Puyi's) reign, on the innermost ring; and in between, the statement in Chinese that this was a "commemoration" of the funeral of the Dezong Jing emperor (that is, Guangxu).

Had Guangxu—who understood the need for reform and modernization—

ruled in his adult life, China might have become a constitutional monarchy, embodying both the old and the new. Instead, a powerless young Manchu boy had been chosen by Cixi to mount the throne. The rule of China by the liberal-minded Guangxu had also been the hope of some of the Westerners in China. Guangxu was buried in the Western Tombs of the Qing emperors, far from the woman who had ruled China and controlled his life.

Puyi—The Last Manchu Emperor as a Child

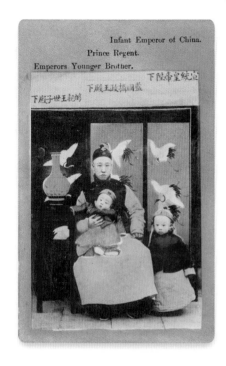

Left Prince Chun, the regent, seated; child-emperor Puyi on right; his infant brother in the arms of their father *Japanese publisher 1910*

Right Enthronement of boy-emperor Puyi on December 2, 1908 *Japanese publisher retouched image from etching based on a photograph, ca. 1910*

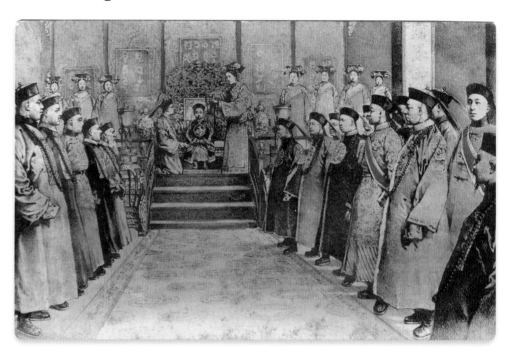

Left Child-emperor Puyi in front of crane screen, symbolic of longevity *no publisher Real Photo postcard, ca. 1910*

Right Imperial family with viceroy and statesman Li Hongzhang seated at left *Japanese publisher retouched image, ca. 1910*

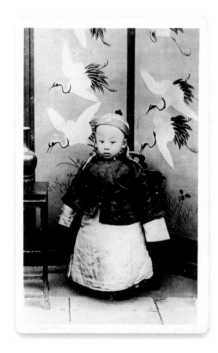

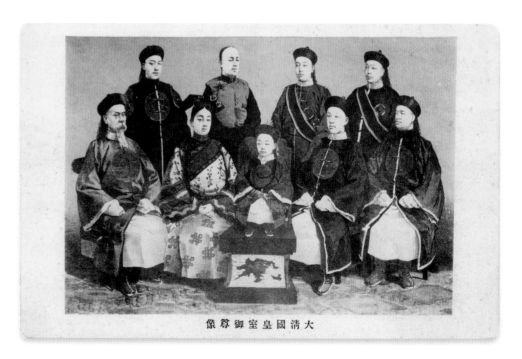

PUYI, THE LAST QING EMPEROR— A FAILED REGENCY AND A TORMENTED LIFE: FROM EMPEROR TO PRISONER TO HOUSE ARREST

Postcards of Puyi (1906–1967), the last emperor of China, whose reign took the title Xuantong, show him as a child in 1909 standing next to the regent, Prince Chun, who held Puyi's infant brother in his arms; then again in a retouched photo of a painting of his coronation; and finally with his principal consort, Wanrong.

Puyi's forced abdication in 1912 ended the Qing dynasty. He was six years old. He had been born in 1906, the nephew of the Guangxu emperor, who was his predecessor. His father, Prince Chun, served as his regent throughout his tenure. Puyi was the grandnephew of the Empress Dowager. He ruled as a child from the Forbidden City from 1908 until 1912. Of his childhood and youth, he writes in his memoirs that he was never left alone but was always surrounded by eunuchs: "They waited on me when I ate and slept, they dressed me, they accompanied me to my lessons . . . they never left my presence," he says.

The leaders of the new republic that was founded in 1911 requested Puyi's abdication, which occurred on February 12, 1912. An agreement guaranteed him the retention of the dynastic title and granted him and his family a pension, allowing them stay in the Forbidden City and the Summer Palace. He was provided with an English tutor, who informed him about Western life and culture. At the age of sixteen he was presented with four photographs from which to choose an empress. He was advised, however, not to take his choice, Wenxiu, but the young woman named Wanrong. He added Wenxiu as a consort, not an uncommon custom in China. A wedding ceremony was held in the Forbidden City on December 1, 1922.

The warlord Feng Yuxiang surrounded the city of Beijing in 1924, expelling Puyi and forcing him to surrender his dynastic title when he escaped to the Japanese Concession in Tianjin. After the Japanese militarists occupied Manchuria in 1931, Puyi was taken by them to Manchuria and was proclaimed emperor of the Japanese puppet state of Manchukuo (the Nation of the Manchus). When the Chinese Communists took Manchuria, he was returned to Beijing, where he spent ten years in prison and was placed in a camp for "reeducation." Being a target during the Cultural Revolution in 1966, he was divested of his few amenities but was permitted to write his memoirs. He died in Beijing on October 17, 1967, in the midst of the Cultural Revolution. Puyi's ashes were later buried near the Western Qing Tombs northwest of Beijing, where four of the nine Qing emperors preceding him were buried, together with three empresses and sixty-nine princes, princesses, and imperial concubines.

No innocent man could have suffered more inhumanity at the hands of man than Puyi, who was driven from one state of imprisonment to another, from one political torment to another, but who stood up valiantly in a spirit of detachment and intellectual independence.

Puyi as a Teenager

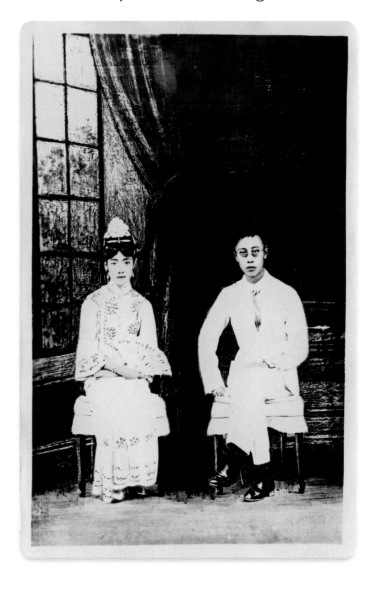

Puyi and principal consort, Wanrong
no publisher Real Photo postcard, ca. 1923

5

Three Powerful
Qing Statesmen

AN URGENT COMPROMISE WITH WESTERN THOUGHT

LI HONGZHANG, 1823–1901

A Qing viceroy, general, and statesman with diplomatic skills, Li Hongzhang believed in industrializing China without abandoning her heritage. He made deals with Western businessmen for railroad franchises, started his own shipping companies, developed an arsenal in Hanyang and a coal mine near Beijing, and fought the Taiping rebels from 1860 until their defeat in 1864. During these years, he was made a governor and later viceroy, and by 1870 he became a member of the Grand Council of the empire. He concluded the Chefoo Convention with Sir Thomas Wade in 1876, yielding this harbor and others to the British. He played a major role in ending the Boxer Uprising in 1900. He saw it as a fault of the court to have engaged with the Boxers, and was the principle negotiator with the foreign powers that had captured Beijing. On September 7, 1901, he signed the Boxer Protocol that yielded to the wishes of the Westerners, his last effort to mediate during Qing rule.

He was the first Chinese diplomat to be invited to tour Europe and America, and on his 1896 tour he met with Count von Bismarck, Lord Salisbury, and Lord Curzon. Queen Victoria made him a Knight of the Grand Cross of the Royal Victorian Order. In the United States he advocated reform of U.S. immigration law. He was much photographed everywhere he went. During his service to the Qing court he tried to maintain the difficult balance with a powerful industrialized foe from abroad. He was a favorite of Western entrepreneurs, of course, who called him the "Grand Old Man of China."

ZHANG ZHIDONG, 1837–1909

An eminent Chinese statesman and intellectual of the late Qing dynasty, Zhang Zhidong advocated broad educational reforms to cope with the inroads of Western thought and technology. He was one of the "Four Famous Officials of the Late Qing." He served as governor and as viceroy of diverse provinces. He was promoted to the elite Hanlin Academy by the Empress Dowager. During the First Sino-Japanese War, he along with Li Hongzhang advocated buying naval equipment from the European powers to prevent further Japanese encroachments. At court, he unsuccessfully opposed the cession of Taiwan to Japan. In 1898, he published a widely read book, *Exhortation to Study,* advocating radical educational reform, with "Chinese learning for fundamental principles and Western learning for practical application" as a way of guarding the Chinese heritage. In 1907, he was appointed head of the new Ministry of Education.

YUAN SHIKAI, 1912–1916
GENERAL, THE SECOND PRESIDENT OF THE REPUBLIC, AND A SELF-STYLED EMPEROR

A postcard of Yuan Shikai depicts the most powerful military and political leader in the last days of the Manchu dynasty and the first days of the Republic. In 1898 he sided with the

Li Hongzhang, Zhang Zhidong and Yuan Shikai

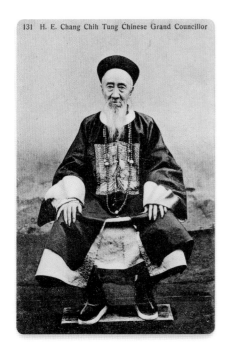

Zhang Zhidong, Chinese grand councilor, in Qing court robes
no publisher ca. 1890

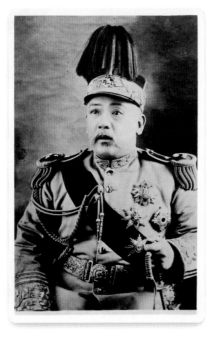

Yuan Shikai, president of the Republic from 1912 to 1915, in general's uniform with assortment of medals *no publisher Real Photo postcard, ca. 1911*

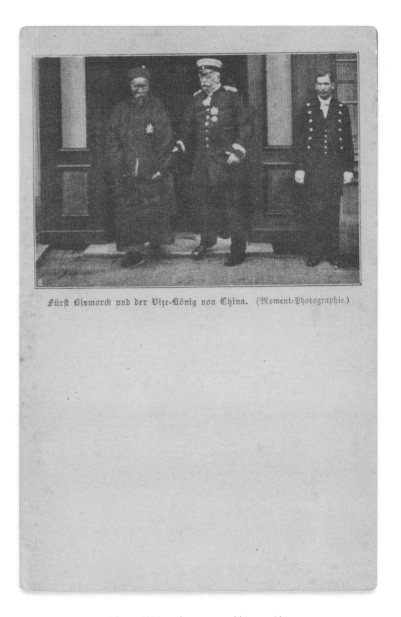

Viceroy Li Hongzhang on world tour, with Count von Bismarck in 1896
Candid shot, ca. 1896

Empress Dowager against Guangxu's attempted reforms. He was elected the second president of the Republic in 1912, after Sun Yat-sen. Sun Yat-sen had proclaimed the Republic in 1911 and thereby overthrown the Manchu dynasty, but he stepped down from the provisional presidency in favor of the powerful general, possibly because he lacked an army with which to unite China. Yuan Shikai remained president until 1916. Having harbored imperial ambitions all along, Yuan proclaimed himself emperor in the Throne Hall of the Forbidden City in a coup, but was forced by the leaders of the Republic to resign a few months later. He died in his own palace next to the Forbidden City in 1916, a broken-hearted man, leaving behind, it was said, a wife, nine concubines, seventeen sons, and fifteen daughters.

6

Manchu Fashions

and

Manchu Ladies

about Town

The Qing dynasty rulers brought their own fashions with them to Beijing from their Manchurian homeland in 1644: for women, a long gown and the so-called butterfly hairdo—two side panels or wings of hair, decorated with flowers and jewels. The traditional Manchu gown, or *qipao*, is shown on a postcard juxtaposed with its modern version—with a mandarin collar, slits on the sides, and a row of knotted buttons—a favorite of Madame Chiang Kai-shek. The *qipao* has regained popularity today.

Manchu women are seen in the streets of Beijing on a number of postcards. Being of nomadic ancestry, they enjoyed more freedoms than their Chinese sisters, who were brought up under the constraints of Confucianism and with bound feet. The binding of a young girl's feet was a six-hundred-year-old custom. It acted as a deterrent to the mobility of Chinese women and served as a beauty ideal for men. In comparison, the Manchu women's feet appeared large, and their shoes were built on platforms as a means to enhance their femininity. The Manchu men were soldiers and officers charged with protecting the nation. In Beijing, the Manchus were forbidden to work manually; all laborers, craftsmen, and artisans were Han Chinese.

We see Manchu ladies in the streets all over town, intermingling freely with the Chinese vendors, bargaining, riding unescorted in Peking carts and pulled in rickshaws. They were a sought-after subject by the foreign photographers of the twentieth century, who would follow them around since they were beginning to disappear from Chinese society. I still saw an occasional Manchu lady in the streets during the Republican era. Princess Rongling (the later Madame Dan), a Manchu and once a lady-in-waiting to the Empress Dowager, was still living in Beijing when I had the good fortune to meet her. Her sister, Princess Der Ling, also a one-time lady-in-waiting, had married an American and moved to the United States, where she wrote books about her association with the Empress Dowager and about life in the Forbidden City. Both princesses were the daughters of an early Manchu envoy to European courts and had learned to speak several European languages.

Regal gowns were an early tradition in Chinese dynastic history. They were brought to unparalleled perfection under the Manchu emperors and, like men's court robes, bore symbols indicative of rank. They were worn according to a protocol by which the nature of the event to be attended dictated the type of robes to be worn.

Manchu Official and Ladies

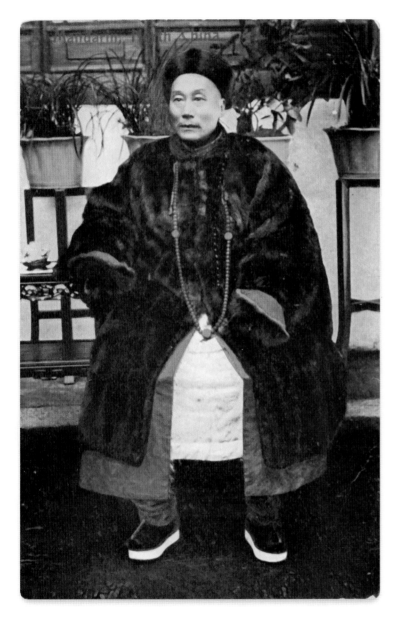

A high Manchu official in sable coat with horse-hoof sleeves, fur cap, and beads with buttons indicating rank *Kingshill*
U.S.A. consulate postmark on back, ca. 1910

Chinese lady (left) in modern long gown modeled after traditional Manchu lady's gowns (right). Compare the shoes.
no publisher 1930s

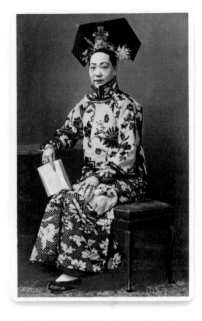

Manchu lady in Manchu regalia with large feet, holding book
Hartung's Photo Shop hand-colored card, 1920s

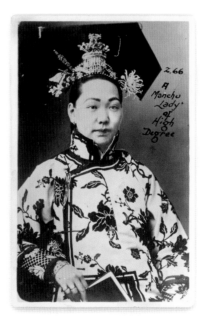

Manchu lady of high degree
Hartung's Photo Shop 1920s

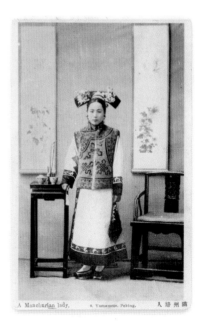

Young Manchu lady holding embroidered kerchief, on Manchu stilt shoes
S. Yamamoto, Peking 1920s

Manchu Commoners

Manchu Ladies Unescorted about Town

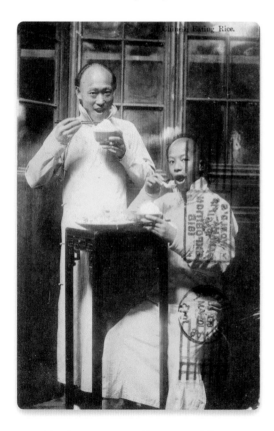

A Chinese family—or Manchu? The girls' feet appear to be unbound. *Japanese publisher 1920s*

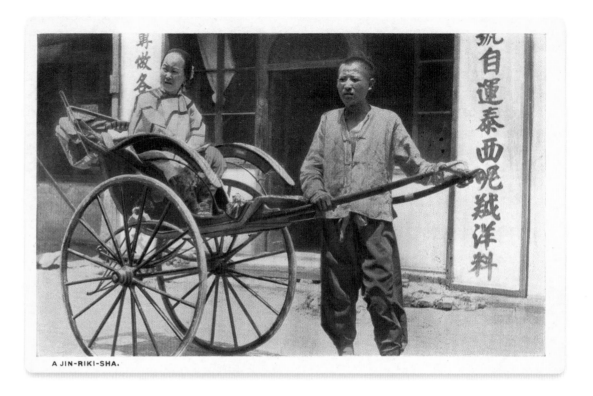

A JIN-RIKI-SHA.

Manchu commoners with queues and shaven heads, eating rice *Japanese publisher postmarked World's Panama Pacific Exposition, 1915*

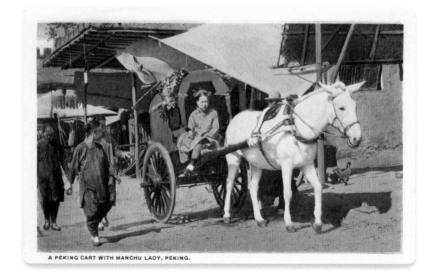

A PEKING CART WITH MANCHU LADY, PEKING.

Above Manchu lady in rickshaw *Camera Craft hand-colored card, 1910–1920*

Left Manchu girl sitting in a Peking cart *Camera Craft hand-colored card, 1910-1920*

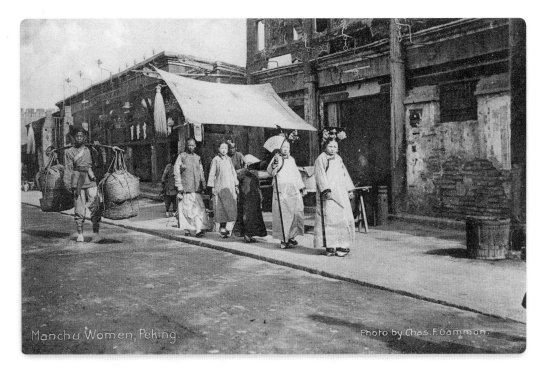

Manchu ladies with child and servant in street *Chas. F. Gammon photograph,*
Denniston & Sullivan 1920s

Right Manchu mother with
young son shopping at Chinese
vendor *no publisher 1920s*

Far right Manchu lady (near
center) amid Chinese vendors
S. Yamamoto 1910–1920

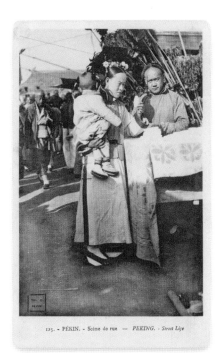

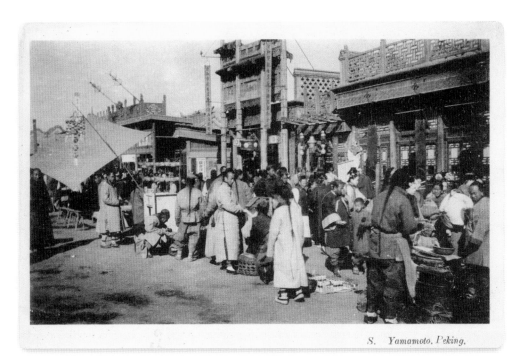

7

The Legation Quarter

FOREIGN REPRESENTATION

IN THE IMPERIAL CITY

After 1900, quiet prevailed once again in the Foreign Quarter after the fearsome Boxers—with their white turbans, red sashes, and polished sabers—had finally disappeared. Deep sighs of relief were emitted by the surviving Westerners, thankful to be alive after the Boxer Uprising. They had endured, while seventy Westerners' lives had been lost at the hands of this secretive terrorist group, such as appear in classic Chinese tales. The Westerners had remained adamant about securing their foothold in Beijing, cost what it may. After the signing of the Boxer Protocol of 1901, sumptuous new legations were built close to the Forbidden City seat of power.

A collection of postcards shows the modest first legation quarter as well as the second post-protocol compound. We see the English, American, French, Spanish, German, Italian, and Russian residences. Ambassadors lived and worked in mansions of their own traditional style and kept a staff. They brought their wives and children with them, observed their national holidays, entertained richly with teams of servants, held banquets and dinner dances, and staged intrigues against each other, vying for spheres of influence, railroad franchises, and trade and shipping rights to satisfy the overwhelming urge to exploit the untapped resources of China. Like the Jesuits, they brought European technology and their religion with them and expected to modernize China for profit. In 1861 the Manchus established a foreign office, called the Zongli

Yamen, near the quarter. It was headed by Prince Gong, the uncle of the then newly appointed child-emperor Guangxu. Foreign ministers met there with Chinese and Manchu officials, pressing ceaselessly for more concessions and deals. The classic era of imperialism had broken out in a country with a weak and confused court and an empress who didn't grasp the need for change and industrialization. These things were left in the hands of foreign countries, which were "slicing up the melon," as the saying went.

Postcards show the entrance to the Legation Quarter and the German post office, which dates back to the time of separate postal services for each legation, as well as individual residences, banks, hotels, schools for the children, hospitals for the sick, a racecourse for horse racing, a golf course, and a club, called the Peking Club, with a swimming pool.

In the early decades of the twentieth century, Beijing was discovered by the Western world to be a luminous architectural treasure. Thomas Cook became the leading travel agent. Streams of travelers came to see the city. They landed in Shanghai on luxury liners and proceeded by train to Beijing for a look at the Forbidden City, the Temple of Heaven, and the Summer Palace and for a shopping spree. A new tourism had emerged. Curios, porcelain vases, carved screens, lacquerware, and so-called Peking rugs were bought and began to decorate homes in the United States.

The Legation Quarter retained its status until 1949, even after the

The Legation Quarter before 1900

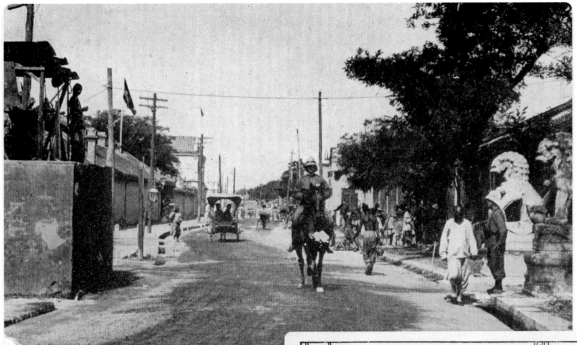

Left First Legation Street before 1900. Note the guards. The text on the back reads: "Legation Street, Peking, China. – This is a view of Legation Street before the Boxer Rebellion. Legation Street, Peking, is the section of the town set aside for all the representatives to the Imperial Court of China, of the different kingdoms, empires and principalities of the world." *no publisher*

Below Beijing's diplomatic enclave, the Legation Quarter, was established "at gunpoint" in 1860. Within a few decades, it was to rival the Forbidden City as the focal point of power in the Chinese state. This map, from a Thomas Cook's guide of the early 1900s, shows the national divisions of the quarter in its heyday.

embassies had relocated to the Republican seat of government in Nanjing (but with an interim period during the Japanese occupation, from 1937 to 1945). It met its demise when the Chinese Communist government was proclaimed in the year 1949 and ousted all foreigners.

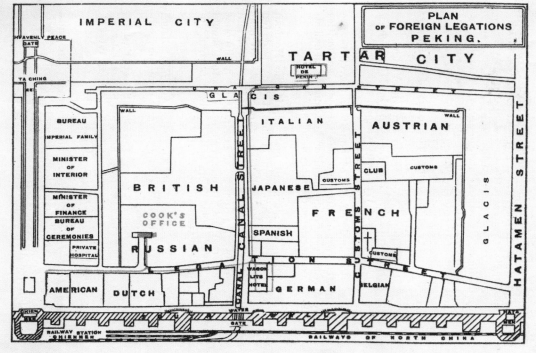

Destruction from the Boxer Uprising

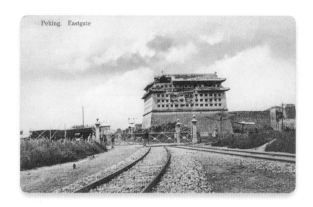

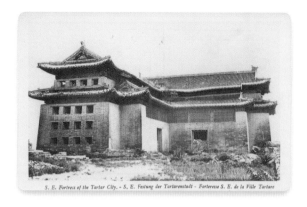

Above from left A portion of the old city wall, showing Boxer damage *no publisher after 1900*

Side view of White Dagoba in Beihai, showing destroyed wall *I. Wannieck after 1900*

Southeast tower with Boxer damage
I. Wannieck after 1900

Below Memorial arch for German minister Baron von Ketteler, killed in the Boxer Rebellion, 1900. The memorial text on arch was removed after Germany lost World War I. *no publisher after 1900*

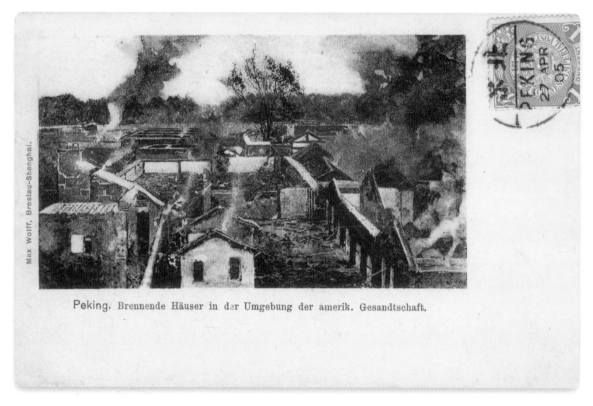

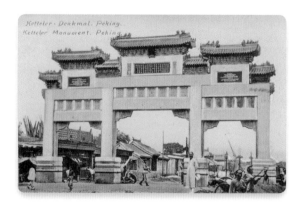

Above Burning house near American Legation *Max Wolff, Breslau-Shanghai*
Peking stamp cancellation 1905

Views from Hatamen Gate

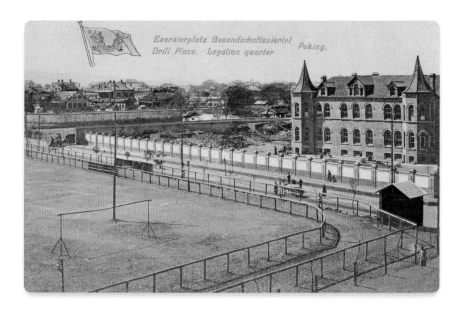

Drill field and French Hospital
no publisher ca. 1910

Procession on Hatamen Street
no publisher ca. 1910

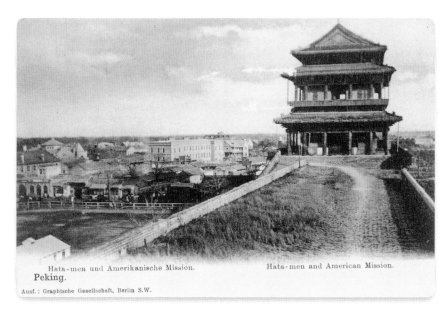

Hatamen Gate, side view, and American Mission at left
no publisher ca. 1910

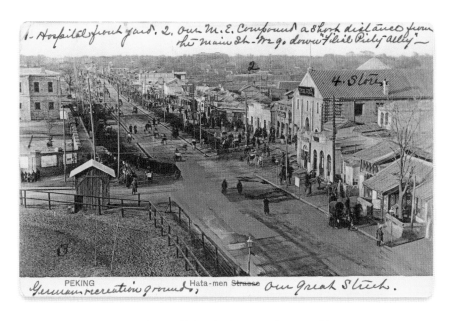

Hatamen Street with hand-written notation on card front
no publisher ca. 1910

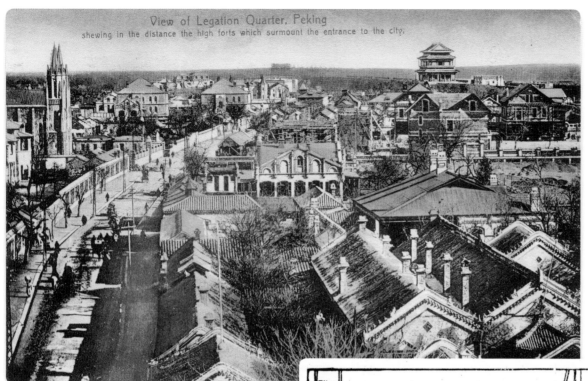

View of Legation Quarter, Peking
shewing in the distance the high forts which surmount the entrance to the city.

Left Legation Quarter after 1900. Note that the Western buildings are almost as high as the adjacent city wall. The card was issued by a San Francisco leather firm with extensive interests across the Pacific in order to advertise their own arrival in Beijing after the Boxers had been suppressed. *H. N. Cook Belting Co., sent 1914*

Below Second Legation Quarter in a map from a Thomas Cook guide

The New Legation Quarter after the Boxer Uprising

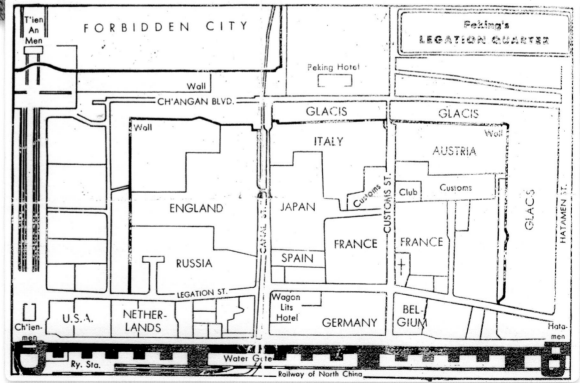

The Entrance to the New Legation Quarter

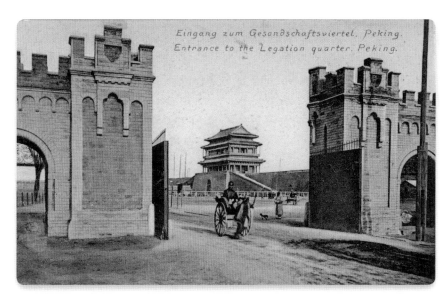

Entrance to new Legation Quarter with rickshaw and Hatamen Gate
no publisher ca. 1910

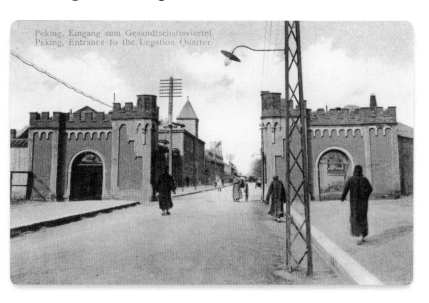

Gas-lit street lamp at entrance to new Legation Quarter
no publisher ca. 1910

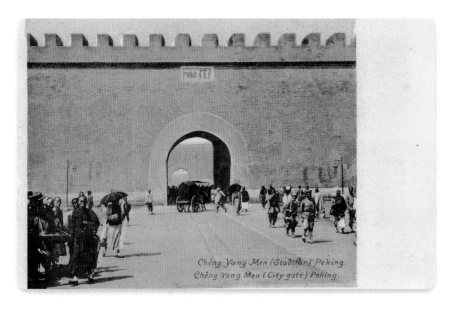

To the Legation Quarter through Ch'ien Men
no publisher ca. 1910

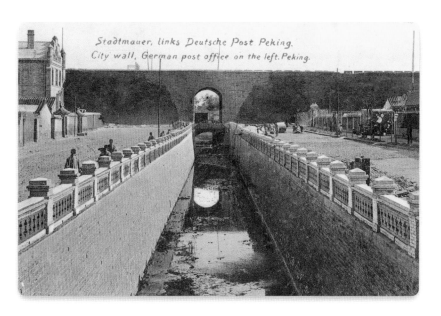

German post office at left of canal leading to the Water Gate,
opened during the Boxer siege *no publisher ca. 1910*

Sumptuous New Embassies

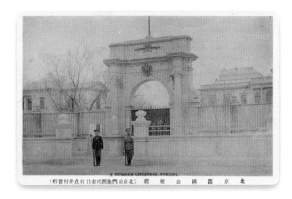

Gate of Russian Legation with posted sentries
Japanese publisher ca. 1910

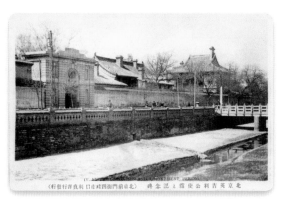

English Legation next to canal
Japanese publisher ca. 1910

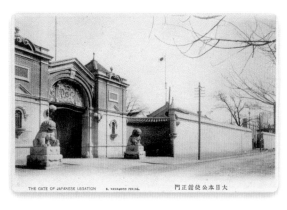

Gate of Japanese Legation with stone lions
S. Yamamoto ca. 1910

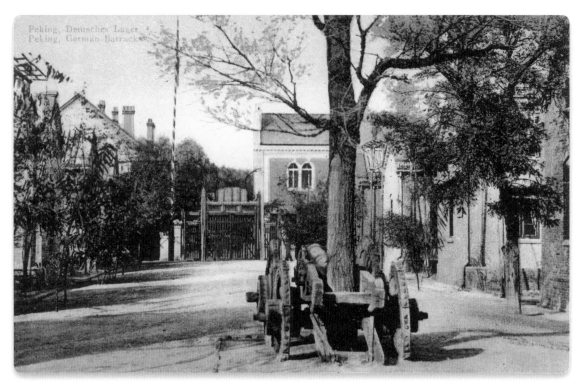

German barracks
no publisher ca. 1910

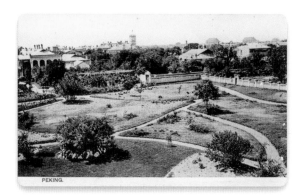

German minister's residence
Hans Bahlke hand-written note on back, ca. 1910

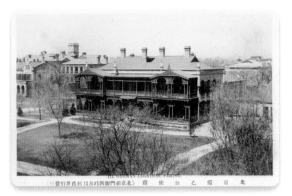

Two-storied German Legation with verandahs
Japanese publisher ca. 1910

The Chinese City around the Time of the Boxer Uprising

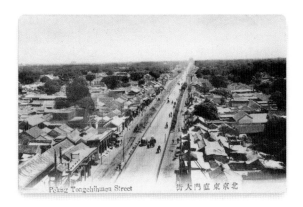

Long sprawl of Dongzhimen Avenue, a major
east-west street in the Tartar City
Japanese card ca. 1910

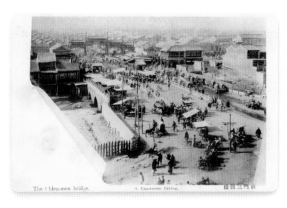

View from Ch'ien Men, looking southwest
S. Yamamoto 1910–1920

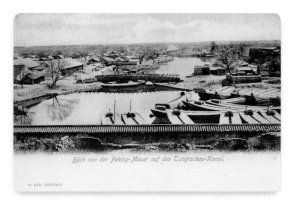

View east of the canal that connected Beijing to the Grand
Canal *E. Lee, Tientsin 1910–1920*

**EARLY STREETS OF BEIJING AT THE
TIME OF THE LEGATIONS**
Eliza Ruhamah Scidmore in her book
China, the Long-lived Empire, published
in 1900, describes the insalubrious
streets of Beijing, which were in a state
of miserable decay by the end of the
1800s, the nadir of Manchu decline.
Elisabeth von Heyking, the German
ambassador's wife, speaks in her book
about "the bitterly cold drafty houses in
Beijing, the unkempt city, the lack of a
sewer system and the grimy canals."
Obviously, the foreign invader with his
pronouncedly more advanced material
civilization looked on these deficiencies
with greedy eyes, finding the
opportunity for business deals to
upgrade the cities.

We see on a postcard what seems like
an interminably long Dongzhimen
Boulevard, an example of the geomantic
east-west grid according to which the
city was laid out by the builder of
Beijing, the emperor Yongle. The
Dongzhi Gate itself is faintly visible at
the end of the street at the far distant
horizon. So-called saddleback houses of
the Manchus, made of gray brick with
inner courts for the extended families,
lined this long Tartar City thoroughfare,
as can be seen on this postcard.

On another card we see the Ch'ien
Men Bridge with a marble balustrade
across a canal. This was the bridge the
emperor had to cross on his way to the
Temple of Heaven. The card entitled
"View from the Water Gate" shows the
opening through which the Eight-
Nation Alliance armies poured into the
Legation Quarter during the Boxer siege
as well as a few early first legation
buildings. Other early cards show the
city's mud streets.

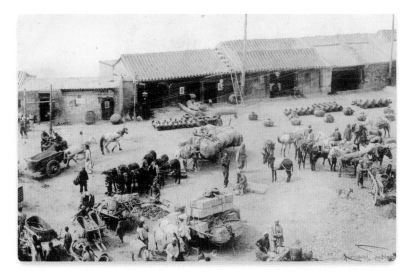

Busy transfer of goods outside the Hatamen Gate
S. Yamamoto 1910–1920

Ch'ien Men Bridge and Chinese Streets

Right View from Ch'ien Men of the marble bridge on emperor's path to the Temple of Heaven, looking southeast *S. Yamamoto 1910–1920*

Below View of the Legation Quarter from the Water Gate through which Western troops poured into the walled city during the Boxer Uprising, ending the assault on the foreign legations *S. Yamamoto ca. 1910*

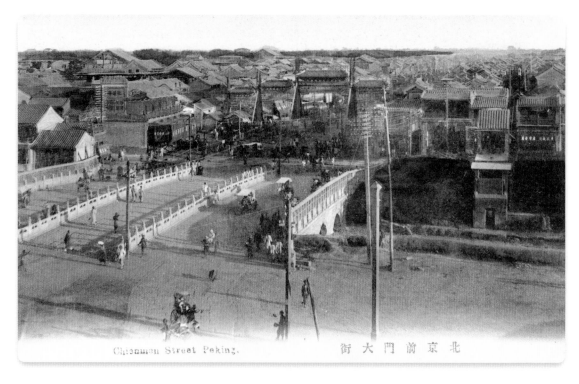

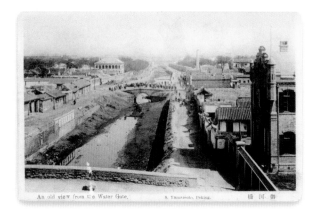

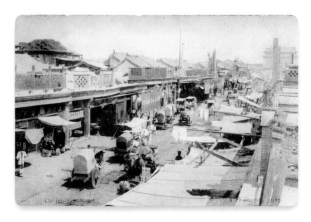

Above Street scene outside Ch'ien Men, with Peking carts *S. Yamamoto 1910–1920*

Right Man with loaded donkey on a backstreet
no publisher 1910–1920

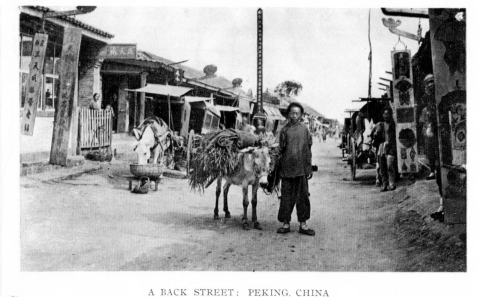

A BACK STREET: PEKING, CHINA

The End of the Qing Dynasty—The Revolution of 1911

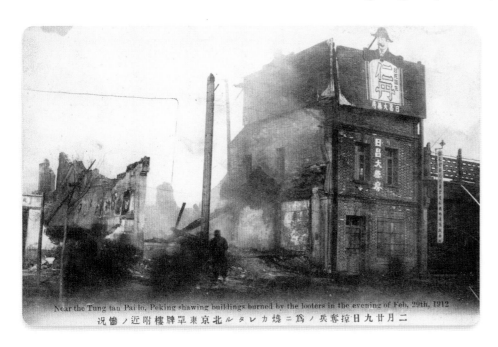

Near the Tung tau Pai lo, Peking shawing buildings burned by the looters in the evening of Feb, 29th, 1912

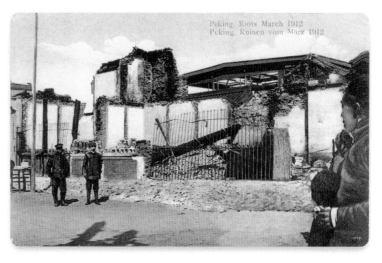

Peking, Riots March 1912
Peking, Ruinen vom März 1912

Left Riots and demolition near Dongdan Pailou, inside Hatamen, February 1912 *Japanese card ca. 1912*

Above Result of riots in Beijing, March 1912 *no publisher ca. 1912*

Below Sun Yat-sen, father of the 1911 Revolution, first provisional president of China *Hartung's Photo Shop ca. 1911*

THE REVOLUTION OF 1911: RIOTS AND THE END OF THE QING DYNASTY

Two postcards depict the damage done by the riots of 1912, when Nationalist revolutionaries struggled against a warlord government in Beijing. The year before, the Wuchang Rebellion of 1911 had led to the declaration of a republic. Another postcard depicts a wall of sandbags with gun windows on top of Ch'ien Men Gate, with a Western woman standing in front for a pose after the uprising. Once more Beijing had to undergo fire and brimstone and what seemed like an unending chain of political upheavals.

The Hartung Photo Shop in Beijing, which produced many wonderful postcards, issued one of the ponderous Sun Yat-sen (1866–1925), the father of the Chinese Revolution.

Sun Yat-sen had travailed abroad for many years in the name of a revolution to end the Manchu regime and establish a republican government for China. He collected money from overseas Chinese to fund this goal, but lost power to Yuan Shikai and saw China rent apart by competing warlords. Only in 1927 was Sun's successor, Chiang Kai-shek—presiding over the new government with its capital in Nanjing—able to march toward the north to take Beijing and incorporate it into the new republic. Sun Yat-sen's philosophy of the Three Principles of the People had finally prevailed. It was learned nationwide and welded the Chinese together. An unending toiler, Sun Yat-sen never gave up, though he didn't live to see the united republic. He died in Beijing in 1925, attended to by the staff of the Peking Union Medical College.

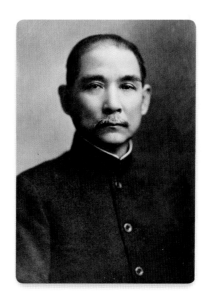

Westerners and Missionaries in Beijing

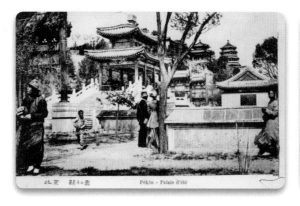

Western couple taking in a view of the Summer Palace
Eliot P. Pedrini, Torino Real Photo postcard, 1920s

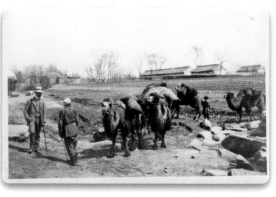

Western man poses with camel train for the photographer.
no publisher Real Photo postcard, 1920s

FOREIGNERS IN BEIJING

According to Thomas Cook's 1917 guide, *Peking, Overland Routes*, about eight hundred foreigners lived in Beijing at the time of its publication. A few of them are glimpsed on postcards. A Western couple posing in the Empress Dowager's Summer Palace; a Western man next to a camel train ready to be photographed; dark-suited men with felt hats leaning on resting camels; and missionaries outside the Methodist compound show the mix of foreigners living in Beijing. A special missionary card shows a garden party of Chinese Christians standing in the back of a baptismal font, commemorating the loss of three missionaries during the Boxer Rebellion. A bearded man in the back row is most probably the head of the mission. An upright card depicts a Western man in Chinese finery, wearing a skullcap with an artificial queue attached to it. The addressee is Miss Eleanor Knowland, the daughter of the renowned publisher of the Oakland Tribune, Representative J. R. Knowland of California.

The city housed embassy staff, scholars, missionaries, and a few businessmen. It had become a favorite of the Western eccentric, who dreamed about living in one of the saddleback houses, whiling the time away learning Chinese characters, reading the Chinese classics with a Chinese teacher, or writing his own thoughts down to be printed by a local printing press. Peking, as it was known, had become the haven of writers, poets, artists, and photographers.

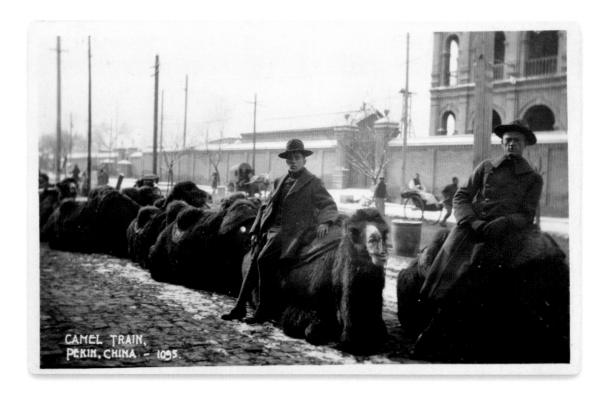

Western men with broad-brimmed hats leaning on camels
no publisher Real Photo postcard, 1920s

A CHINESE GARDEN PARTY.

THE S.P.G. supports work in North China. Three of its Missionaries were killed by the Boxers. The S.P.G., however, refused to receive any compensation, as it desired to make clear to the Chinese that the message which its Missionaries came to bring was one of forgiveness and peace.

Above Unknown Westerner in Beijing dressed in Chinese finery with skullcap, button, and artificial queue
no publisher hand-dated 1907

8

Luxury Hotels
for Foreigners

THE POSH

PEKING HOTEL

AND THE GRAND

HOTEL DES

WAGONS-LITS

Two large hotels built by Westerners became the leading hostelries in Beijing: the Grand Hotel de Pekin on Chang'an Street, which passes in front of Tiananmen, and the Wagons Lits Hotel, a railway terminus inn, inside the Legation Quarter. Two advertisements from Thomas Cook's Peking guidebook of 1917 highlight these hotels. The former, renamed the Peking Hotel, was enlarged during the early Communist regime and is still open for business. Baggage labels for both hotels can be seen here, as well as a tiffin (lunch) menu from the Wagons Lits and a menu from the Chinese government railways of the 1920s.

The images of the interior of the Peking Hotel depict arched hallways with a dining nook; the reception desk; and a tableau with the manager and other staff, showing the dining salon and the white rattan settees standing ready for teatime, a colonial tradition all over Western man's Asia. These two hotels served many travel groups and people of importance. The Peking Hotel hosted innumerable Western celebrities and, since it was located close to the Forbidden City, an easy walk could be taken from this Western architectural giant to Yongle's masterpiece. A large shopping area stretched along Morrison Street (today's Wangfujing), which bounded the hotel on one side. Exquisite art was for sale here in enticing displays in Chinese shops that attracted the many hotel guests. These guests arrived in tour groups for shopping and to visit the ancient capital and its palace. An industry of rugs developed in Beijing

and became world-famous. An American woman started a business making them, and many people yearned to own one. Tourists had their purchases sent to their homes by overseas mail, keeping the post offices busy.

The Wagon Lits Hotel in the Legation Quarter was built near the Water Gate and new railroad station by a Belgian concern. The postcard here shows the early Flemish–style complex, which was later enlarged to a huge many-storied hotel. Called the Wagons Lits Hotel, which meant "Train Berth" or "Sleeping Car Hotel," it was built to accommodate travelers of the Trans-Siberian Railroad coming down from Manchuria on the Shenyang (Mukden)-Peking Railroad. Completed in 1898, the Trans-Siberian Railroad crossed Russia and the Siberian wilderness to link Moscow and Vladivostok, Europe and Asia. It became the fastest link to Europe for Westerners living in China, such as my family and me. We used it often. It made the trip every two weeks and took two weeks to get to Moscow, where travelers changed trains to further destinations in Europe. It had compartments with bunks and a dining car, where the traveler presented pre-purchased coupons for meals or exchanged them for black bread and red caviar. At stations along the way, sturdy Russian peasant women wearing a kerchief around the head would stand below compartment windows and offer fruits, berries, and baked goods. Crossing the Ural Mountains, one had passed from Europe to Asia or vice versa. A statue commemorated this event. Getting off the train at one's

The Peking Hotel

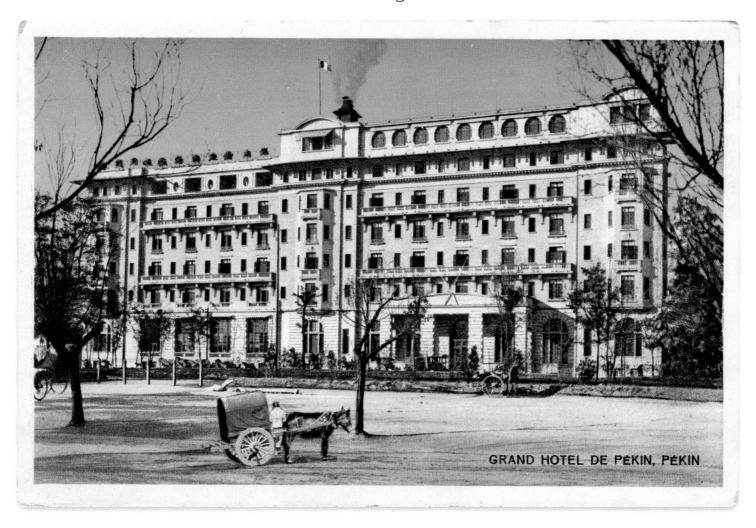

GRAND HOTEL DE PEKIN, PEKIN

destination, the rhythmic rattle across the tracks lingered in the ears for a few days or even weeks. I was taken on the Trans-Siberian to a Swiss boarding school by my mother during World War II, when the turmoil caused by the Japanese invasion of Shanghai in 1937 turned me into a near anorexic teenager.

In Beijing, Thomas Cook's office offered excellently planned one-day and one-week tours covering the most important sights of the city and its environs. Tourists coming up to Beijing from the south on the train returned home via Shanghai, where they boarded luxury liners, their trunks filled with treasures from the Imperial City. Beijing had become the quintessential stop on the itinerary of the leisure class from the 1920s to the 1940s.

Above Peking Hotel with Peking cart posing in front
no publisher 1920s

Right Hotel baggage label

Interior Views of the Peking Hotel

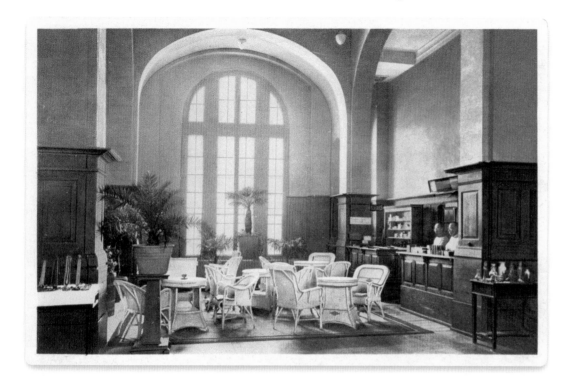

Left Reception hall, counter, and seating area with white rattan furniture *Hotel card 1920s*

Below Peking Hotel reception desk, with Western manager, Chinese clerks, and uniformed concierges *Hotel card 1920s*

Bottom Managers and staff posing at hotel teatime *Hotel card 1920s*

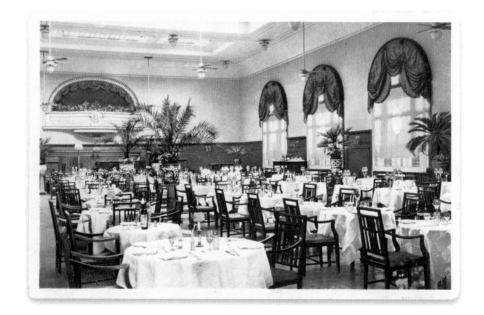

Left Peking Hotel dining salon *Hotel card 1920s*

The Grand Hotel des Wagons Lits

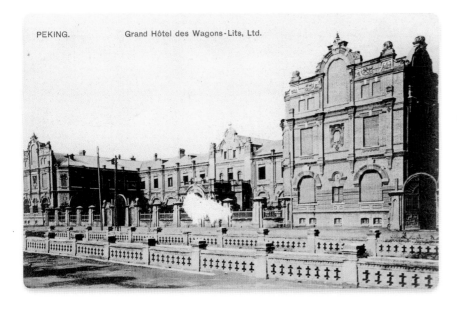

PEKING. Grand Hôtel des Wagons-Lits, Ltd.

Left Original Grand Hotel des Wagons Lits in the Legation Quarter, Peking —a Flemish-style train terminus hotel that was later enlarged
O. Ludwig damaged card, 1920s

Right Tiffin (lunch) menu. Wagons Lits Hotel
dated October 3, 1920

Far right Chinese Government Railways Peking, Tianjin, Mukden dining car menu
1920

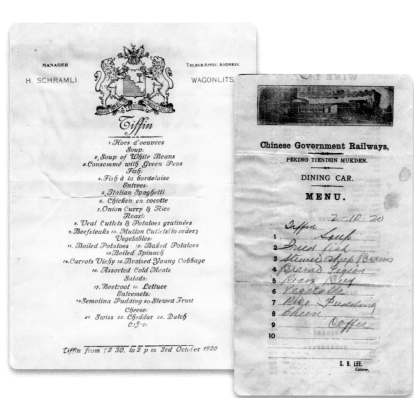

Above Baggage label of the Grand Hotel des Wagons Lits, Peking, depicting a lama feeding birds

Right A baggage label with lions and Great Wall

9
Peking Union
Medical College

AN AMERICAN
PRESENCE IN CHINA

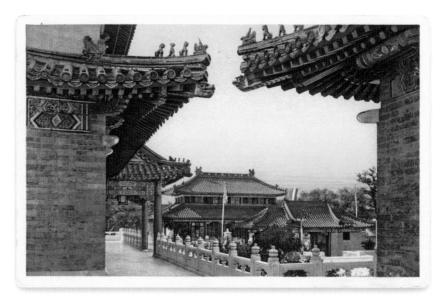

Peking Union Medical College gate, house, and dormitory from terrace—former Manchu residence *Hartung's Photo Shop 1920s*

The Peking Union Medical College was a medical school founded in 1906 by a group of missionary associations together with the Qing government. The school was modeled after Johns Hopkins in the United States. In 1917, the Rockefeller Foundation assumed financial responsibility for the school and reorganized it. The college became the leading hospital and medical training center in China and still is today. One section was named after Laura Spelman (d. 1915), the wife of John D. Rockefeller. A former princely mansion was bought to house this prestigious school, and the entire complex of buildings was preserved, as handsomely colored postcards show. It is here that Dr. Sun Yat-sen, the first provisional president of the Chinese Republic, was treated for cancer, and where the illustrious revolutionary died in the year 1925. His body was kept in a vault at Biyunsi, the Temple of the Azure Clouds, until his memorial in Nanjing was completed.

A large number of Western missionaries had come to China after the Treaty of Tianjin of 1885 and the Boxer Protocol of 1901, which had fully opened up China to them nationwide, granting them residence and permitting the building of churches, schools, orphanages, and other structures all over the country. Beijing acquired its share. The Westerners brought modern hospitals, schools and universities with a humanist curriculum, and museums for preserving culture, institutions novel to China.

Fine Hand-Colored Cards by Max Hartung

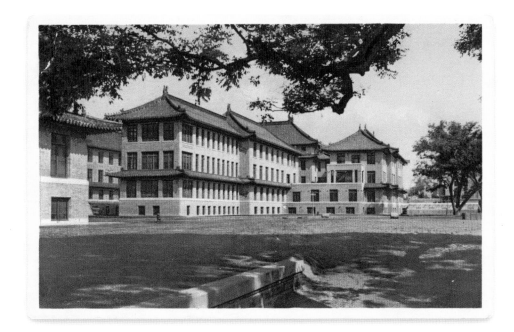

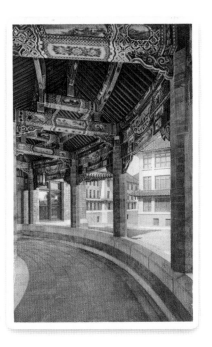

Left Medical ward with pathology building *Hartung's Photo Shop 1920s*

Right Chemistry and anatomy buildings, with connecting corridor *Hartung's Photo Shop 1920s*

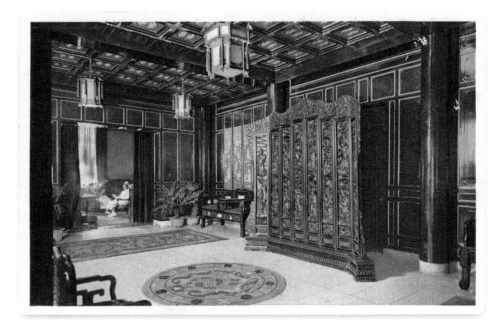

Left Laura Spelman House with Western nurse reading in lounge *Hartung's Photo Shop 1920s*

Right American influence is evidenced by the message on the back of this card, which reads in part: "The climax is here! We had a royal time and all is *fine*! Gave talks this past week at: Yanching College, Nankai College, Amer. College . . ." *hand-dated 1922*

10

Coal Hill, the Winter Palace, and the White Dagoba

A PLAYGROUND OFFERING REST AND RECUPERATION TO THE WORK-WEARY EMPERORS

Coal Hill, North of the Forbidden City

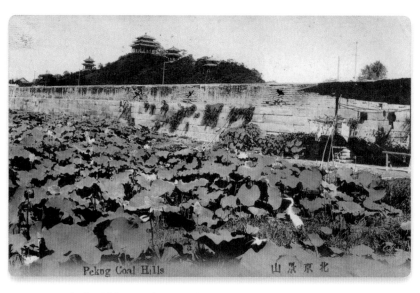

Coal Hill, with lotus and crane in the moat around the Forbidden City
Japanese publisher 1910–1920

Directly outside the Forbidden City's north gate stands Coal Hill, an artificially created hill that is an observation point and said to be a coal deposit in case of an enemy attack on the Imperial City. It was here that the last Ming emperor, Chongzhen, met his self-imposed demise "in shame" when rebels seized the city. Its five pavilions on mounds of different heights were built by the Qianlong emperor and are classical examples of Chinese pavilion architecture. The best views of the Forbidden City as well as the nostalgic Drum and Bell Towers to the north can be had from here.

Next to the Forbidden City and Coal Hill lies the Winter Palace, with its three lakes—named Beihai "North Lake";

Zhonghai "Middle Lake"; and Nanhai "South Lake"—and their parks and scattered palaces. The shores of these lakes constituted an additional precinct to which the emperors could withdraw from the Forbidden City. The area was originally marshland; it is said that Kublai Khan drained the marsh and built a large audience hall of his palace here. Most of the extant buildings date back to the Ming and Qing dynasties.

The main feature of North Lake is the glowing White Dagoba, which reigned above the city and is approached through a memorial gate and across a marble bridge. This white, bottle-shaped structure was built by the Manchu emperor Shunzhi in 1651 to commemorate a visit by the Dalai Lama.

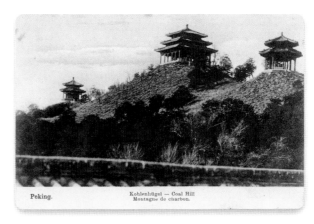

Peking. Kohlenhügel — Coal Hill Montagne de charbon.

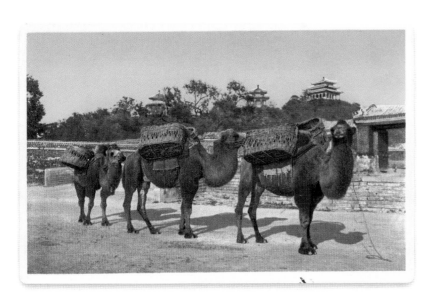

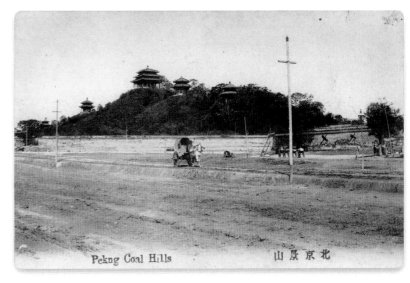

Pekng Coal Hills 北京景山

It is evidence of the close relationship of the court with Tibet and the Manchu preference for Lamaism. It is modeled after a *chorten*, a Buddhist reliquary commonly seen throughout Mongolia and Tibet. The different sections of the tower symbolize the five elements— earth, water, fire, air, and metal. Its purpose was to cast a beneficial influence over the city. It is the largest *chorten* structure of its kind in China. The Nine Dragon Screen is another shield against evil spirits. It is made of colored glazed tiles and is an artistic masterpiece and landmark of North Lake.

The piers on the shore of North Lake are where the emperors moored their pleasure boats for excursions on the water. The shore of Central Lake held an audience hall for meetings with envoys of tributary countries. It was here in 1760 that Qianlong received his generals who had returned from Central Asia after a number of victorious battles, and he had their portraits painted and hung. The Winter Palace was a favorite playground of the Empress Dowager, who built a palace for herself on one of the islands. There she later imprisoned the Guangxu emperor. Also located on the Winter Palace grounds was the Altar to the First Silkworm, where the empresses of the Forbidden City came to worship and pay homage. Western relief forces against the Boxers took up residence on the grounds in 1900, leaving destruction behind them.

In the 1930s, all the palaces and pavilions of South Lake were converted to residences, offices, and reception halls for the presidents and dignitaries of the Nationalist government in Nanjing, just as they are now serving the leaders of the People's Republic of China. Jiang Qing, Mao Zedong's third wife, a woman with a determined mind like Cixi, was sequestered in a house and died here, a renegade of the political system. Ironically, history repeats itself.

The Three Lakes, the Winter Palace, and the White Dagoba

(NO. 15) THE PEI-HAI WINTER PALACE, PEIPING. 海 北 平 北

(No. 16) The North lake winter Palace, Peping. 海 北 平 北

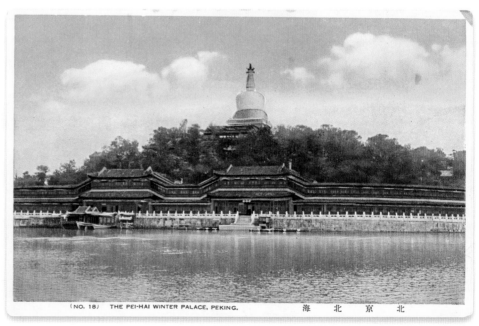

(NO. 18) THE PEI-HAI WINTER PALACE, PEKING. 海 北 京 北

Above Archway (*pailou*) at marble bridge entry to White Dagoba, a tribute to the Dalai Lama
no publisher 1920s

Above right Marble bridge, *pailou*, and White Dagoba aloft
no publisher 1920s

Right White Dagoba overlooking the lake, with palaces below
no publisher 1910–1920

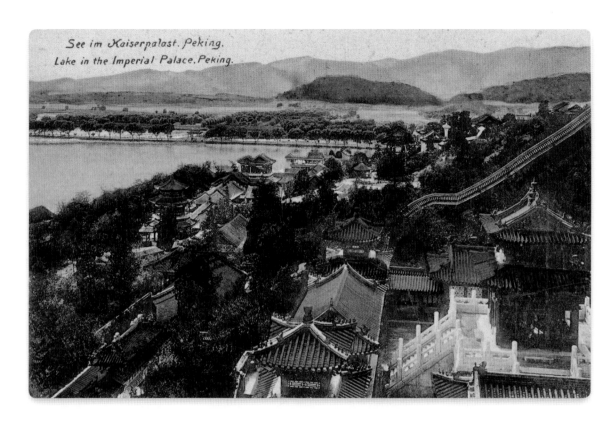

See im Kaiserpalast. Peking.
Lake in the Imperial Palace. Peking.

Above Jade Buddha in Winter Palace
no publisher Real Photo postcard, 1920s

Above right Overview of the Winter Palace,
showing the Western Hills
no publisher 1920s

Right Nine Dragon Screen to ward off evil spirits,
Winter Palace
Camera Craft 1920–1930

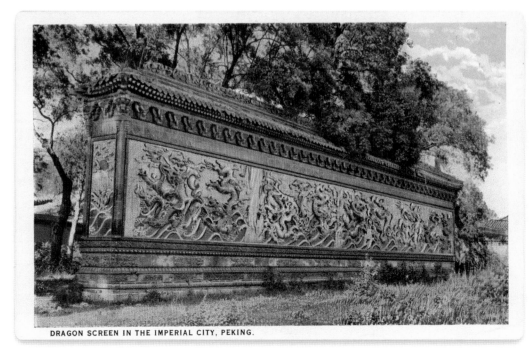

DRAGON SCREEN IN THE IMPERIAL CITY, PEKING.

II

Jesuits, the Catholic Cathedral, and the Old Observatory

THE JESUIT PRESENCE
IN OLD BEIJING

A postcard shows the Roman Catholic Cathedral, Beitang (Northern Prayer Hall), which stands to the west of South Lake of the Winter Palace. In 1693, the Manchu emperor granted the early Jesuit missionaries a piece of land upon which they were allowed to build a cathedral. The structure was rebuilt several times. The Kangxi emperor even visited the first cathedral himself. It was here during the Boxer Uprising that hundreds of Chinese converts as well as Western relief forces sought refuge, and many believers became martyrs during the attack. The modern version of the building still stands in Beijing today and offers religious services.

During the West's Age of Discovery, different popes sent out missionaries to Christianize China. The first Jesuit to attempt to reach China, Francis Xavier, died in 1553 on an island off the mainland. Matteo Ricci, who succeeded him, arrived in Macao around 1582. He was a formidable personality, both missionary and scholar, and was the first Westerner to master the Chinese characters and to have read the classics. He reached Beijing in 1598 and in 1601 became the first Jesuit priest to be invited to the Imperial Palace. He died in Beijing in 1610 at the age of fifty-eight.

Ricci discovered Chinese culture and literature for the West. He was the first to translate the Confucian classics and introduce them to Europe. In Paris, they caused a stir with Voltaire and Leibniz, who were the leading minds of the Age of Enlightenment, for promoting religious tolerance. These thinkers proclaimed Confucius the first humanist and suggested bringing Chinese scholars to Europe to teach the precepts of a harmonious society to the Europeans, who at the time were involved in devastating religious wars. Ricci equated Shangdi, the Chinese Lord of Heaven, with the Christian God. Adapting to Chinese culture, he and other Jesuit priests dressed in Chinese gowns and head covers. Matteo Ricci and the early Jesuits took the stand that the age-old Chinese ancestor rite was a civil and not a religious ceremony, and therefore not objectionable to Catholicism. This became the subject of a dispute, called the Rites Controversy, among Catholic orders and resulted in the pope recalling the Jesuits from the mission field, which ended their time in China.

The Jesuits' knowledge of mathematics and astronomy was recognized and much valued by the Ming and Qing emperors. The Chinese had developed astonishingly accurate measurements of the movement of the stars, eclipses, and comets. They had developed a lunar calendar, which the emperor introduced to his people from the Wumen Gate (Meridian Gate) of the Forbidden City at the beginning of each year, and the Jesuits were invited to work on the calculations for it.

However, the pope's determination to rule over the Chinese Christians himself eroded Kangxi's positive disposition toward Christianity and the official policy of tolerance. The following emperor, Yongzheng (r. 1723–1735), banned Christianity altogether. There were over a hundred Catholic missionaries in China in 1701.

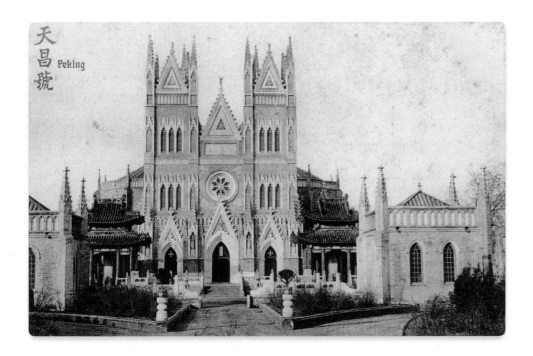

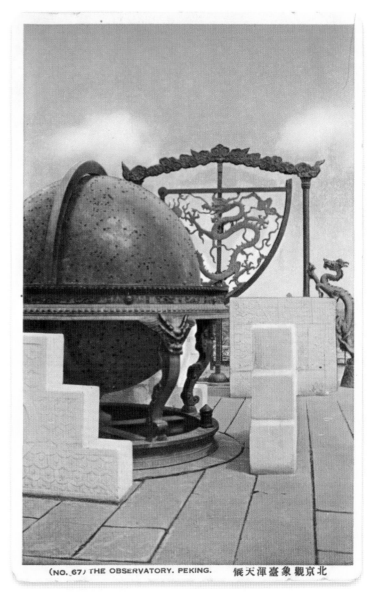

Seen on a postcard is the Observatory, which goes back to Kublai Khan's day and at one time was directed by a Jesuit missionary. Ferdinand Verbiest was an accomplished mathematician who worked on the calculations for the lunar calendar. His knowledge was greatly admired. He befriended the Qing emperor Kangxi and imparted Western learning to him, translating Euclid's first six books into Manchu. He composed a table of all solar and lunar eclipses for the next 2,000 years. Awarded the post of head of the Mathematical Board and director of the Observatory, he was asked to rebuild the Observatory in 1673. For the new observatory, he designed six new instruments: an altazimuth, a celestial globe, an ecliptic armillary sphere, an equatorial armillary sphere, a quadrant altazimuth, and a sextant. They were very large, made of bronze, and decorated with Chinese dragons. The emperor had them placed on top of the east side of the Tartar Wall, and they can still be seen on a remnant of the wall today. Some were fabricated by the Chinese themselves. Ferdinand Verbiest was given permission by the emperor to discourse on Christianity in the whole empire. He died in Beijing and was buried near Matteo Ricci and Adam Schall von Bell, the other most important Jesuit missionaries in China.

Above The Observatory, dating from the Mongol dynasty, with imperial dragon ornament
no publisher 1920s

Above left Catholic Cathedral, Beitang
Tien Chang Ho, Peking Real Photo postcard, 1920s

12

Two Temples
in a City
of Religious
Tolerance

THE CONFUCIUS
TEMPLE AND THE
LAMA TEMPLE

CONFUCIUS TEMPLE, CHINA'S ETHICAL RITUAL CENTER
Confucius Temple and the Hall of Classics are sanctuaries dedicated to China's age-old revered sage, Kong Fuzi (551–479 BCE) or Confucius, whose name was latinized by the Jesuits and is still rendered in that form in the Western world today. Confucius gave the Chinese ethical guidelines and a moral foundation that held the people together for more than two thousand years. Twice a year, the emperor paid a visit to the temple and recited the classics from a throne in the Hall of Classics. In this way he underwrote Confucius's tenets as the ethical bedrock of China.

Confucius Temple stands in the northeast corner of the Tartar City near the Lama Temple. It was originally built in the thirteenth century during the Yuan dynasty and was repaired and remodeled during the Ming and Qing dynasties. Both the Mongol and the Manchu rulers adopted the teachings of Confucius as the central tenets of the educational and examination system. The interior of the temple building is frugal, unlike other temples, and does not have an altar with manifold statues of deities, incense burners, and sacrificial appurtenances. Instead, a solitary memorial tablet was placed on the altar, in respect for Confucius's influence on Chinese thought and society.

Confucius was a native of the state of Lu (modern Shandong Province). He wandered from state to state advising princes on how to arrive at a harmonious society and a just government. "Princes should be philosophers," he admonished the rulers because of their continuous wars. Annual celebrations in memory of Confucius were held in all the Confucian temples throughout the nation, down to the Republican era of the 1930s and 1940s. Subsequently, there was a time when Confucius was pushed aside, even discarded for being a feudal as well as bourgeois thinker. His teachings were combated in anti-Confucian campaigns, which substituted for them the *Communist Manifesto* and *Das Kapital* by Karl Marx, a Western thinker's theoretical writings.

The handsome Hall of Classics is a rectangular building with a golden-tiled roof, set on a marble terrace. Though built to be the Directorate of Education, or Imperial Academy, it became the repository of the Confucian classics, which are engraved on sixteen stone steles to protect them against wars and destruction. Scholars had "picked up the pieces" after the first emperor, Qin Shihuang, had burned the books in 221 BCE, and they patched them together in the text now engraved on stone.

A spectacular memorial arch, decorated with glazed colored tiles, at one time announced the visitor's arrival at the Hall of Classics and the Confucius Temple. It was considered the most beautiful arch (*pailou*) in the city of Beijing. The arch at the Ming Tombs rivaled it, but only in size. Now, nearly all of Beijing's arches have been taken down.

The Confucius Temple and the Hall of Classics

Left Glazed-tile arch before the Hall of Classics, the most beautiful arch in old Beijing *Hartung's Photo Shop Real Photo postcard, hand-colored, 1920s*

Below left Looking through the arch to the Hall of Classics, where the hallowed Confucian classics were stored
Graphische Gesellschaft, Berlin pre-1907

Below Confucius Temple, dedicated to China's revered sage
Camera Craft hand-colored, 1920s

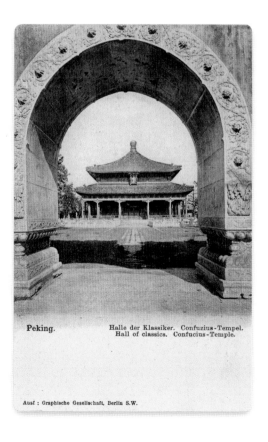

Peking. Halle der Klassiker. Confuzius-Tempel.
 Hall of classics. Confucius-Temple.

Ausf : Graphische Gesellschaft, Berlin S.W.

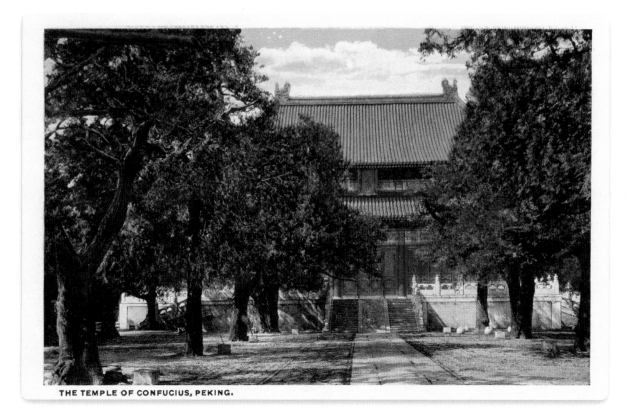

THE TEMPLE OF CONFUCIUS, PEKING.

Buddhist Temple Interiors

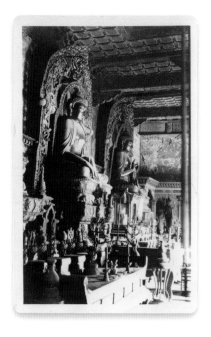

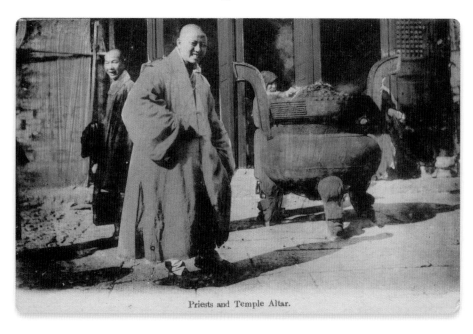

Priests and Temple Altar.

Far left Interior of a temple, with Living Buddha Sakyamuni in center in teaching mode *no publisher Real Photo postcard, 1920–1930*

Left Priest at big incense burner *no publisher 1910–1920*

Bottom left Temple interior with Buddhist trinity. The card mistakenly identifies this as the Confucius Temple. *Camera Craft 1920–1930*

Bottom Interior of the Temple of Long Life, Wanshousi, with carved lacquer altar tables *Camera Craft 1920–1930*

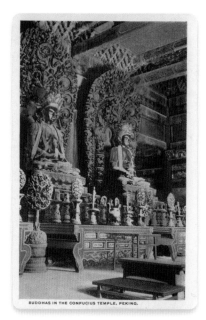

BUDDHAS IN THE CONFUCIUS TEMPLE, PEKING.

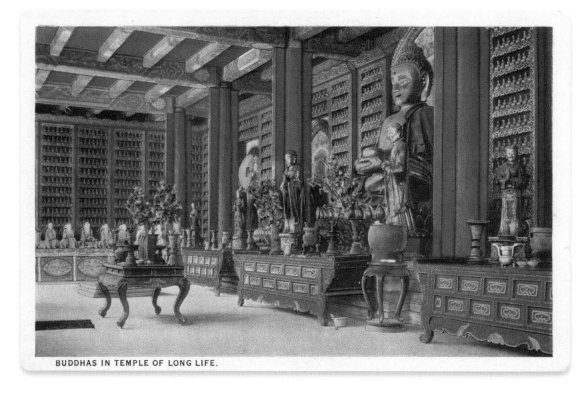

BUDDHAS IN TEMPLE OF LONG LIFE.

Lama Temple Designs

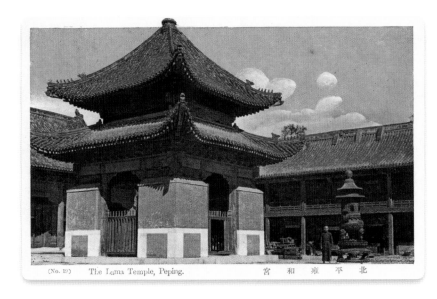

The Imperial Stele Pavilion at the Lama Temple *no publisher 1920s*

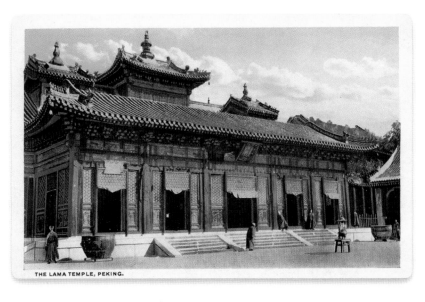

Hall of the Wheel of Law at the Lama Temple *Camera Craft 1920s*

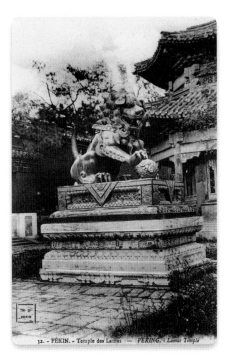

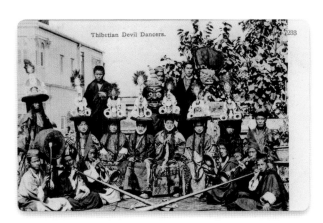

Far left Hall of the Great Buddha of gilded sandalwood
S. Yamamoto Real Photo postcard, 1920s

Left Lama Temple, one of a pair of stone lions before hall
French publisher Real Photo postcard, 1930s

Above Tibetan "devil dancers" with musical instruments at rest
no publisher Real Photo postcard, 1930s

The Lama Temple, Former Residence of a Manchu Prince, Later Dedicated to Tibetan Buddhism

LAMA TEMPLE, HEADQUARTERS OF THE TIBETAN DIGNITARIES AND UP TO A THOUSAND MONKS The Qing emperors preferred Lamaism (Tibetan Buddhism), and supported visits by high Tibetan religious dignitaries and the building of innumerable Tibetan temples in and around the city of Beijing. The Lama Temple or Yonghegong is the largest of these. It is located in the northeast corner of the Tartar City at the end of the long Hatamen thoroughfare, next to the Confucius Temple. It had been a palace of Manchu princes. Yongzheng, the son of the emperor Kangxi and later his successor on the throne, lived there, but it was converted into a temple by the Qianlong emperor. One thousand five hundred Tibetan and Mongol lamas were resident monks here during Qianlong's reign. At the height of the influence of Tibetan culture it sustained a thoroughly developed iconography and flourishing libraries in its different halls. Lamaism spread to Mongolia, China, and Manchuria. The Mongols embraced it wholeheartedly and made it their cult, practicing it in their own temples, dagobas, and shrines.

The most notable statue in the temple complex is the Buddha Maitreya, the Messiah Buddha, in the Pavilion of Ten Thousand Fortunes. It is carved from a single block of sandalwood and stands sixty feet high in its own hall. The statue of Tsongkhapa (1357–1419), the famous Tibetan reformer of the Gelugpa or Yellow Sect, stands in the Hall of the Wheel of Law. It still is the leading creed of the Tibetans today, including the Dalai Lama. The prayer hall where the lamas assembled in the Yonghegong also contains the statue of the historic Gautama Buddha, Sakyamuni.

Rich Tibetan ritual appurtenances, banners, and *thangka* were hung in the different halls in great numbers. Tibetan craftsmen excelled in many forms of art inspired by India, which evolved into distinctively Tibetan forms. The human skull was used as a handsome libation jar, a bowl, and a hand-held drum that were mounted with hammered copper designs. In front of temples, fierce-looking stone guardians with rolling eyeballs and fangs lent the complex an air of the occult. Every year in spring, devil dances were held in the temple grounds in order

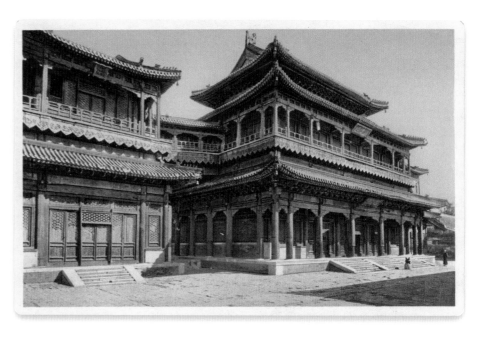

Hall of the Great Buddha, Lama Temple
Librairie Française, Peking 1920s

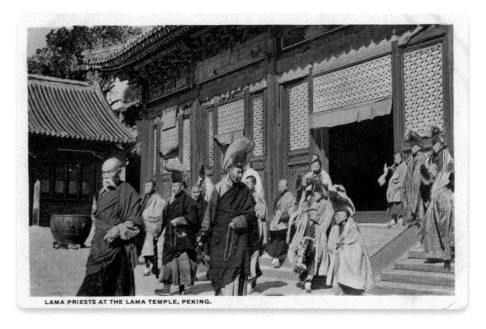

Lamas with yellow miters leaving temple building
Camera Craft, Peking 1920s

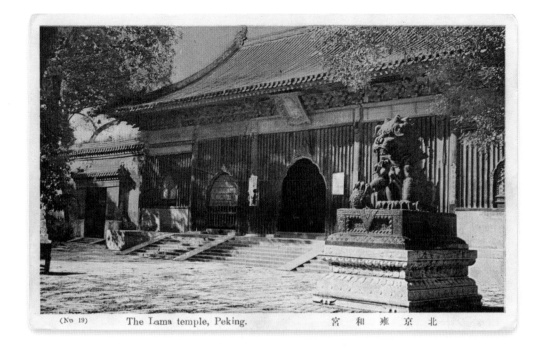

(No 19) The Lama temple, Peking. 北京雍和宮

Left Yonghemen, Gate of Harmony and Peace, with guardian lion *Japanese publisher* *1920s*

Below Hall of the Wheel of Law *Japanese publisher* *1920s*

to exorcise evil spirits and protect its inhabitants.

Lamas in saffron and yellow robes and lamas with miters on their heads could be seen walking, praying, and genuflecting in and outside the halls in my time. My brother and I were taken there by our mother, and the visit stirred my child's imagination in wondrous ways. After paying a coin to a lama, we were let in to the many inner courts, stepping over high sills. The Buddha statues exuded serenity, while the protective demons' ferocious facial expressions made us hold on to our mother's hands for reassurance. In this temple a very different world reigned from the one we knew.

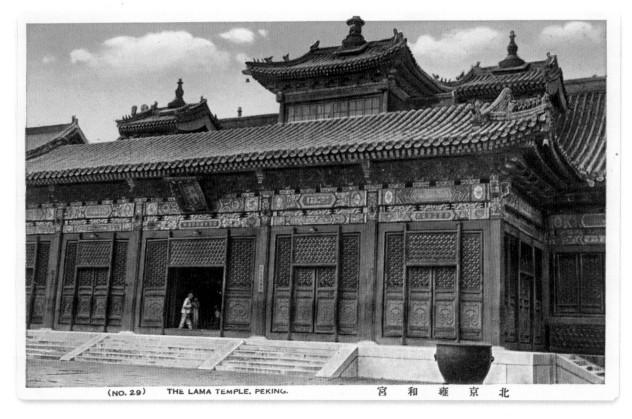

(NO. 29) THE LAMA TEMPLE, PEKING. 北京雍和宮

13

The Drum and Bell Towers, the Oldest Structures in Beijing

FOND MEMORIES
OF KUBLAI KHAN

ALSO THE OLD

EXAMINATION HALL

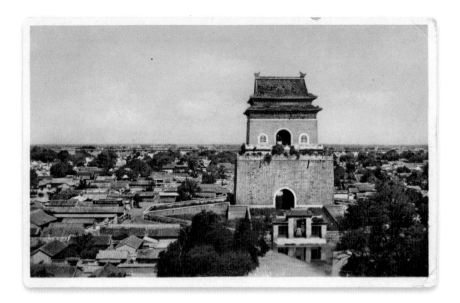

Bell Tower from a distance, rising high above the old city, was a point of reference.
Hartung's Photo Shop ca. 1920

These two massive towers stand on the northern end of a long boulevard that runs north from Coal Hill. The original buildings are said to have been part of Kublai Khan's "homeland security." Erected during the Yuan dynasty, they were set in the center of Kublai's onetime capital, Khanbalic. Their twofold function was to be lookout posts over the city and the surrounding countryside and "clock towers" from which to announce the noon hour and various hours at night. They are the vestige of what once was the Mongol palace that was extolled by Marco Polo, destroyed by the Mings, and replaced by the emperor Yongle in the 1410s.

The massive Drum Tower was rebuilt in its present form in the eighteenth century. It has corridors north and south and east and west on the ground floor. A flight of seventy-two steps on the inside lead to an interior platform, where there were several large drums and an ancient water clock comprised of four vases out of which water trickled, the level indicating the hour. A mechanical device above the vases sounded the hours. Later, incense sticks and torches of sawdust served the same purpose. Street watchmen hearing the sound passed it on by clicking two bamboo sticks together, so that the signal could be picked up by guards posted on the different walls. At five a.m. the city gates were reopened.

On the north side stands the Bell Tower, also originally built by the Mongols. It is 108 feet high. A bell placed in it was sounded to indicate the watches. A mate to the bell was placed in the Great Bell Temple northwest of Beijing outside the wall and still exists today. A number of large bells had been cast at this time for diverse uses.

A legend formed around the casting

of the Bell Tower's huge bell, which was to measure eighteen feet high and eighty feet in circumference. After Yongle's master founder had failed twice in casting it, the emperor became impatient and threatened him with severe punishment. So the founder's devoted daughter consulted an astrologer, who told her that the blood of a beautiful maiden would have to be mixed with the molten iron. On the day of the third casting, a huge crowd gathered. Just as the iron ran from the furnace into the mold, the girl threw herself headlong into the white-hot mass and disappeared. A witness tried to save her and seized one of her shoes. The father went mad. The bell, when sounded, however, had a marvelous tone with a soft after-ring reminding one of a wail. People heard the word *xie* ("shoe") expressed in it and claimed that the founder's beautiful daughter was calling for her lost shoe. Beijing dwellers of the past all knew this story. It was part of city's folklore and appeared in Western literary writings as well.

The Examination Hall near the Observatory was built by Yongle. Young men from provincial capitals came here to compete in the highest level of civil service exams and advance their official careers. The buildings could accommodate 10,000 candidates in separate cubicles. The examinations dealt with topics from the Chinese classics and literature. China can claim to have had the oldest civil service system. After the Examination Hall's destruction during the Boxer Uprising, the bricks from its cubicles were used to rebuild the damaged foreign legations.

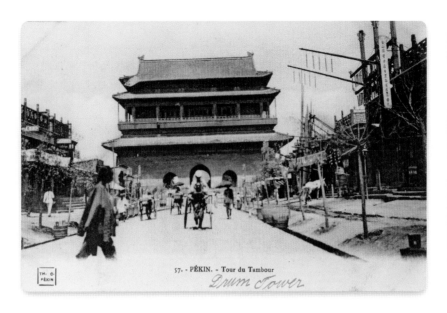

57. - PÉKIN. - Tour du Tambour
Drum Tower

Above Drum Tower, the time keeper, goes back to Kublai Khan. The drums in the tower marked the hours of the night.
Japanese publisher 1907

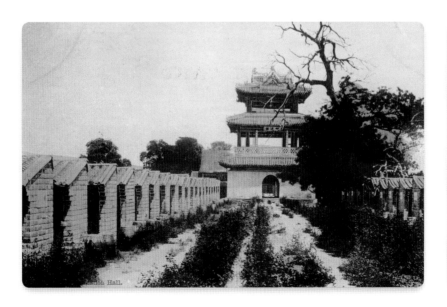

Below The Examination Hall and its cubicles were damaged during the Boxer Uprising. The examination system was abolished in 1905.
no publisher 1900

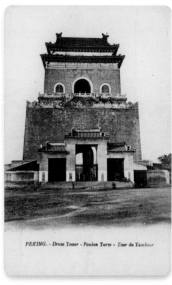

PEKING. - Drum Tower - Pauken Turm - Tour du Tambour

Above The Bell Tower goes back to Kublai Khan as well. The card erroneously calls this the Drum Tower.
I. Wannieck ca. 1910

Below The Yongle Bell at the Great Bell Temple was cast at the same time as the 63-ton bronze bell of the Bell Tower. *no publisher pre-1907*

14

Decorative Memorial Arches

STREET EMBELLISHMENTS

Memorial arches, called *pailou* in Chinese, are a traditional architectural feature. Possibly inspired by Indian arches, these Chinese structures usually memorialize a person for a meritorious act, such as widows who did not remarry, or they served as entrances to important places. Innumerable streets were arched over by *pailou*. As a resident of Beijing, one might name the arches in order to give directions to the rickshaw puller or the taxi driver, Made of wood or stone, most arches have three gates, one in the middle and two side gates. The more venerable the person memorialized the more gates the arch has, such as the five in the outstanding *pailou* at the Ming Tombs. Many arches within the city were torn down by the Communist regime as vestiges of feudalism and with the excuse that they were traffic obstructions. Once, though, the many arches lent Beijing a romantic appearance. As a student of Chinese studies in the 1940s, I rode under *pailou* on my bicycle many times.

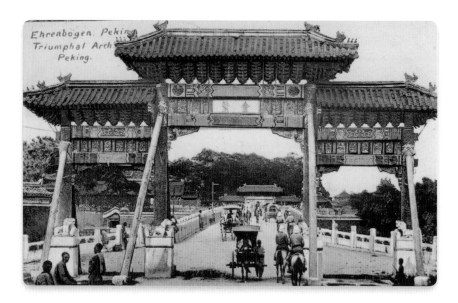

The Golden Tortoise *pailou,* which originally stood at the western end of the Beihai Bridge
no publisher ca. 1910

Once a Special Embellishment on Beijing Streets

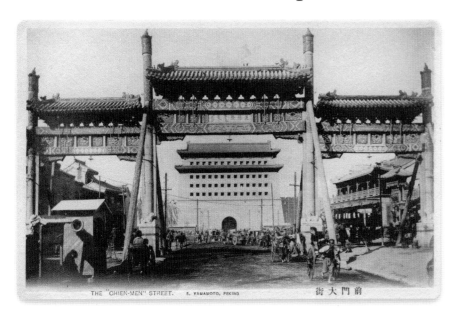

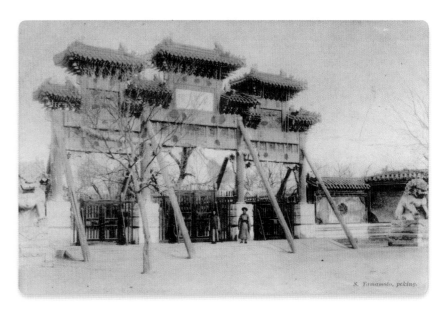

Above left Memorial arch on Ch'ien Men Street with guardhouse
S. Yamamoto ca. 1910

Above right Memorial arch, with Chinese and Manchu standing below
S. Yamamoto ca. 1910

Right The Jade Rainbow *pailou*, which originally stood at the eastern end of Beihai Bridge, with Peking cart and men with queues *no publisher ca. 1910*

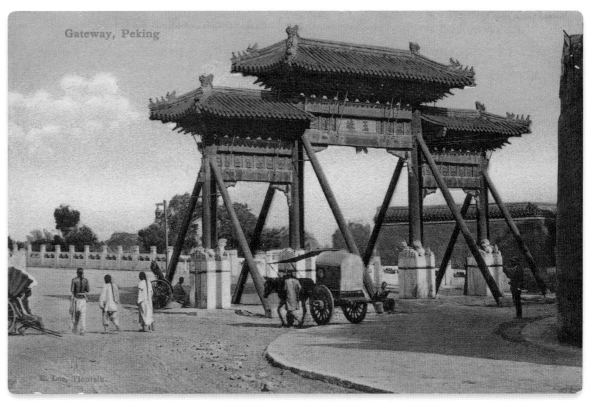

15

Buddhist and Tibetan Temples and Pagodas in and around Beijing

FIVE PAGODA TEMPLE,

YELLOW TEMPLE,

TEMPLE OF THE

AZURE CLOUDS,

BLACK TEMPLE

Beijing was surrounded by Buddhist temples but especially by Tibetan Buddhist temples, which were built mainly by the Qing emperors Kangxi and Qianlong, who favored Lamaism. Lamaism flourished in China, along with what the Chinese referred to as their "three teachings," which included Confucianism and Taoism.

The three Tibetan-style temples depicted here—Wutasi, the Five Pagoda Temple; Huangsi, the Yellow Temple; and Heisi, the Black Temple—originally lay outside Beijing proper. They were influenced in their design by Buddhism, Lamaism, and Hinduism and were built in honor of Tibetan dignitaries. Postcards in this collection show them in part or whole. Two of the temples were located in the Western Hills north of Beijing, a veritable Tibetan sanctuary of *chortens*, *dagobas*, and, to us, exotic temple structures, all of them sites for worshipping Buddha's various incarnations.

Buddhism and its Tibetan version, Lamaism, made their second home in Beijing, a testimony to the religious tolerance generally practiced by different dynasties and to their close relations with outlying countries, such as Tibet and Mongolia. Buddhism made a deep impression upon the Chinese, who had philosophies like Confucianism and Taoism as well as ancient forms of animism rather than a religion that offered salvation from the woes of life. Over the centuries, hundreds of temples, shrines, and pagodas were erected everywhere on plains and

hilltops and near the water in China, similar to the way the Christian religion and its cathedrals and churches spread in Europe.

The Buddha, Siddhartha Gautama, was born sometime around 500 BCE. His faith, promising salvation by following what he called the Four Noble Truths and the Eightfold Path and by mental exercises, spread far and wide across Asia, taking on different forms along the way, while disappearing in India. Buddhism traveled from Nepal and India to China on the old Silk Road by camel caravan via Afghanistan, across the Hindu Kush and the Taklamakan Desert. It reached Dunhuang, the oasis of the Caves of the Thousand Buddhas, where foreign voyagers stopped to dedicate an image of the Buddha in a cave, in thanks for a safe journey or in the hopes of one. They continued across the Gobi Desert to Chang'an, an early capital. In the south, Buddhists reached China on junks that had sailed to India and back to the China coast pursuing trade, carrying merchandise and Buddhist scriptures.

Two types of reliquary, the bottle-shaped stupa and the pagoda—a Chinese version of the stupa—could be seen far and wide in Tibet, Mongolia, and throughout China, where the pagoda was most prevalent. The temples shown on the postcards here are Lama temples.

For a week in 1936, my mother took my brother and me, together with the three young daughters of our hostess, to stay in a rented Chinese temple in the Western Hills. The shimmering, lacy

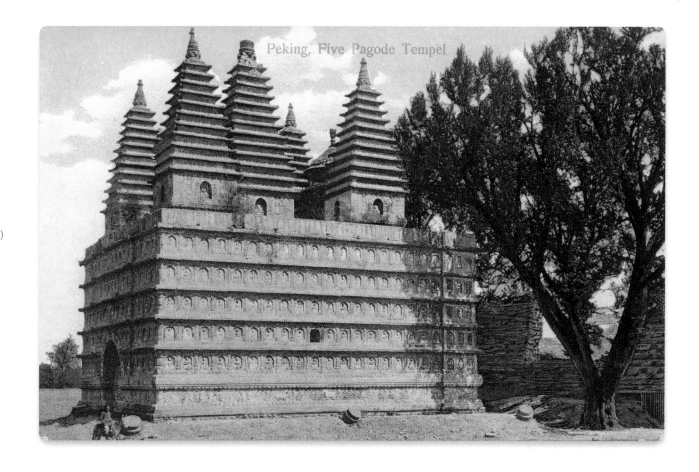

Temple of Five Pagodas (Wutasi)
and horseman at left for scale
no publisher 1910–1920s

Peking, Five Pagode Tempel

deciduous woods struck me as mysterious. Sitting in a rattan chair on the verandah closed in by fly-windows, with bees buzzing outside and butterflies fluttering, an unusual stillness prevailed. In my wanderings, I came upon Buddhist temples, where I discovered hundreds of Buddha images on the walls. Had I been transported into another fairyland, I wondered? My mother hired donkeys on which we rode on stony paths. A Chinese boy from the Franciscan monks' hillside monastery delivered cheese and milk in the morning for breakfast.

It was during this stay in Beijing that my mother took a trip with a group of ladies of the Beijing foreign community to visit another Manchu emperors' summer resort, called Jehol, in the northeast. She left my brother and me with our hostess and her daughters, with whom we climbed up the Tartar Wall (we were living in the Legation Quarter near Hatamen) and took in sweeping views of the city through the crenellation. My mother returned excited by what she had seen. She told us about the "Potala" on a mountain, with palaces, temples, and gardens below. Another one of her dreams had been fulfilled. Jehol was a small version

of the Tibetan Potala Palace and was built high on a hill like the real one in Tibet. Here was another example of Tibetan influence on Manchu emperors. In Jehol they held audiences and performed their manifold protocol, and it was there that the English Lord McCartney was received in 1793 after a long trip from England, hoping to get the emperor's consent for a trade agreement. The Englishman refused to kowtow before Qianlong and had to turn back to Canton. Qianlong was not interested in foreign products. "We have everything," he said: "tea, silk, and rice."

THREE TIBETAN TEMPLES
THE FIVE PAGODA TEMPLE
The Five Pagoda Temple, also called the "Temple of the Great Righteous Awakening," is located on the road to the Summer Palace. It was said to have been erected by the Yongle emperor in the early 1400s in honor of five golden Buddha statues that a wealthy Indian who had journeyed to China had presented to the emperor, along with a carved model throne similar to one in India. The temple has massive side walls and is constructed of brick and marble. On top of the masonry terrace stand four minor stupas with a taller one in

Five Pagoda Temple

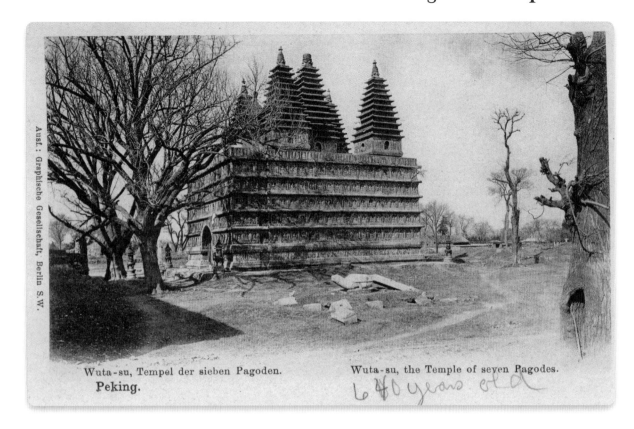

Wuta-su, Tempel der sieben Pagoden.
Peking.

Wuta-su, the Temple of seven Pagodes.

640 years old

the middle. Legend has it that the five golden statues are housed in them. The four walls of the structure are appointed with rows of one thousand Buddha images and sutra texts. A pair of the Buddha's footprints is a special motif in the temple, symbolizing the spread of the Buddha's teachings as the traveler from India had in mind.

THE YELLOW TEMPLE

The Yellow Temple, directly north of Beijing outside the Tartar Wall, also in the Tibetan style, became a favorite rendezvous site for Mongols, who pitched their tents outside. It takes its name from the Yellow Sect, founded by the reformer Tsongkhapa, and was erected by the Qing emperor Shunzhi in about 1651 as a residence for a visiting Dalai Lama. The temple has a compelling marble stupa with a metal cap and is dedicated to the earthly Sakyamuni

Above Five Pagoda Temple (Wutasi), in winter
Graphische Gesellschaft, Berlin ca. 1910

Right Five Pagoda Temple, in summer *no publisher ca. 1910*

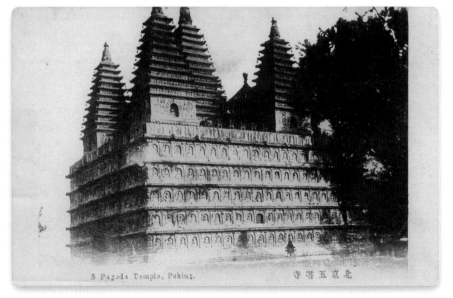

5 Pagoda Temple, Peking.　　　　北京五塔寺

The Yellow Temple

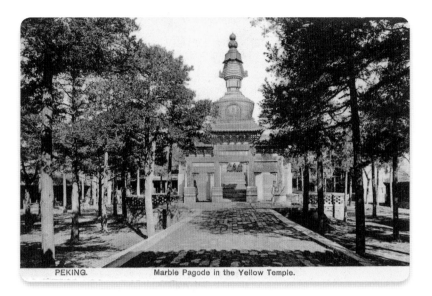

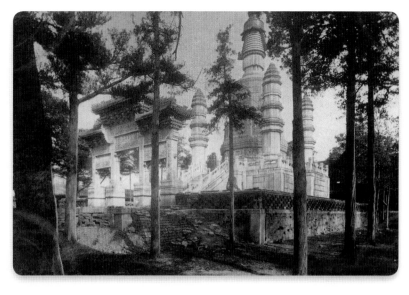

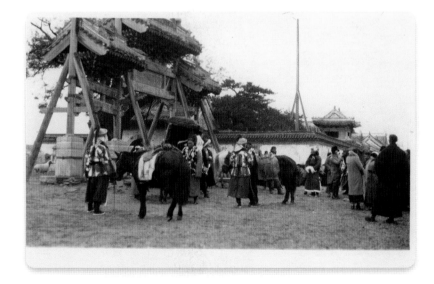

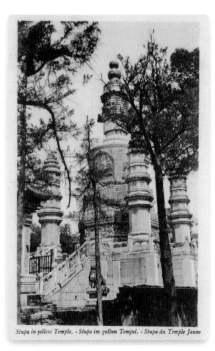

Buddha. It became a stronghold of Tibetans and their religion. The Mongols, who had embraced Lamaism, were fervent followers and had become much more frequent visitors than the Tibetans, so the emperor Qianlong had the eastern section of the temple renovated for Mongol princes and dignitaries. A thousand Tibetan and Mongol monks resided here at one time. This temple too is a hybrid of styles. The West Temple was built by the emperor Kangxi in 1722 to enhance China's new friendship with its nomad neighbors. Devil Dances were held annually, and the statue of the Buddha was carried around in a procession. The East Temple was destroyed during Mao's Great Leap Forward.

Above Mongolian horse market on temple grounds *no publisher hand-written note in Chinese on back, Real Photo postcard, ca. 1920*

Top left Marble stupa at Yellow Temple, front view
Hans Bahlke 1910

Top right Side view of stupa complex of Yellow Temple
no publisher ca. 1910

Above Stupa of Yellow Temple with metal cap
I. Wannieck ca. 1910

Temple of the Azure Clouds, Renowned for Its Beauty and Location

A BUDDHIST TEMPLE

BIYUNSI, THE TEMPLE OF THE AZURE CLOUDS

The Temple of the Azure Clouds was considered the most beautiful temple outside Beijing. It is also located in the Western Hills northwest of the city, as are many other hidden temples. Elaborate carvings of female figures, flowers, and birds in the Hindu style as well as of hundreds of Buddha images are found on the temple structures.

The Temple of the Azure Clouds is dedicated to the Sakyamuni Buddha, the living Buddha, The temple was expanded by the Ming and the Qing emperors, among them Qianlong. The reliefs represent the life of the Buddha and of bodhisattvas, the enlightened beings who remain as teachers among humankind. The first large pavilion houses the principal Buddhist deities. The Hall of Five Hundred Disciples of Buddha houses statues of these famous *lohan* (*arhats*), or saints. A splendid view of the Summer Palace and the city of Beijing can be had from Biyunsi.

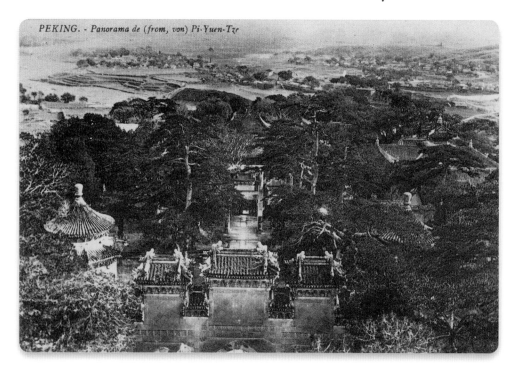

PEKING. - *Panorama de (from, von) Pi-Yuen-Tze*

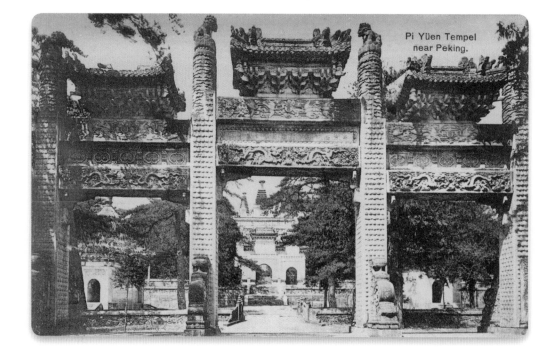

Pi Yüen Tempel near Peking.

Top Famous panoramic view of Beijing from the Azure Cloud Temple
no publisher ca. 1910

Right Gateway to the Azure Cloud Temple *I. Wannieck pre-1907*

Black Temple and White Stupa

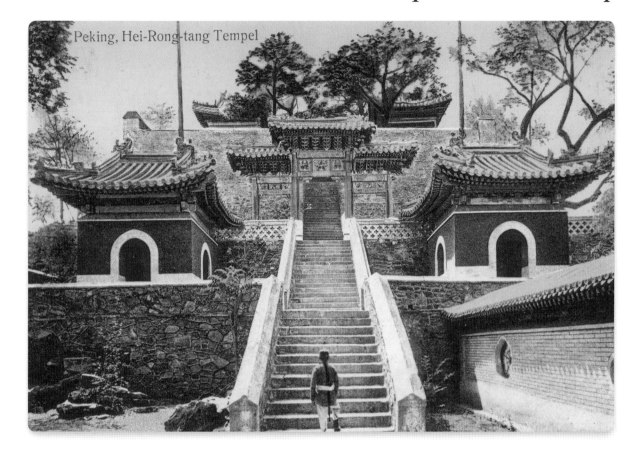

Peking, Hei-Rong-tang Tempel

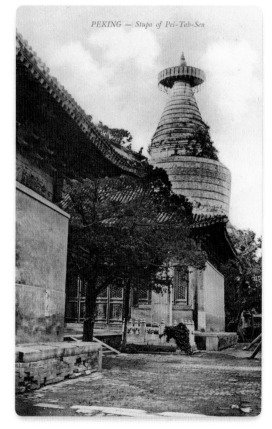

PEKING — Stupa of Pei-Tah-Sen

THE BLACK TEMPLE

The Black Temple is so called because of its black-colored tiles and a well with black-looking water. The temple buildings cascade down a hill. Mongol horse traders congregated here, and the temple grounds became the site of exhibitions of their horses that were attended by a jostling crowd. At one time the temple had a foundry, where bronze statues were manufactured for believers in the far west. The work of wiring and filling patterns with enamel to create cloisonné was also done here, and temple records report that the manufacturers paid the lamas poorly.

Pagodas in and around Beijing

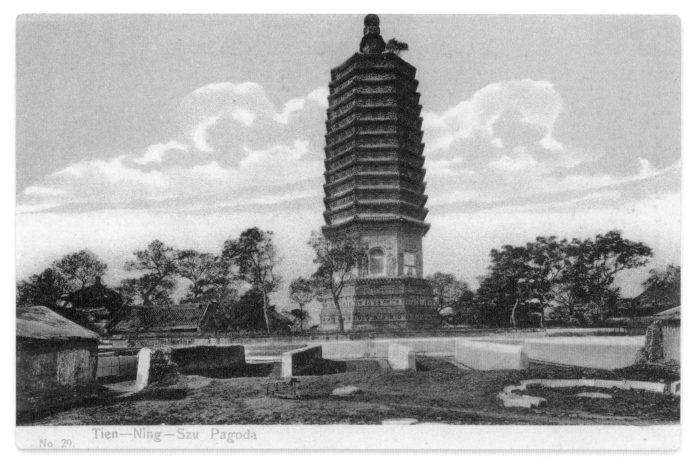

No. 29. Tien—Ning—Szu Pagoda

Tianningsi Pagoda, near the city wall. On this lovely hand-colored card, the clouds have been painted in. They are not in the original photograph. *The Hongkong Pictorial Postcard Co. hand-colored, pre-1907*

PAGODAS, FREQUENT MEMENTO MORI AND A POINTER TO A TRANSCENDENTAL WORLD
Developed from the ancient Indian stupa, the pagoda evolved into its own form in China, as it did in other Asian countries as Buddhism spread. The pagoda became the dominant structure in China. It achieved a uniform design, usually consisting of a tower of diminishing tiers, totaling nine or twelve, since these numbers are symbolic in Buddhism. Its segments represent the different parts of the cosmos, with a column at the center that represents the axis between heaven and earth. The pagodas stand next to rice fields and monasteries, on hilltops, and near the water. Some have a distinct purpose, such as to protect a certain neighborhood from natural calamities. They were a great visual as well as religious enhancement —the surprise reminder of another, better life to be striven for through personal effort by practicing the Buddhist Eightfold Path. For Buddhism promised salvation, which contributed to its popularity among the Chinese.

When I was growing up in China, pagodas were a common and beloved feature of the landscape that I would never have wanted to miss. They would show up as a sudden surprise whenever we traveled in the countryside in the 1930s.

Frequent Memento Mori, Reliquaries, or Shrines

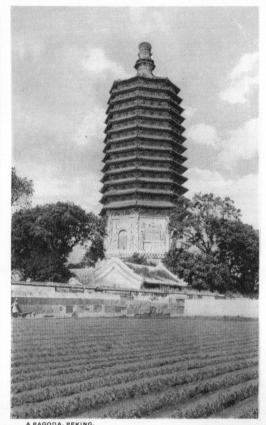

A PAGODA, PEKING.

Right Balizhuang Pagoda, on the west side of the city
*Graphische Gesellschaft, Berlin
ca. 1910*

Above Another view of the Tianningsi Pagoda, with its fourteen-tier tower
I. Wannieck 1920s

Right The temple attached to the Tianningsi Pagoda
Camera Craft Peking 1920s

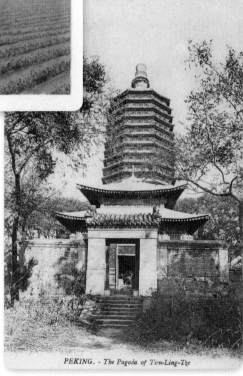

PEKING. - The Pagoda of Tien-Ling-Tze

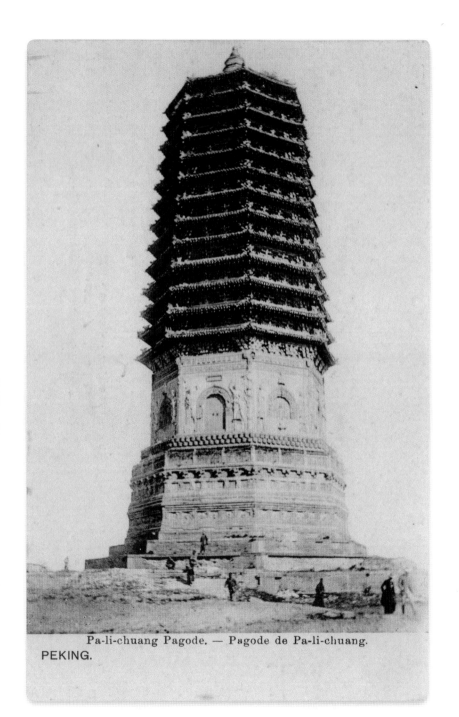

Pa-li-chuang Pagode. — Pagode de Pa-li-chuang.
PEKING.

16

Yuanmingyuan, the Old Summer Palace

DRAWINGS OF MIXED
ROCOCO PALACES ON
THE OLD SUMMER
PALACE GROUNDS

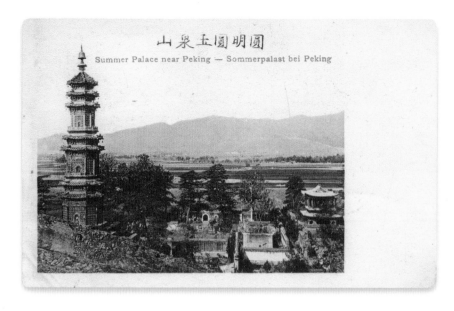

Jade Fountain Pagoda, overlooking onetime Old Summer Palace grounds
no publisher pre-1907

The following nine cards are from a set of twenty that reproduce engravings based on architectural drawings made by the Jesuit Giuseppe Castiglione in the 1740s at the behest of the Qianlong emperor. The emperor had a fondness for the exotic, and Castiglione's designs display mixed chinoiserie and rococo-style palaces, residences, gardens, and fountains. Qianlong had them built in a part of the Garden of Perfect Clarity, also called the Old Summer Palace, for his use and pleasure. The original drawings were sent to Paris by the Jesuits. A small version of engravings was produced by the printmaker and engraver Isidore Stanislaus Henri Hellman in the mid-1700s and widely circulated. The fanciful buildings and the collections of European art pieces housed in them were summarily destroyed in the Second Opium War in 1860. Only copies of the engravings such as these fill the visual gap in Chinese architectural history. In his book *Imperial Palaces of Peking* (1926), Osvald Siren, a leading Swedish sinologist of the 1930s, presents a number of such postcards together with photographs taken by him of the corresponding ruins left behind after the destruction. Siren writes that cards of the engravings of the Old Summer Palace could be bought in Beijing at the time. Possibly he was referring to the ones made by Max Hartung.

The Garden of Perfect Clarity was a vast park-like area north of the city. From its rural splendor, Kangxi, Yongzheng, Qianlong, and subsequent emperors—including the emperor Xianfeng and his young concubine

Yehonala, later the Empress Dowager—ruled the country when they were not in the Imperial Palace in Beijing.

Giuseppe Castiglione (1688–1766) was trained in Venice as a painter and architect. He was sent to China as a missionary by the pope in 1715, first landing in Macao. Accepted by the Manchu court, he moved to Beijing and worked for three Manchu emperors in succession for a period of seventeen years. His Chinese name was Lang Shining. He painted a large portrait of Qianlong in shimmering military regalia on a white stallion and did many court scenes. A mixed style all its own evolved at the hands of Castiglione, who blended the European and Chinese artistic styles "such as had never been seen before." He died in Beijing. He and the other Jesuits helped create a fairyland of unique European-style buildings at the Summer Palace.

Frère Denis Attiret, a contemporary of Castiglione and also a painter at the court, described the Summer Palace in a letter as a Rococo "fantasyland" of untold beauty and quaintness, "consisting of small valleys, canals of clear water and fountains, as well as the emperor's apartment near the entrance." He writes that the rooms of the buildings were filled with exquisite porcelain vases and pieces of lacquer for which gold and silver had been dispensed abundantly. Attiret himself acquired the style of Chinese painting, specializing in portraiture. Qianlong liked to observe the artist in his studio.

In 1860, in his wrath over what he saw as a Manchu breach of promise during the Second Opium War, Lord Elgin ordered his forces to enter and destroy the Old Summer Palace. The emperor's residence and other structures were demolished and the grounds wrecked. In addition, the troops looted artwork the emperor had collected and stored in the buildings. This act of vandalism is deeply deplored by most historians and is regarded as nothing less than a scandal.

Nine Castiglione Cards

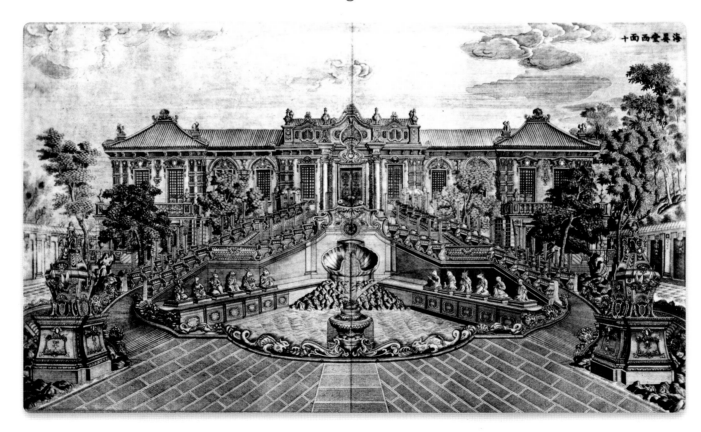

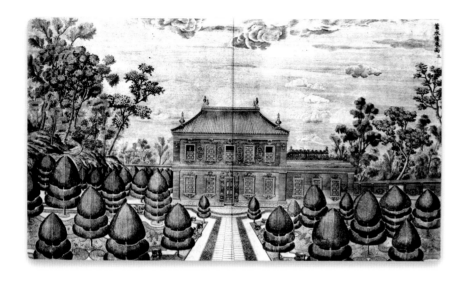

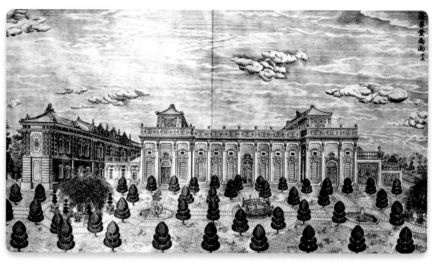

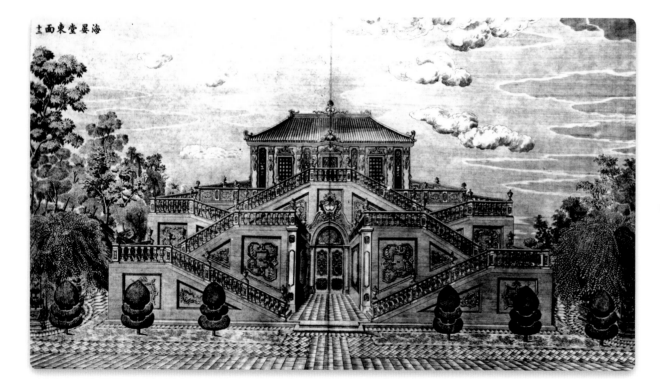

Top left Xushuilou, the Reservoir Tower (east façade) *Hartung's Photo Shop*

Top right Haiyantang, The Hall of Boundless Peace (east façade) *Hartung's Photo Shop*

Left Haiyantang, the Hall of Boundless Peace (west façade) *Hartung's Photo Shop*

Overleaf Haiyantang, the Hall of Boundless Peace (west façade) *Hartung's Photo Shop*

Xieqiqu, Palace Harmonizing the Marvelous and
Amusing (north façade) *Hartung's Photo Shop*

Left Yangquelong, the Aviary (east façade) *Hartung's Photo Shop*

Right Xianfashan, Perspective Hill (front view) *Hartung's Photo Shop*

Left Yuanyingguan, Observatory of
the Distant Seas (front view)
Hartung's Photo Shop

Below Zhuting, Bamboo Pavilions
(north façade) *Hartung's Photo Shop*

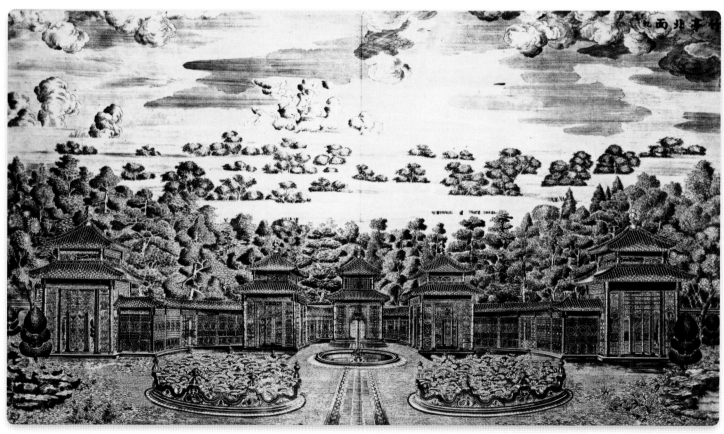

17

The Jade Fountain
—a Celebrated Well Near Beijing

THE KANGXI EMPEROR'S

FAVORITE HUNTING PARK

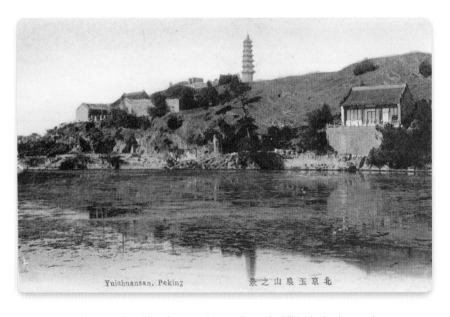

Jade Fountain with Jade Fountain Pagoda on the hill in the background
Japanese publisher back hand-dated 1908

Jade Fountain is a spring that issues the crystal-clear water from which it takes its name. The Jade Fountain Pagoda stands on a rise above the fountain like the well's sentinel, with a companion at its back in wide-open, hilly country. The pagoda is faced with intricately carved glazed tiles, while other pagodas nearby are made of stone and brick. It is a true architectural treasure.

The cold water of the spring gushes forth from rocks into a brook that feeds Lake Kunming of the new Summer Palace and continues to Beijing and into the Imperial Canal. The fountain lies three miles north of the Summer Palace in an area that had been used as a park by the Mongols and the Tartars for eight hundred years. The great Manchu emperor Kangxi, whose favorite hunting grounds and recreational park it became, built temples and pagodas there. Qianlong had an inscription carved on a structure near the well, saying: "The First Spring under Heaven." Little remains of the original park today.

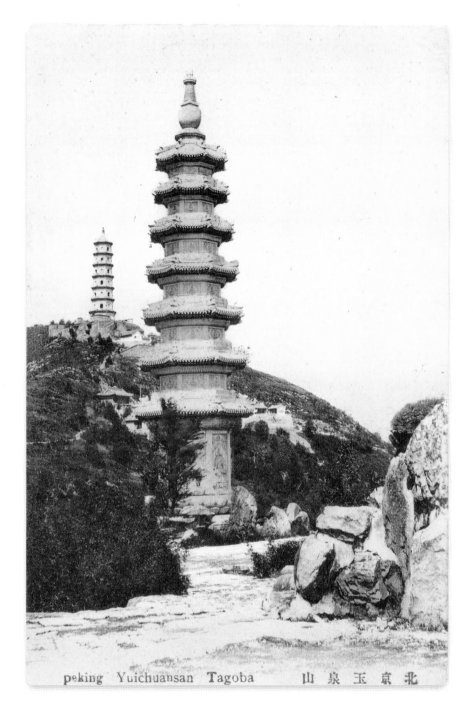

peking Yuichuansan Tagoba　北京玉泉山

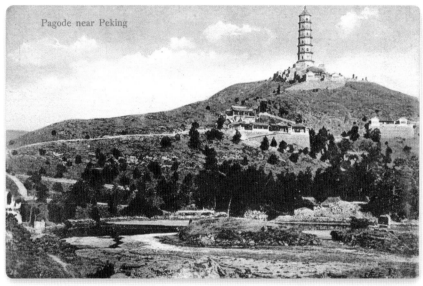

Pagode near Peking

Above Brick pagoda on a hill above the fountain
no publisher ca. 1910

Left Jade Fountain Pagoda, with tiles made of porcelain and with a mate in the
distance　*no publisher　Real Photo postcard, ca. 1910*

18

The
Summer
Palace
(Yiheyuan)

CIXI'S BELOVED

SECONDARY RESIDENCE,

RESTORED BY HER LOYAL

TEAM OF A THOUSAND

EUNUCHS AFTER THE

BOXER HOSTILITIES

The Summer Palaces were the playgrounds of the Qing dynasty emperors, who sought rest, recreation, and recuperation there from their heavy duties and daily long hours in the downtown palace. The summer palaces also were their escape from the torrid Beijing summer heat. The many-tiered pagoda on top of Longevity Hill, the mound that dominates the vast lakeside acreage, was built in 1750 in celebration of the sixtieth birthday of Qianlong's mother. A cluster of buildings cascades down a hill on the south side to the shore of Lake Kunming.

This marshland was first drained and turned into a lake by Kublai Khan, and its shores were used for buildings. It was rebuilt and embellished as a park by the Manchu emperors Kangxi and Qianlong, Kangxi's grandson, two avidly art- and architecture-loving monarchs. Among its highlights are a mile-long covered colonnade with an ornately painted ceiling borne by red columns, a bronze pavilion, a camel-back bridge and a seventeen-eyed bridge that unite parts of the land around the lake, and a theater. Serious damage was done to this section of the Summer Palace by the attacks of the Western forces in 1860 and during the Boxer Uprising in 1900.

When the Empress Dowager received funds to build a navy to protect China against the Western invader, she sidetracked the money for the restoration and embellishment of her beloved lakeside park. She followed her passion, making the new Summer Palace shine and shimmer once more. She let her artistic urge go too far, however, when

she built a big two-tiered marble pleasure boat alongside the lake, to serve as a stop where she could imbibe a cup of tea with her retinue. It was called the Marble Boat, and some thought it hideous. Today it remains a pièce de résistance for tourists. With all its restored beauty, it was little wonder that the Summer Palace was the Empress Dowager's preferred refuge, where she moved in retirement. She loved to amble among trees and flowers, walk in the snow in winter escorted by her ladies-in-waiting, attend a play in the impressive theater that she had restored, and hold audiences in lakeside palaces instead of in the Forbidden City in the heart of Beijing.

I remember visiting the Summer Palace with my mother and brother in 1936. My mother hired a boat whose boatsman was a eunuch with a large head and big wide-set eyes, characteristics of such men. The Nationalist government had given this kind of job to some of the eunuchs as a retirement package. The boatsman rowed us across the glistening lake, under marble bridges and alongside pavilions and palaces, with the proverbially translucent, azure Peking sky overhead. I also remember standing on the shore of Lake Kunming as a girl, with my mother, who was well-read in Chinese history and art, holding Juliet Bredon's guidebook *Peking* in her hands, looking in the direction of the Old Summer Palace and bemoaning the inability to see Castiglione's fairy-tale buildings that Cixi had loved so much.

The Empress Dowager's Favorite Spot—Her Heart Was Here

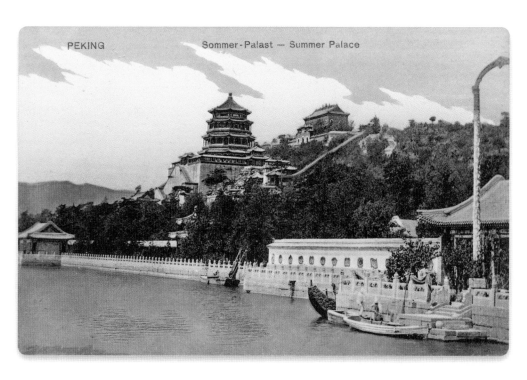

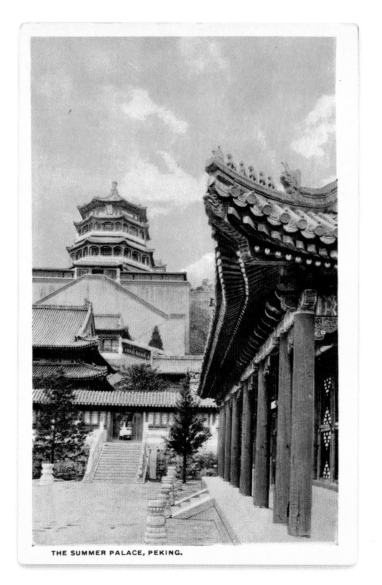

Above View of the Summer Palace, showing Longevity Hill, the Pavilion, and Kunming Lake *Hartung's Photo Shop hand-colored, 1910–1920*

Right Summer Palace building *Hartung's Photo Shop 1910–1920*

Exquisitely Restored by Cixi through the Labor of Thousands of Loyal Eunuchs after the Boxer War Ransacking and Destruction

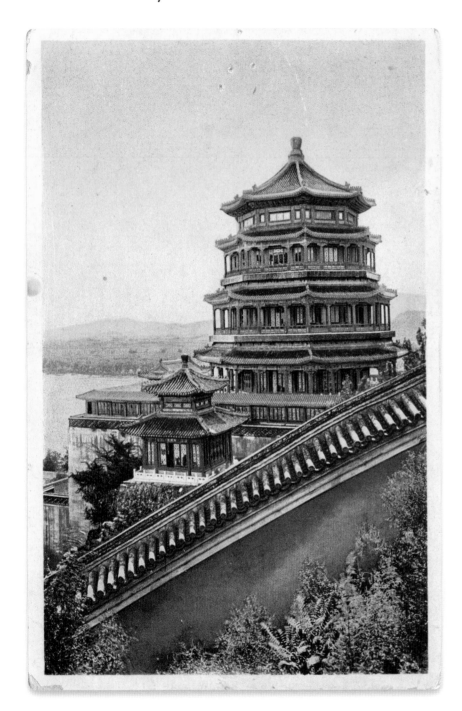

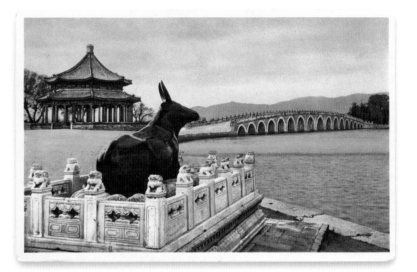

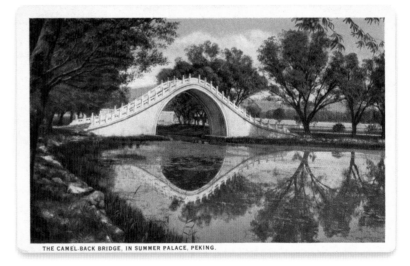

THE CAMEL-BACK BRIDGE, IN SUMMER PALACE, PEKING.

Left Main pagoda on Longevity Hill, the Pavilion of Buddha's Fragrance, with a view of the lake and hills *Hartung's Photo Shop 1910–1930s*

Top Bronze ox and Seventeen-Eyed Bridge, also known as the Seventeen-Arch Bridge *Hartung's Photo Shop 1920–1930s*

Above Camel-Back Bridge and reflection
Camera Craft 1920–1930s

Right Carved Colonnade, known as the Long Corridor, side view
Camera Craft ca. 1920

Far right Carved Colonnade with deep horizon line *Hartung's Photo Shop ca. 1920*

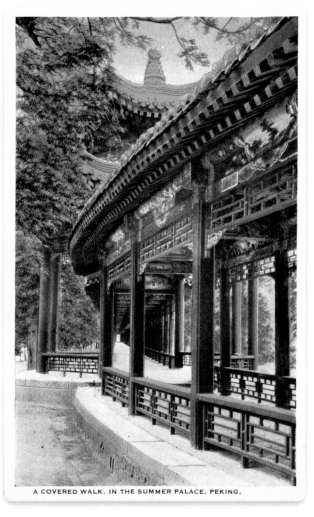

A COVERED WALK, IN THE SUMMER PALACE, PEKING.

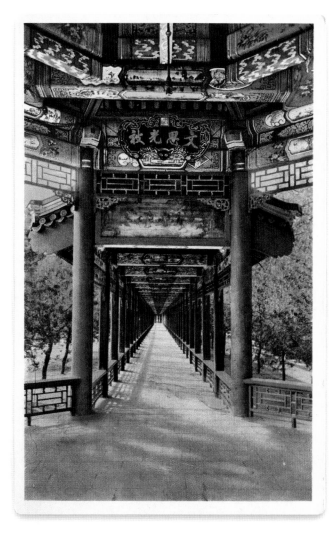

Right The Paiyundian Arch—a Cixi favorite—near Kunming Lake *no publisher pre-1907*

Far right The Cloudy Peak Arch at Floating Heart Bridge *no publisher ca. 1920*

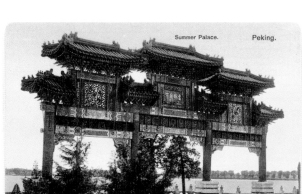

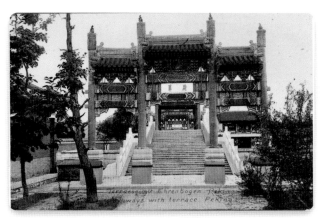

Beauty, Refreshment, and a Change from the Harrowing Demands of the Forbidden City

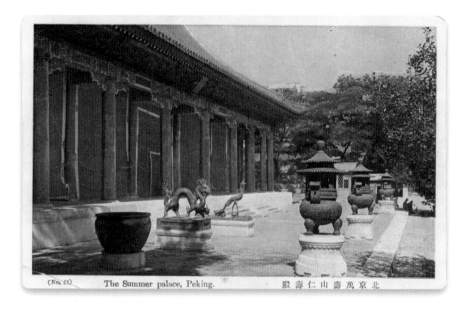

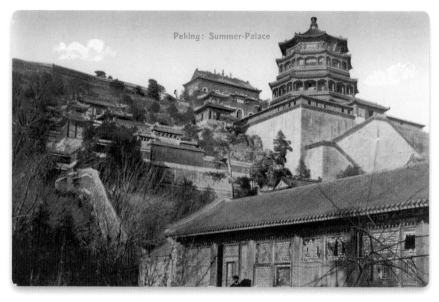

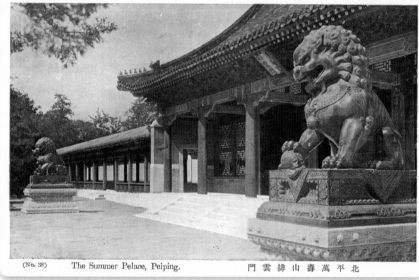

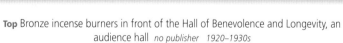

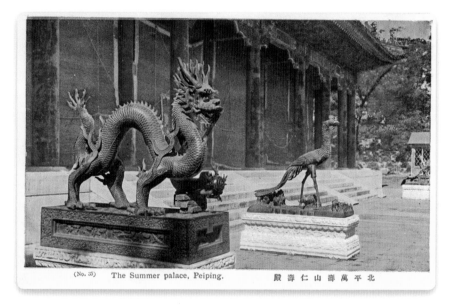

Top Bronze incense burners in front of the Hall of Benevolence and Longevity, an audience hall *no publisher 1920–1930s*

Above Bronze heavenly lions guard the Paiyun Gate.
no publisher 1920–1930s

Top Looking up Longevity Hill
no publisher 1920–1930s

Above Auspicious bronze dragon and phoenix before the Hall of Benevolence and Longevity *no publisher 1920–1930s*

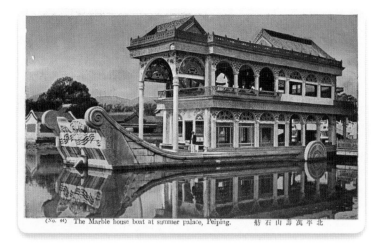

(No. 44) The Marble house boat at summer palace, Peiping. 北平萬壽山石舫

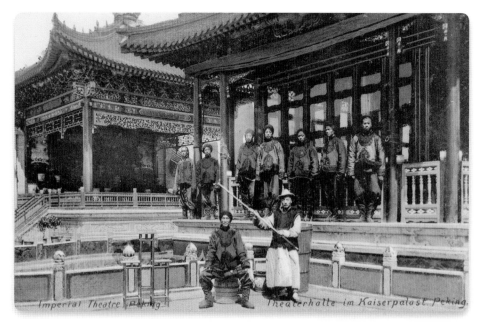

Imperial Theatre Peking. Theaterhalle im Kaiserpalast Peking.

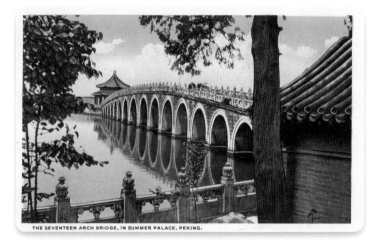

THE SEVENTEEN ARCH BRIDGE, IN SUMMER PALACE, PEKING.

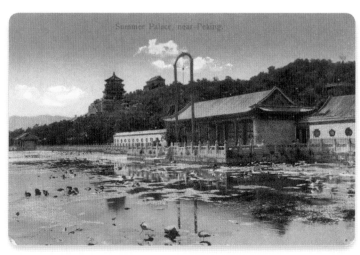

Summer Palace, near Peking.

Above Imperial Theater,
built by Cixi *no publisher 1920s*

Right All-bronze Pavilion of Precious
Clouds, damaged in Boxer Uprising in
1900 and rebuilt by Cixi
Hartung's Photo Shop 1920s

Left top The Marble Boat with side wheel,
Cixi's special notion *no publisher*
hand-colored, back hand-dated 1929, Peiping

Left middle The Seventeen-Arch
Bridge in color *Camera Craft*
hand-colored, 1920s

Left Summer Palace buildings on Kunming
Lake *Hartung's Photo Shop 1920s*

19

The Ming Tombs

and the Spirit Path

THE YONGLE EMPEROR'S

SPLENDID BURIAL GROUND

AND HIS TABLET TEMPLE

The grand burial site of the Ming emperors north of Beijing is referred to as the Ming Tombs, or Shisanling in Chinese, the "Thirteen Tombs." The site of the thirteen tombs of this purely Chinese dynasty was carefully chosen in the mountains due north of Beijing according to age-old beliefs that human remains must be buried in the bosom of Nature, where there are trees for shade. Most of China's dynasties had their memorial arches, spirit paths, and tablet temples as well as burial vaults cut deep into a mountainside following the Way of Nature, and this was true for the Ming dynasty before Yongle, the third of the Ming emperors. However, Yongle refused to be buried in the grave site of his father, Hongwu, in the mountains of Nanking, and instead laid out a prestigious grave site for himself with a memorial arch, a spirit path, and a tablet hall near Beijing.

A giant stone memorial arch with five gates and six carved giant pillars supporting a yellow-tiled roof stands like a prelude to this path, which is lined with huge stone figures. There are officials about nine feet high and animals such as elephants about thirteen feet high, each carved out of a single block of stone from a quarry nearby. The statues loom in the open like a line of silent sentinels along an avenue leading to Yongle's tablet temple, once the biggest building in China. A giant stele resting on a large turtle beyond the arch is said to have been erected by the emperor Renzong in 1425 in memory of Yongle, who died the year before. The

emperor Qianlong had one of his poems inscribed on it. The last of the thirteen Ming tombs is of the emperor Chongzhen (r. 1628–1644), whose self-imposed death took place on Coal Hill when rebels had entered the Forbidden City. The Ming Tombs lie in the mountains about thirty miles north of Beijing. The once tedious and lengthy cross-country trip to them was greatly shortened by the building of the Peking-Kalgan Railway via the Nankou Pass at the Great Wall nearby.

The Manchu emperors were buried in two different places. In the Eastern Tombs (Dongling), northeast of Beijing, fifty emperors, empresses, princes, and princesses have their tombs. Among the emperors interred there are Shunzhi, Kangxi, Qianlong, Xianfeng, and Tongzhi. These burial sites are nothing more than an extension of the geomantic conceptual realm of the imperial palace in the Forbidden City. The Western Tombs (Xiling) in contrast are located northwest of Beijing, close to their homeland of Manchuria. They are the burial site of the other half of the Qing emperors and their families: four emperors and three empresses and imperial concubines. It is here the Empress Dowager was buried with all her robes, jewels, and valuables stored in a separate mausoleum that was later looted. The unfortunate emperor Guangxu was buried in a remote part of the Western Tombs because of his departure from Manchu orthodoxy and desire for modernization that had resulted in his unnatural death.

Right Marble pillars and spirit path, Ming Tombs
Hartung's Photo Shop 1920s

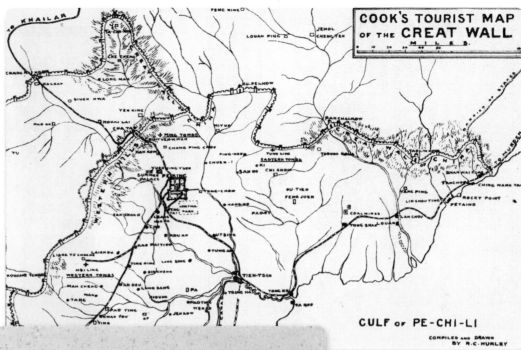

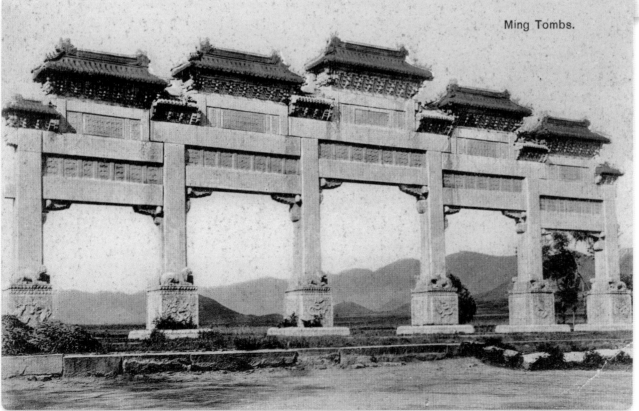

Ming Tombs.

Above Cook's tourist map of the
Great Wall. This map shows the
Eastern Tombs, Ming Tombs, and
Western Tombs, where the Empress
Dowager Cixi was buried in 1908.

Left Huge five-gate memorial arch
at entrance to the tombs of thirteen
Ming emperors *no publisher*
pre-1907

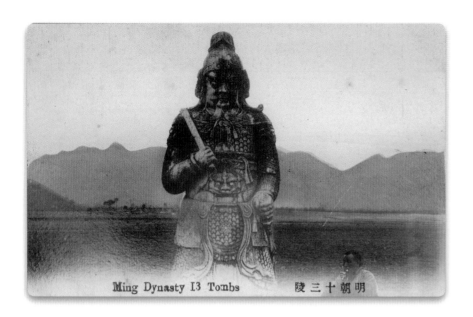

Ming Dynasty 13 Tombs　陵三十朝明

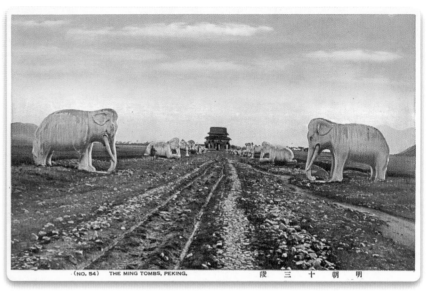

(NO. 54)　THE MING TOMBS, PEKING.　陵三十朝明

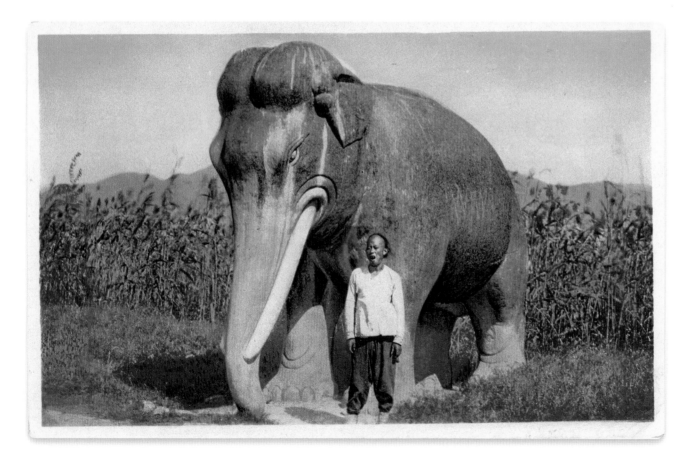

Top left Stone guardian at Ming Tombs
Japanese publisher 1920s

Above Stone elephants on Spirit Path to
Yongle's tomb *no publisher 1920s*

Left Stone elephant and man in white
tunic for scale, Ming Tombs
no publisher 1920s

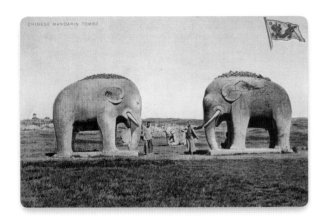

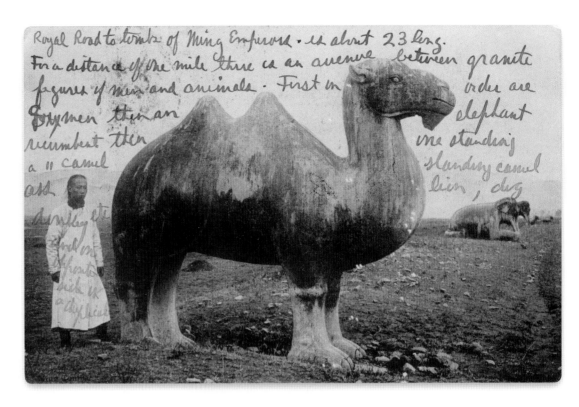

Royal Road to tombs of Ming Emperors is about 23 ling.
For a distance of one mile there is an avenue between granite
figures of men and animals. First in order are
six men then an
recumbent then
a ʺ camel
ass
elephant
one standing
standing camel
lion, dog

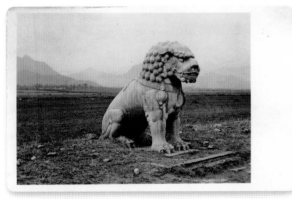

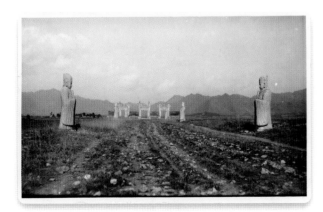

Left at top Two stone elephants
in color, Ming Tombs
*Kingshill (Qing dragon flag)
1910*

Left middle Stone lion on
spirit path *no publisher Real Photo
postcard, ca. 1910*

Left High official guardians on
spirit path *no publisher Real Photo
postcard, ca. 1910*

Right Stele on top of tortoise,
bearing a poem by Qing
emperor Qianlong *no publisher
Real Photo postcard, ca. 1910*

Above Stone camel and man in
white gown. The message on the
front reads: "Royal Road to
tombs of Ming Emperors is about
23 ling. For a distance of one
mile there is an avenue between
granite figures of men and
animals. First in order are six
men, then an elephant
recumbent, then one standing, a
[recumbent] camel, standing
camel, ass, lion, dog, donkey, etc
and on opposite side is a
duplicate." *no publisher back
hand-dated 1906, cancellation "Peking
8 Dec 05, Shanghai Dec 16 05, San
Francisco Jan 6 1906"*

20

The Coming of the Railroad

A FORMIDABLE
TUNNEL AT THE
NANKOU PASS
BY THE ENGINEER
JEME TIEN YOW

The railroad came to China in the mid-1870s. Its introduction was at first strenuously opposed— by the populace because of superstitious beliefs and magical thinking about possible malign influences and by the authorities as a foreign encroachment. In addition, the land required for the tracks had to be diverted from other uses, such as agricultural fields and burial mounds. The building of railroads meant big business for the Westerners, however. Their ambassadors in the Legation Quarter vied with each other for franchises from the Manchu government. Among Chinese officials, Li Hongzhang, the viceroy of Zhili Province, recognized the need for modernization and became a key negotiator with the Europeans. He himself constructed a railroad that would link Tianjin with the coal mines in Tangshan. Jeme Tien Yow (Zhan Tianyou), a Chinese who had studied civil engineering at Yale, worked with a British chief engineer on that line, starting as a junior engineer in 1888 and rising to the position of full engineer and district engineer in twelve years because of his extraordinary talent. In 1902, Yuan Shikai, the powerful general, decided to build a special line for the Empress Dowager so that she could ride to the imperial tombs more readily. Jeme Tien Yow was made chief engineer of this short stub line. The empress was so delighted with the result that she agreed to build more railways in the future.

In 1905 the Qing government saw the need for a railway between Beijing and the important commercial and strategic city of Kalgan (Zhangjiakou) in Manchuria. Jeme Tien Yow was appointed chief engineer again. The project was to be undertaken without foreign involvement—the first time this had happened. Begun in 1905, work was completed in 1909, two years ahead of schedule. It was an impressive engineering feat, utilizing switchbacks for the steep slopes at Qinglongqiao and an innovative method to expedite excavating the Badaling Tunnel to get to the other side of the Great Wall. The engineering at the Nankou Pass, the gateway to Mongolia, was especially admired abroad.

Jeme Tien Yow was awarded an honorary doctorate by the University of Hong Kong in 1916. He died in 1919 at the age of fifty-eight and was buried at the Qinglong railway station, where the Peking-Kalgan railway crosses the Great Wall in the rugged mountains north of Beijing. His statue stands at the station in memory of his contribution to the modernization of China.

Several railway lines converged in Beijing: the Beijing-Hankou line, the Beijing-Zhangjiakou line, the Beijing-Tianjin line, and a line to Mongolia. The Peking-Hankow Railroad runs through the west city gate of Beijing, then southwest along the Yongding River. The river is spanned by an eight-hundred-year-old stone bridge called Lugouqiao that Marco Polo described in his memoirs—for which reason Westerners called it the Marco Polo Bridge. An

incident between Japanese and Chinese soldiers at the bridge became the trigger for the Japanese invasion of North China in 1937 that started an undeclared war and was a further encroachment upon China by another foe.

Right Imperial Railway at North Station between arrivals
no publisher cancellation Shanghai 1903

Below European-style railway station in the Chinese City, near Ch'ien Men *no publisher pre-1907*

Below right Same image as top, but cropped and colored differently. North Station and cabstand outside city wall, with rows of Peking carts *no publisher pre-1907*

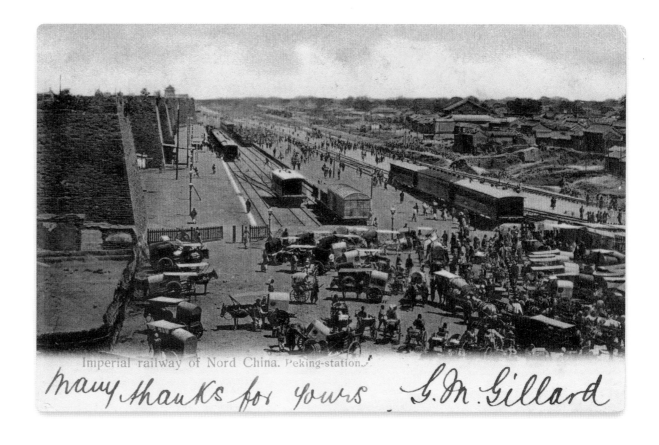

Imperial railway of Nord China. Peking-station.

Many thanks for yours G.M.Gillard

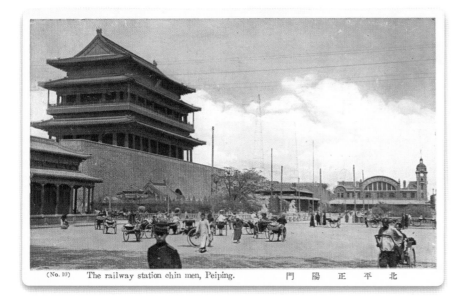

(No. 10) The railway station chin men, Peiping. 門 陽 正 平 北

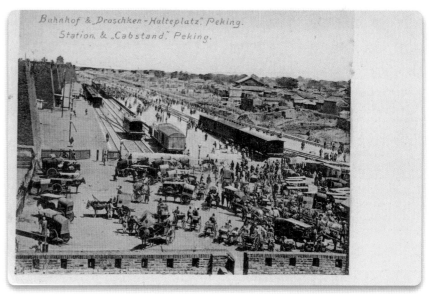

Bahnhof & „Droschken-Halteplatz". Peking.
Station & „Cabstand". Peking.

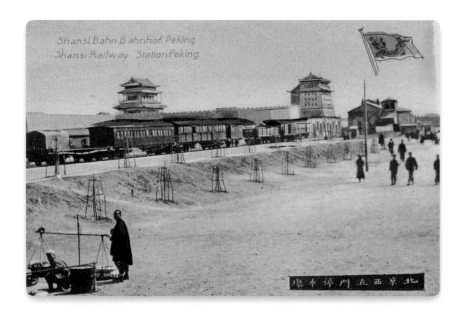

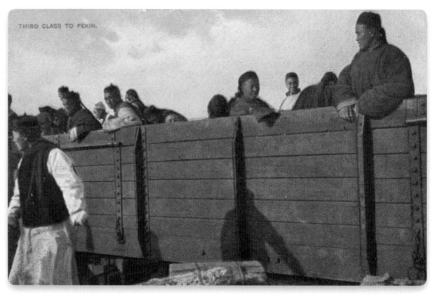

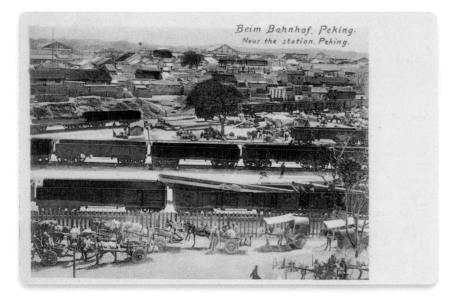

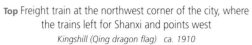

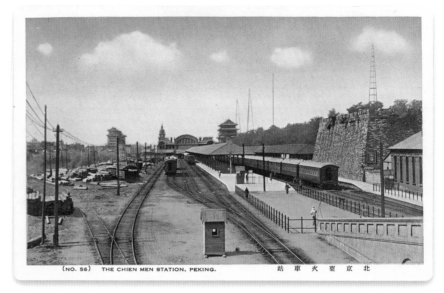

Top Freight train at the northwest corner of the city, where the trains left for Shanxi and points west
Kingshill (Qing dragon flag) ca. 1910

Above Life near the main railway station *no publisher ca. 1910*

Top Third-class Chinese travelers in boxcar
no publisher ca. 1910

Above Ch'ien Men Station outside the city wall, looking west
no publisher 1920s

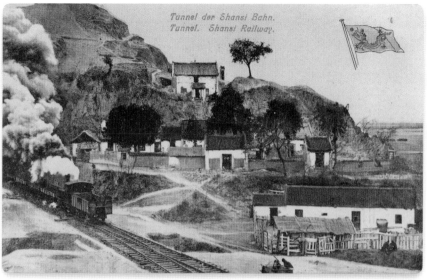

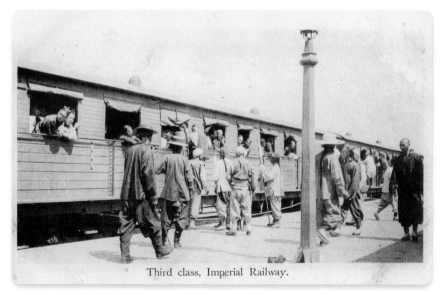

Top South Manchurian Railway, Koki train
Japanese publisher Real Photo postcard, hand dated 9/16–9/19/09

Above Third-class travel on the Imperial Railway
Charles Gammon photo series Real Photo postcard, ca. 1910

Top Shanxi Railway tunnel and train smoke
Kingshill (Qing dragon flag) 1910–1920

Above Station next to city wall, with Peking carts, rickshaws,
and a car waiting *Japanese publisher ca. 1910*

21

Street Life

EVERYTHING

"EN PLEIN AIR"

— THE CHINESE

INFRASTRUCTURE

Much of the life of the Chinese took place outside in the streets, including official business, as postcards show. A judge in his robes, sometimes blind, sitting at a streetside table with his assistants, passed judgment over the criminal, prostrate on the ground before him. Military parades were held in the streets in the public eye. Wedding and funeral processions always have been major streetside events and could frequently be observed, whether on their way to the groom's family or the burial site. In a wedding procession the bride sat behind a veil in a sedan chair and was carried by a minimum number of bearers with no escorts. She was rushed through the streets to the home of the mother-in-law. The trousseau had been sent ahead as a part of the marriage bargain. For a funeral, the wealthier the man, the more pompous the casket and procession and more numerous the bearers. The chief mourner in white sackcloth walked in front, an orchestra followed, and the women walked behind the casket. Additional mourners were hired. An innate theatrical penchant of the Han people enlivened these decisive events.

And, as in other cities, towns, and villages in China, working life in the Beijing streets has always been vibrant. Working men and women as well as vendors outside of stores created self-sustaining communities whose existence bordered on the heroic. They conducted their business in a minimum of space and endured all kinds of weather, from the bitter cold of winter to the torrid summer heat and the whipping

sandstorms in spring, a broad smile never failing. The Chinese in my time were given to an innate cheerfulness even in the worst of conditions. They were frugal in all aspects of life. Artisans, tradesmen, the portable-kitchen restaurateurs, the barber and simultaneous dentist, and the diverse salesmen represented a steadfast infrastructure on which the rest of the population could rely for services. Children often stood by the elders, even took on duties, and were equally fearless. The crab-apple vendor and the chestnut roaster made the children's eyes pop with avidity. The steaming ravioli and the red bean paste–filled buns that the cooks produced out of containers using a pair of extra-long chopsticks were an irresistible temptation even for the wealthy passerby. Among them, the smith labored on shoeing a horse tied to a contrived frame. The roadside theater under a canvas roof affixed to bamboo poles was not to be missed, carrying on the tradition of telling the old folktales and letting people forget their woes. The poor partook of the streetside events of the rich. Life was never dull.

A benign sense of humor ruled the masses. An acceptance of life's woes prevailed, always rising above the situation. The ingenious, survivalist lifestyle of the Chinese was a persistent subject of the Western photographer. He recorded it with his camera time and again.

Street Formalities

Funeral and Wedding Processions

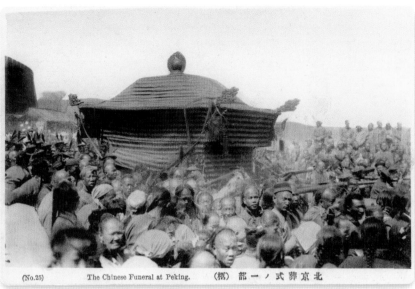

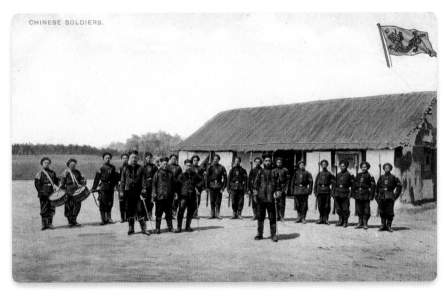

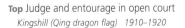

Top Judge and entourage in open court
Kingshill (Qing dragon flag) 1910–1920

Above Officers and soldiers ready for a march
Kingshill (Qing dragon flag) ca. 1910

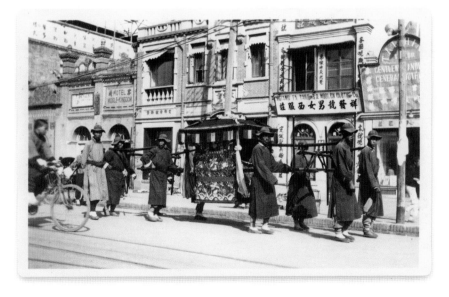

Top Casket among crowd of onlookers
Japanese publisher 1910–1920

Above Bride in embroidered sedan chair on the way
no publisher Real Photo postcard, ca. 1930

Fine Color Prints by Hartung

Far left Chief mourner at the front in white mourning clothes and staff
Hartung's Photo Shop ca. 1920

Left Hired hands carrying funeral banners
Hartung's Photo Shop ca. 1920

Below Colorful procession with priest at front avoiding camera
Hartung's Photo Shop ca. 1920

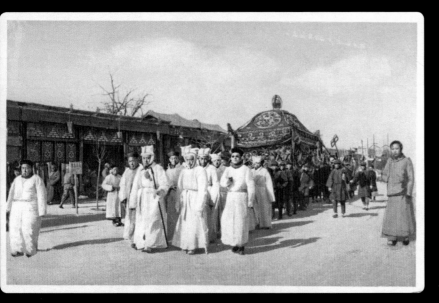

The Indomitable Han Street Vendors of the Manchu Period

Children and itinerant food seller ready for a pose
Japanese publisher ca. 1910

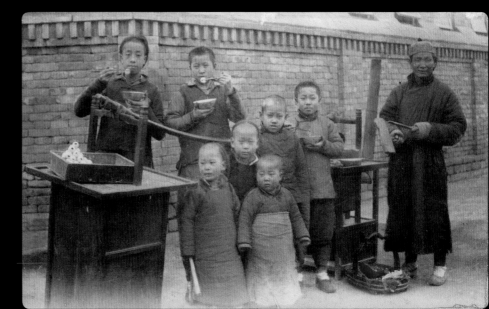

A Photo Album Collection by Charles Gammon and Denniston & Sullivan—
Premier English Photographers and Publishers in Beijing

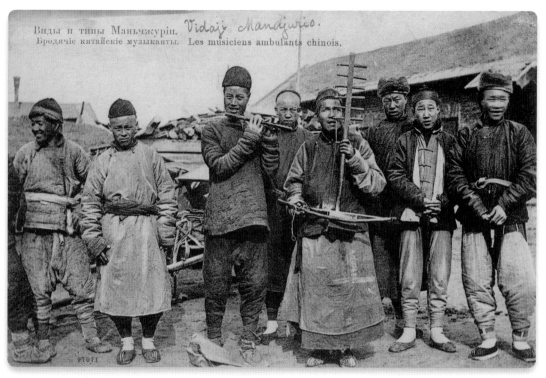

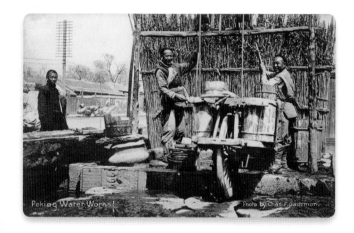

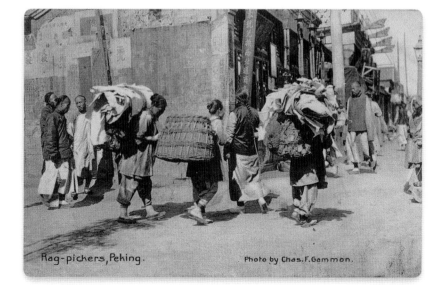

Above Raising well water
Chas. F. Gammon photograph,
Denniston & Sullivan ca. 1910

Above Itinerant musicians, flutist and blind
master violinist playing the *erhu* *Russian publisher*
ca. 1910

Left Rag pickers – the recyclers of former times
Chas. F. Gammon photograph, Denniston & Sullivan
ca. 1910

Vibrant Street Life in China Reflecting the Han Urge to Survive and Communicate

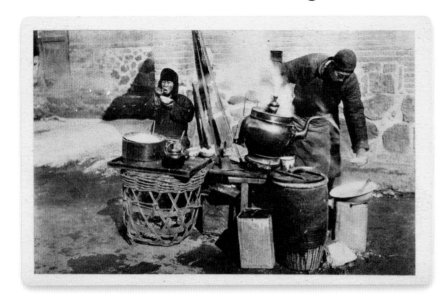

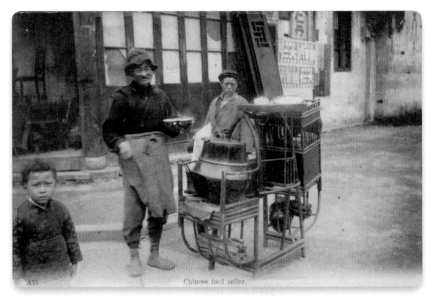

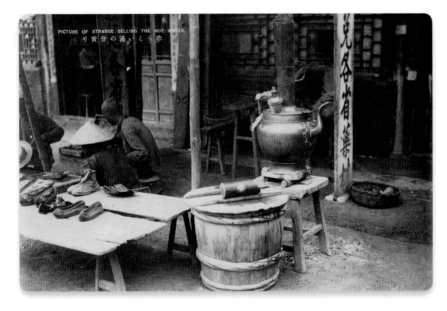

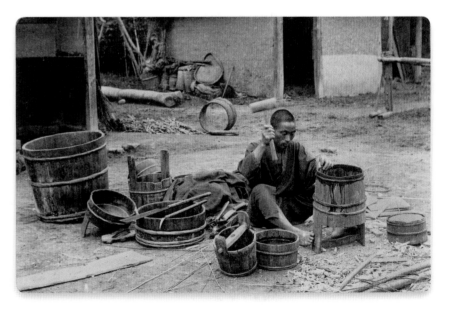

Top Hot water vendor with his paraphernalia
French Apostolic card, Paris ca. 1910

Above Selling hot water, with a shoe repair "next door"
Japanese publisher ca. 1910

Top Food seller with a minimalist kitchen
Japanese publisher ca. 1910

Above Making wooden buckets, hammering with a wooden mallet
Japanese publisher ca. 1910

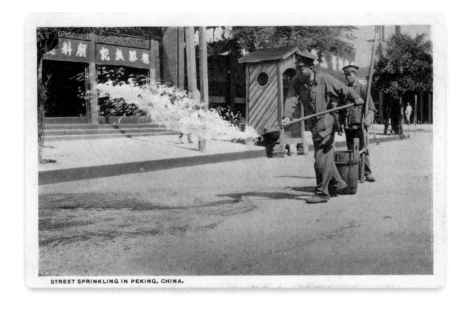

STREET SPRINKLING IN PEKING, CHINA.

Above City workers sprinkling street to keep down the "Peking dust"
Camera Craft ca. 1920

Right Shoemaker at work
Kingshill (Qing dragon flag) ca. 1910

Below Sawing wood next to a stone and brick wall
Japanese publisher ca. 1910

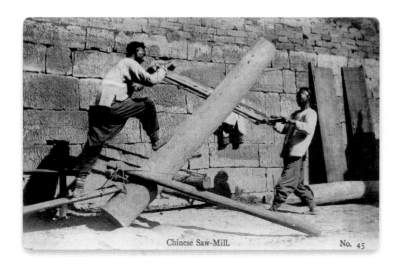

Chinese Saw-Mill. No. 45

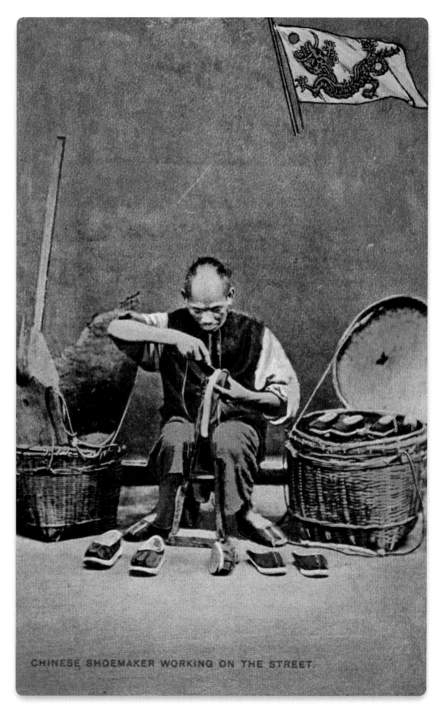

CHINESE SHOEMAKER WORKING ON THE STREET.

Young and Old of the Middle Class

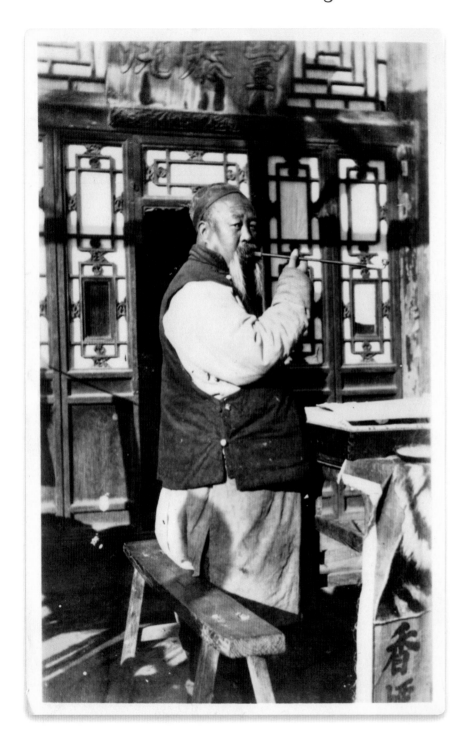

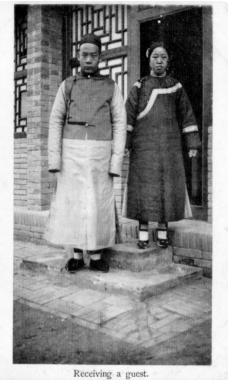

Receiving a guest.

Far left Beijing resident smoking long-stem pipe next to carved windows *Hartung's Photo Shop Real Photo postcard, ca. 1920s*

Left Receiving a guest
Denniston & Sullivan 1920–1930

Below Children posing with birdcage
Japanese card 1910–1920s

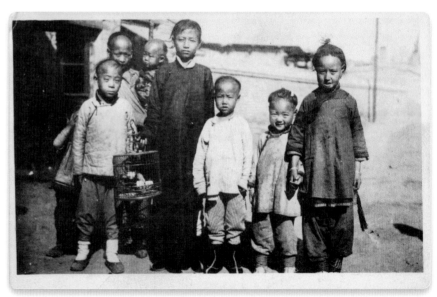

A Camera Craft and Hartung Collection of Colored Street Scenes

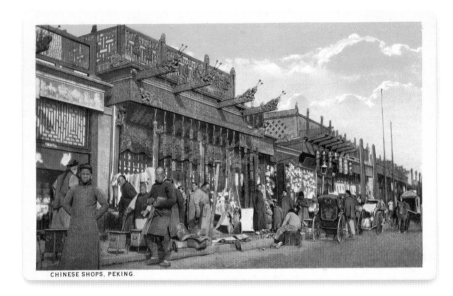

CHINESE SHOPS, PEKING.

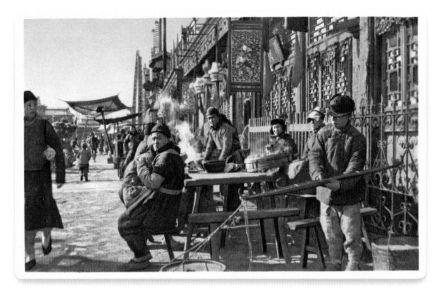

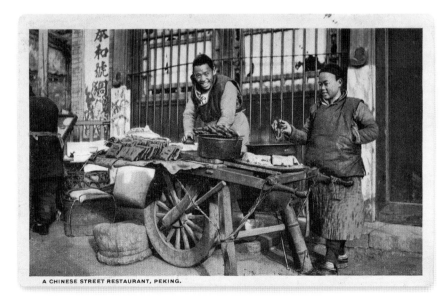

A CHINESE STREET RESTAURANT, PEKING.

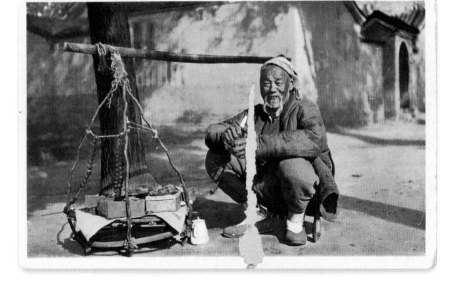

Top Shops inside, street vendors outside
Camera Craft 1920s

Above Fried buns for sale on an urban food cart of yesteryear
Camera Craft 1920s

Top Streetside restaurant in front of stores with carved windows
Hartung's Photo Shop 1910–1920

Above Persimmon vendor
Hartung's Photo Shop damaged card, hand-dated 1929

Sturdy Men at Work—A Collection by Camera Craft

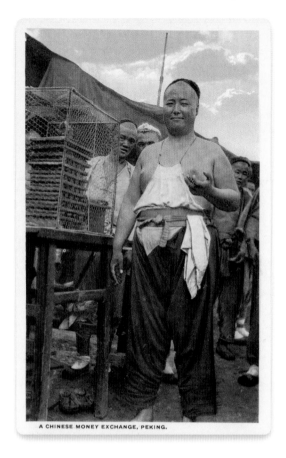

A CHINESE MONEY EXCHANGE, PEKING.

The money changer
Camera Craft 1920–1930

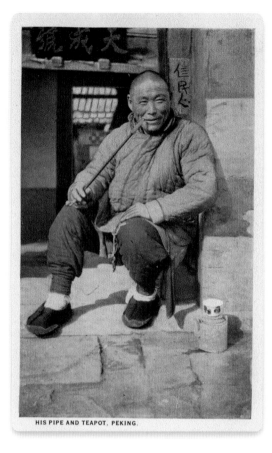

HIS PIPE AND TEAPOT, PEKING.

Man "taking a break" with pipe and teapot
Camera Craft 1920–1930

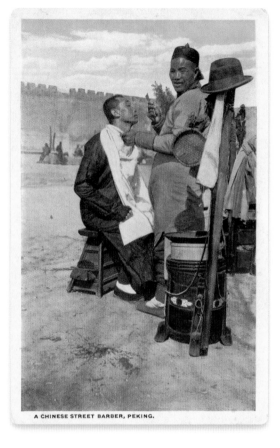

A CHINESE STREET BARBER, PEKING.

Street barber, dentist, and masseur
Camera Craft 1920–1930

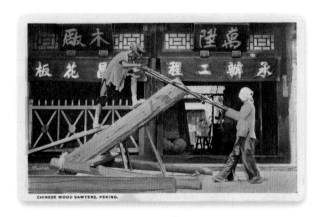

CHINESE WOOD SAWYERS, PEKING.

Left Beijing wood sawyers
Camera Craft 1920–1930

Right Informal horse-shoeing in
the street
Camera Craft 1920–1930

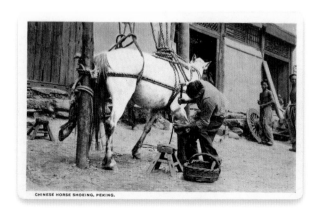

CHINESE HORSE SHOEING, PEKING.

Roadside Theater and Itinerant Musicians

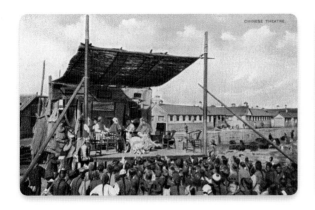

Streetside theater under a tent
no publisher 1920–1930

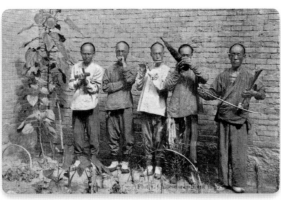

Mendicant musicians playing a variety of instruments
Japanese publisher 1920–1930

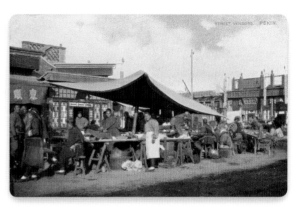

Streetside food vendors doing business under a tent
no publisher 1920–1930

Hardy Beijing Children

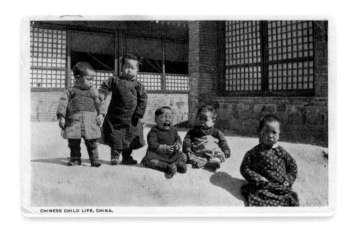

Above Warmly dressed children—not all goes
well for all. *Camera Craft back hand-dated 1924*

Right Children with their nanny
Hartung's Photo Shop 1920s

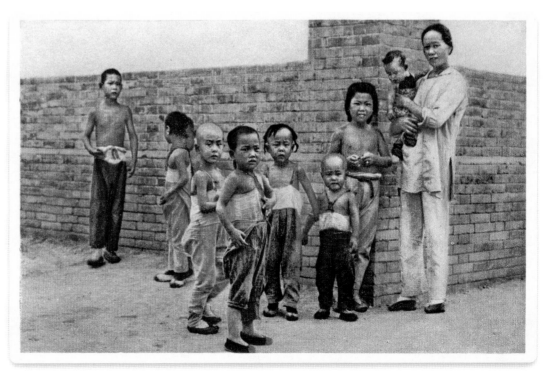

22
Native Transportation

CAMELS,

SEDAN CHAIRS,

THE PEKING CART,

RICKSHAWS,

AND OTHER

CONVEYANCES

Stolid "desert ships"
Franz Scholz, Tientsin 1910–1920

The camel, premier beast of burden, defined the Beijing of old as much as the city walls. Camels silently entered the city gates from the west, gently setting one foot ahead of the other, delivering sacks of coal from nearby mines, a fuel much needed in these climes. Long trains of this introverted, quiet, proud, shaggy animal with half-shut eyes were a daily occurrence. Camels also carried brick tea to Siberia and Russia. They had supplied the distant Roman Empire, coeval with the Han dynasty (206 BCE–220 CE), with silk by way of the old Silk Road, traveling along the way over vast stretches of sand, owing to which they were known as "ships of the desert." Camels were not as approachable as the donkey and the mule. But if only this beast could talk and tell about its

travels! At times, I still saw camels resting below a heavy city wall outside Beijing when I was studying there. The Chinese countryside inns had special gates for camels that looked like wine glasses cut in a wall: a slender stem with a large body for the camel to get through but not to escape from. When riding through the countryside by car as children, we were told by our charming hostess in Beijing to count the camel gates as a way to prevent carsickness. It worked beautifully for me.

The two-wheeled Peking cart, drawn by a donkey or mule and endowed with a round cloth cover and two side windows, was another favorite subject of the foreign photographer. It was Beijing's very own means of transportation and, though it looked

The Age-Old "Ship of the Desert"

engaging, warnings were sounded that it had no springs. The guest would sit inside under the cover with outstretched legs, while an attendant sat on the side of the cart behind the animal, whip in hand. A more rudimentary and older form of transportation was the one-wheeled wheelbarrow, pushed by a man with a strap around his shoulders. A sail might be affixed on poles in front of the wheelbarrow to speed it up and lighten the load with the aid of wind power. This was seen only in north China. A wheelbarrow could carry a maximum of six passengers and was widely used by the average Chinese. The sedan chair, on the other hand, was a wealthy man's conveyance and was carried by a team of two to four men who bore it on their shoulders.

China had been "motored" by donkeys, mules, the horse, the cow, or the oxen—and man himself— throughout the many centuries of its civilization. On the canals in Beijing, rowing boats provided the transport of people and goods. The country was always "abuzz" and in motion. Somebody was always traveling, moving goods, and going places. Processions were passing through the congested streets. This was not a sitting-down civilization, even though untold patience characterized the kite maker, the shoe repairman, the seamstress, the brass workmen, and the money changer. Tea shops served as a rest stop and a place for communication with one's fellow man.

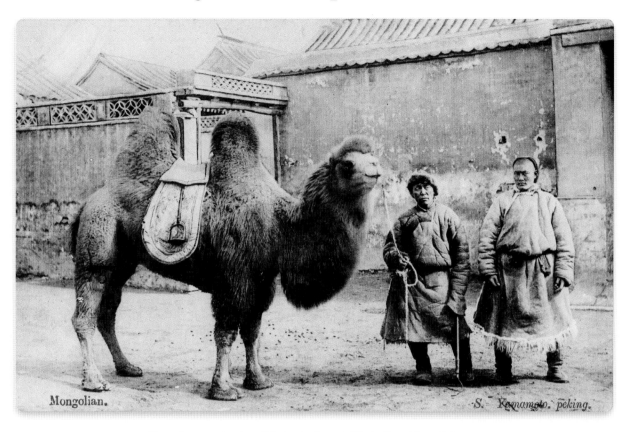

Mongolian men showing off their prized camel, fitted with saddle and stirrups
S. Yamamoto pre-1907

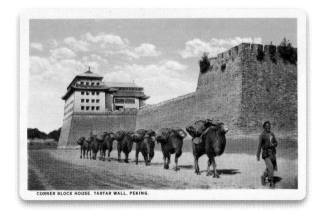

Camel train below city wall and watchtower
Camera Craft 1920–1930

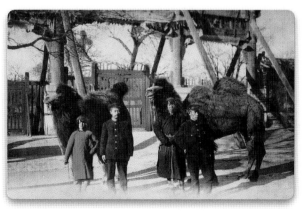

Uniformed Japanese next to camel drivers
Japanese publisher ca. 1910

Camel Trains in Nostalgic Old Beijing

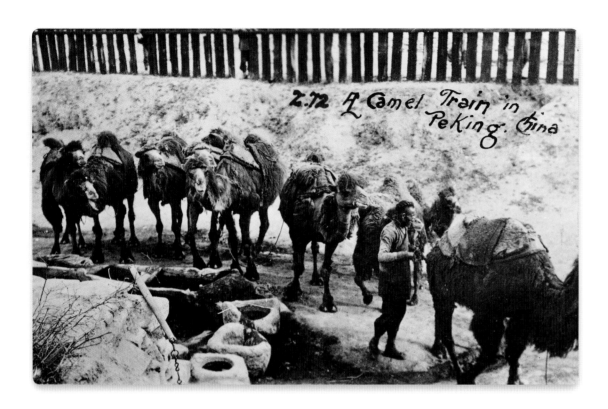

Left Camel train at water hole
no publisher Real Photo postcard, 1920–1930

Below left Camel caravan traveling along crimson
wall of Forbidden City
Hartung's Photo Shop 1920–1930

Below right Camel caravan traveling on mud road
in Outer (Chinese) City *Japanese publisher 1920s*

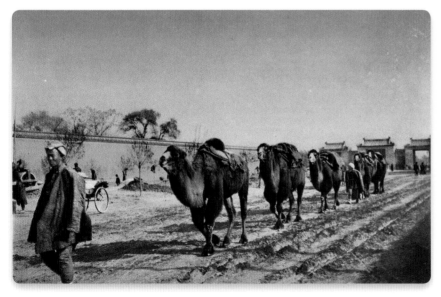

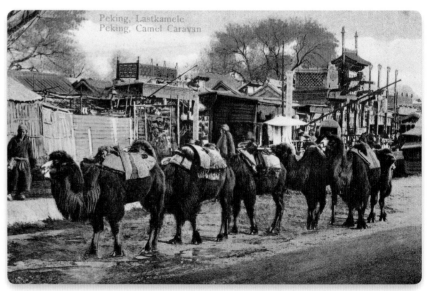

Sedan Chairs for the Well-Off

The Ever Dependable, Never Complaining Donkey and Mule

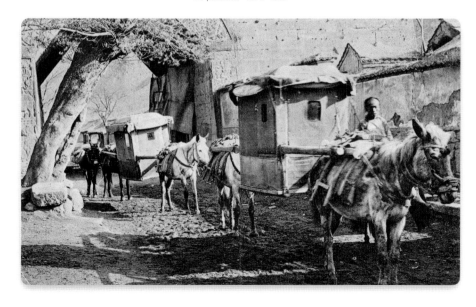

Sedan chair borne by mules, with mule foal in training. Note the bell worn by the lead mule.
no publisher 1910–1920

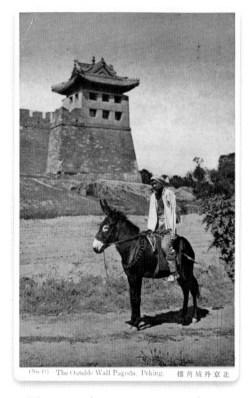

Driver atop mule poses near corner watchtower.
no publisher back hand-dated 1926

Pair of ponies carrying covered chair on a stony village road
Hans Bahlke ca. 1910

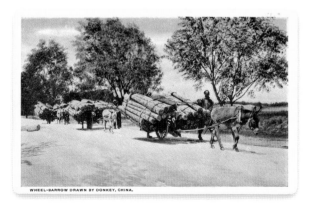

Donkeys pulling heavily laden wheelbarrows
Camera Craft 1920–1930

Other Traditional Conveyances

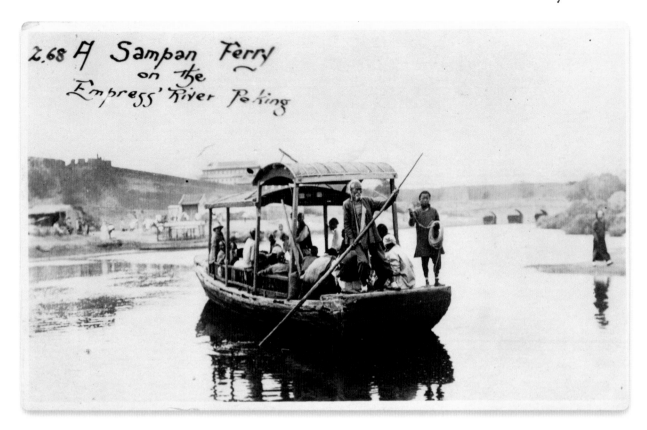

2.68 A Sampan Ferry on the Empress' River Peking

Left Ferry on canal near the city
no publisher Real Photo postcard, 1920s

Bottom left A heavy piece of wood on a cart pulled by two ponies
no publisher pre-1907

Bottom right A water cart drawn by draft animals *Japanese publisher 1910–1920*

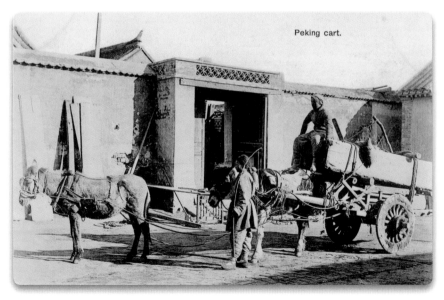

Peking cart.

飲用水運搬 天津風俗

The Peking Cart—Beijing's Unique Conveyance!

Mini-Peking cart and driver, posing in ruined temple grounds
J. H. Schaefer, Kunst, Amsterdam pre-1907

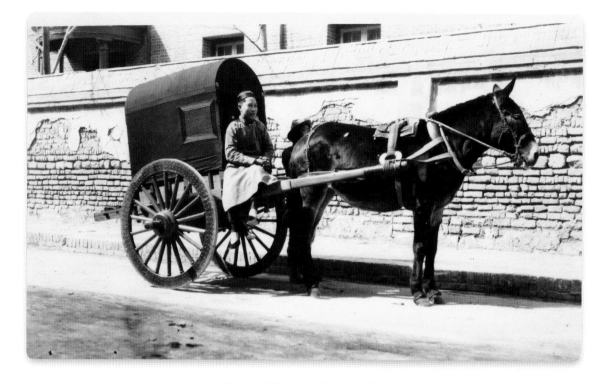

Elegant Peking cart, driver, and mule
Hartung's Photo Shop Real Photo postcard, 1920s

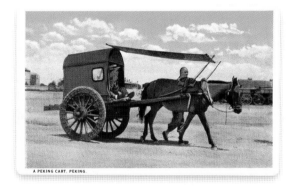

Pulled by a mule, a typical Peking cart with a traveler inside
Camera Craft hand-colored, 1920s

Peking cart and travelers *Chas. F. Gammon photograph, Denniston & Sullivan Real Photo postcard, 1920–1930*

Driver of Peking cart feeding his animal
Japanese publisher Real Photo postcard, 1920s

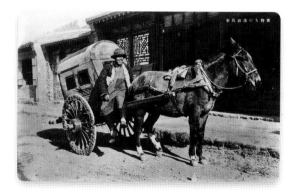

Peking cart, driver, and mule
Japanese publisher 1920s

The Busy Beijing Rickshaw

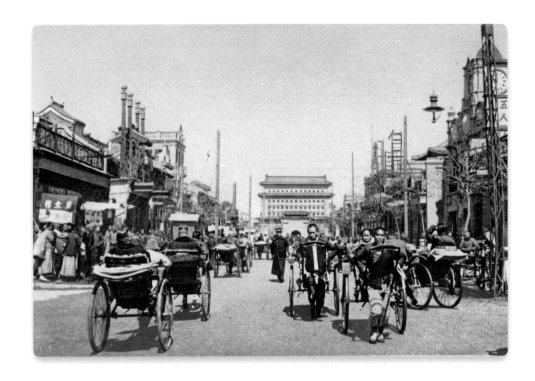

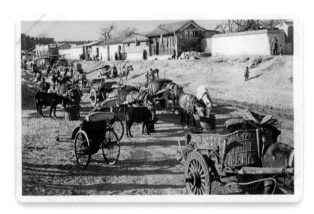

Left Rickshaws on Ch'ien Men Street
Japanese publisher 1920–1930

Below Rickshaws and carts outside city wall, taking a break
Librairie Française, Peking 1920–1930

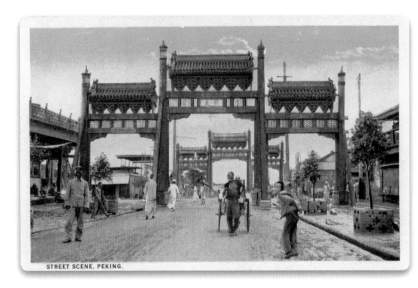

Arches and a rickshaw
Camera Craft 1920–1930

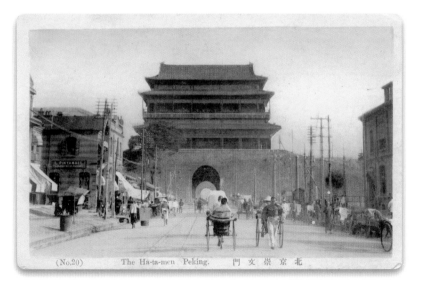

Rickshaws at Hatamen Gate
Japanese publisher ca. 1920s

Traffic New and Old

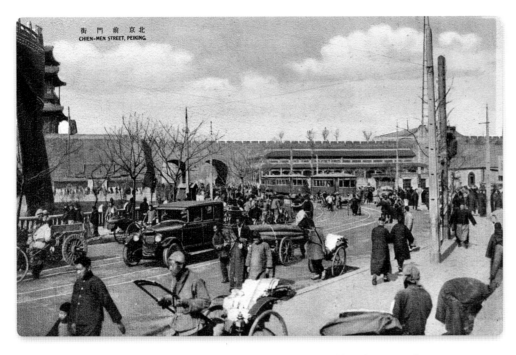

New and old vie in the city streets: now the motor car, tram, and bicycle compete for space.
Japanese publisher 1920–1930

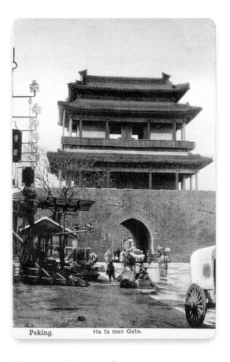

Peking cart at Hatamen Gate *no publisher pre-1907*

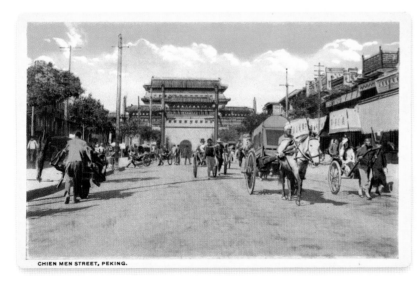

Peking cart, wheelbarrow, and rickshaw in Ch'ien Men Street. An American sailor rides
in the rickshaw at right. *Camera Craft ca. 1910*

A tram and tracks on West Four Arches (Xisi Pailou) Street, with a bicyclist at left
no publisher ca. 1910

23
Country Life
of Yesteryear

OLD TOOLS,

OLD METHODS,

WADDED CLOTHES

AND BOUND FEET

PEASANT AND GENTRY WOMEN'S
BOUND FEET—
A SIX-HUNDRED-YEARS-LONG
SOCIAL CUSTOM CHALLENGED
SUCCESSFULLY BY WESTERN
CHRISTIAN MISSIONARY LADIES

Two collections of postcards show the life of a peasant and his wife in yesteryear. Outside Beijing, a vast area of fields stretched to the horizon. Here peasants lived with their families in villages comprised of thatched-roof houses with brick walls. Ancient plows were pushed by the farmer himself or pulled by an ox. From time immemorial, the fields were tilled from west to east, to obstruct the horses of possible invaders from the north. The furrows acted as a hurdle and were intended to stop them short.

Life was hard, monotonous, uninspiring, and generally without communication with the world, yet the farmer survived. The men, women, and children wore padded clothes that got them through the icy cold winters; sometimes they leased the garments from a clothier. Peasant women had bound feet, though not the smallest, whereas gentry women in the villages possessed tiny ones, as the postcards show. These mutilated feet had pretty-sounding names like "lily" or "lotus feet," and their final size was the object of a class distinction. A young peasant girl's feet were bound by her mother in hopes of a prosperous marriage contract and a better future. Our own women house help in Hankou, in Hubei Province, had them.

Mrs. Archibald Little, the wife of an English shipping magnate, became an early anti-footbinding leader. Together with nine Western women, she launched a "Natural Foot Society" in Shanghai in 1885 under missionary auspices, according to Angela Zito, in her article "Secularizing the Pain of Footbinding in China." This group and others had a large impact in making women aware of what they were doing and encouraging them to break from this custom so deeply ingrained in Chinese society. Later, successive governments forbade "lily feet," while, ironically, Westerners introduced spike-heeled shoes, which were particularly favored in Shanghai in the 1930s, even by Chinese women.

The Chinese never sat still. He was always at work. The onlooker could follow the rhythm of the laborer's body at work. Work too was a ritual that Chinese children soon grew into. Floods, droughts, and famines couldn't discourage him. Death was a philosophical matter. He would continue unrelentingly. Only now in our time have mechanical devices been brought into the countryside to do the labor.

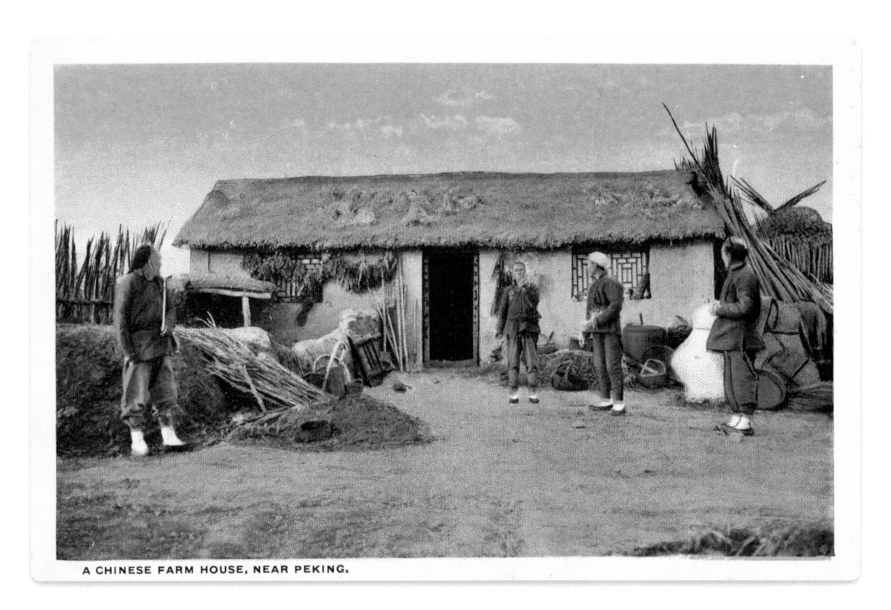

A CHINESE FARM HOUSE, NEAR PEKING.

Farmhouse near Beijing, with farmers posing *Camera Craft* *1920s*

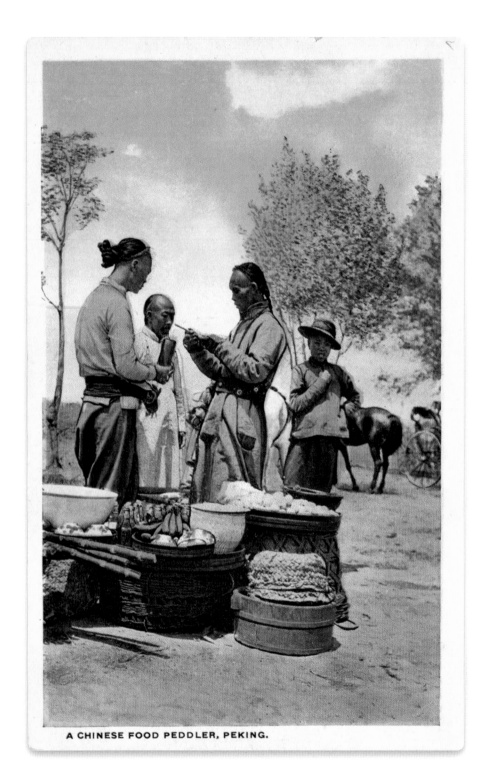

A CHINESE FOOD PEDDLER, PEKING.

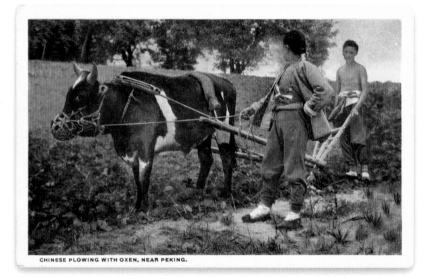

CHINESE PLOWING WITH OXEN, NEAR PEKING.

Above Tilling with ancient plow and ox
Camera Craft 1920s

Left Food peddlers at a country market
Camera Craft 1920s

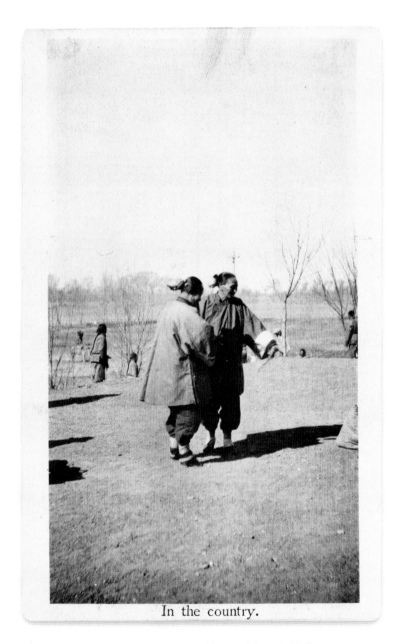

In the country.

No. 2 UN-GROUPE-DE FAMILLE

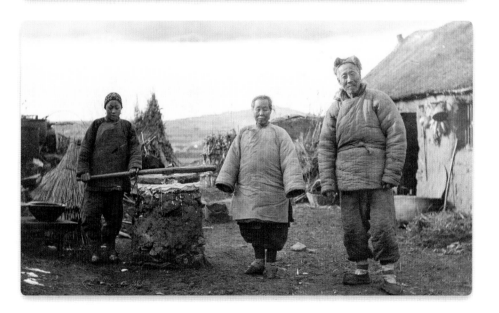

Above Two country women with severely bound "lily feet"
Chas. F. Gammon photograph, Denniston & Sullivan 1910–1920

Top Family group. Note the girl with modern haircut upper left and boy with Manchu queue upper middle. *no publisher Real Photo postcard, damaged card, 1920s*

Above Farmer and wife in padded clothes posing in front of thatch-roofed farmhouse and by a millstone *Japanese publisher ca. 1910*

Plowing, Growing, Harvesting, and Threshing

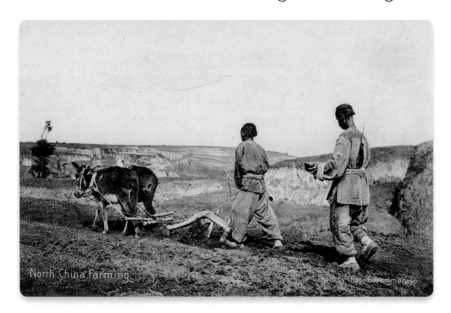

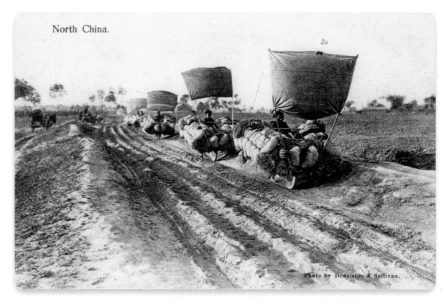

Top left Plowing with ancient plow in North China
Chas. F. Gammon photograph, Denniston & Sullivan ca. 1910

Top right Wheelbarrow with a sail, a farmer's innovation
Denniston & Sullivan 1910–1920

Left The wheelbarrow as all-purpose transport
Denniston & Sullivan pre-1907

Below Threshing with flail *no publisher Real Photo postcard 1920*

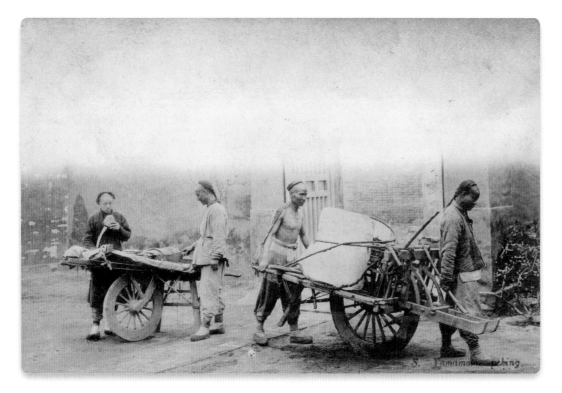

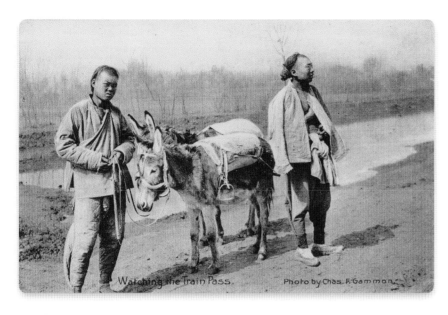

Watching the train pass: wealthy farmers with two content mules, fitted with saddle and stirrups

Chas. F. Gammon photograph, Denniston & Sullivan 1920s

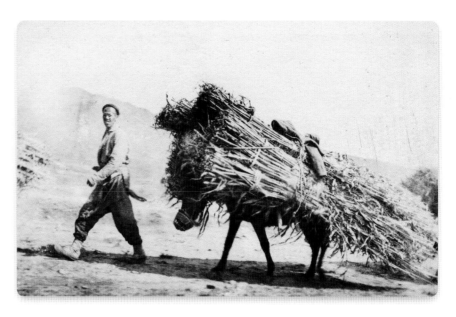

Overburdened mule transporting millet stalks

no publisher Real Photo postcard, 1920s

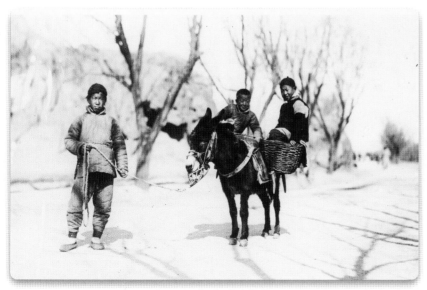

Boys riding in baskets on a pony

no publisher Real Photo postcard, 1920s

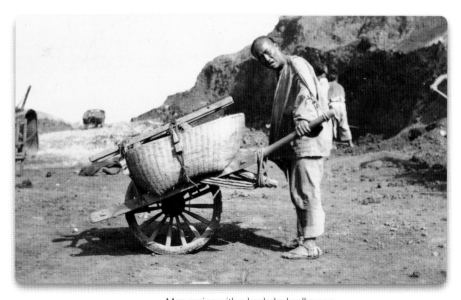

Man posing with a loaded wheelbarrow

no publisher Real Photo postcard, 1920s

24
Oil Paintings
of the
Imperial City
by Carl Wuttke

BEIJING IN THE
PRE-BOXER DAYS

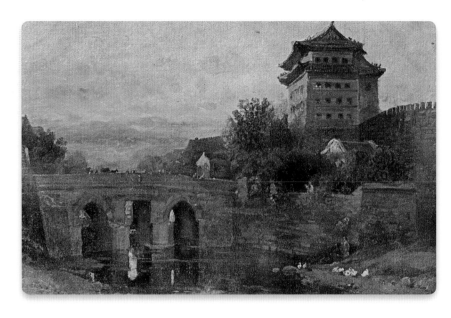

Ch'ien Men and bridge, at sunset. Carl Wuttke, oil painting, 1898. R 318
Römler & Jonas, Dresden

Carl Wuttke, a German-born landscape painter, visited Beijing in 1898 and painted numerous handsome scenes of the city. Wuttke (1849–1927) trained as a painter in Germany. As a young artist, he traveled to other countries to exercise his skills, going first to Italy. Later voyages took him farther afield, to North Africa, the Sinai, and the United States. In the heyday of European imperialism, when all European monarchs wanted to have his or her share of the China melon, Carl Wuttke was commissioned by the German emperor, Wilhelm II, to make a painting of the Bay of Jiaozhou and the German treaty port of Qingdao for his castle in Berlin. Wuttke arrived in Beijing in 1898, two years before the Boxer attack on the foreign legations. In a German art magazine, he wrote that wherever he went with his easel and paints, Chinese onlookers were friendly and never hostile. His compositions of Chinese scenes are true to life, while his palette is friendly and colorful and concentrates on the browns, the dominant color of old Beijing. His figures hardly show European characteristics, which was typical for most Western painters depicting Chinese people at that time. He reveled in Chinese art, architecture, and the scenery of the country. His wanderings took him to the Western Hills outside of Beijing, where the Tibetan fairyland prevailed, with stupas, temples, and memorials to Asia's enlightened spiritual leader, the Gautama Buddha.

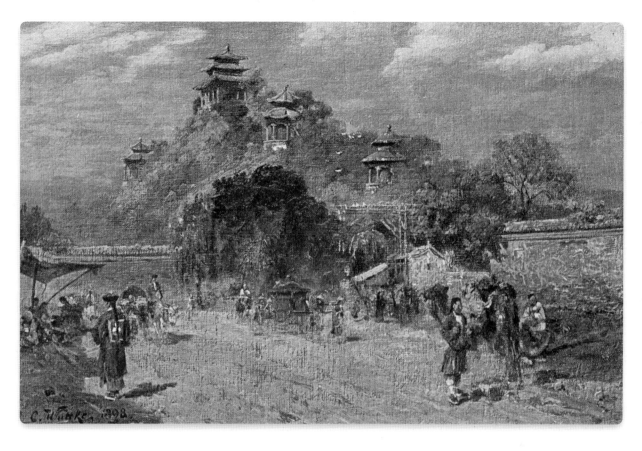

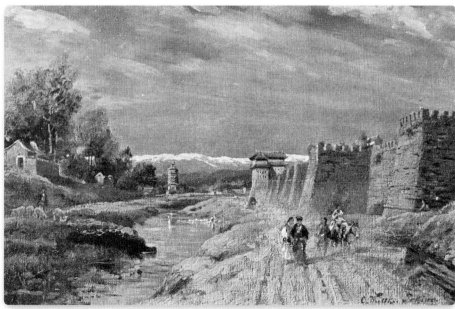

Above Coal Hill and red sedan chair. Carl Wuttke, oil
painting, 1898. R 301 *Römler & Jonas, Dresden*

Left Outside the city wall, moat, pagoda, and travelers
Carl Wuttke, oil painting, 1898. R 309
Römler & Jonas, Dresden

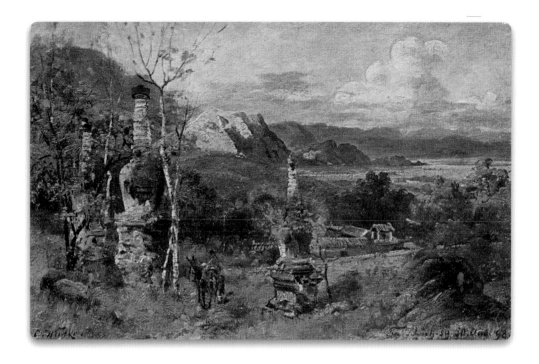

Left Tibetan stupas in Western Hills. Carl Wuttke, oil painting, 1898. R 305
Römler & Jonas, Dresden

Below left Nankou Pass. Carl Wuttke, oil painting, 1898. R 303 *Römler & Jonas, Dresden*

Below *Pailou* and Hatamen Gate. Carl Wuttke, oil painting, 1898. R 306
Römler & Jonas, Dresden

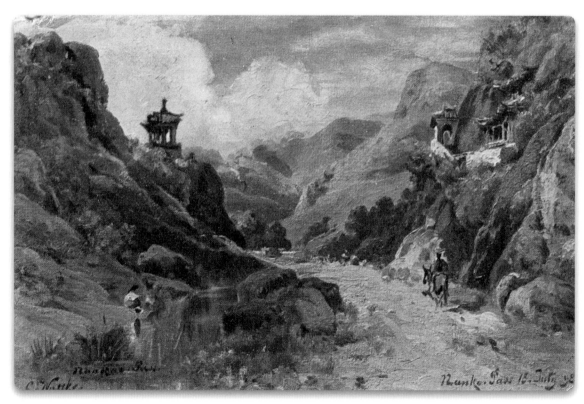

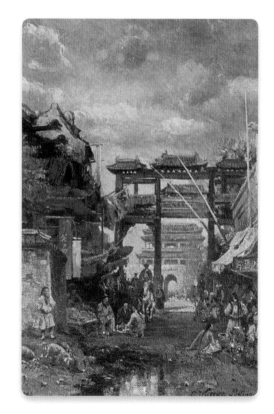

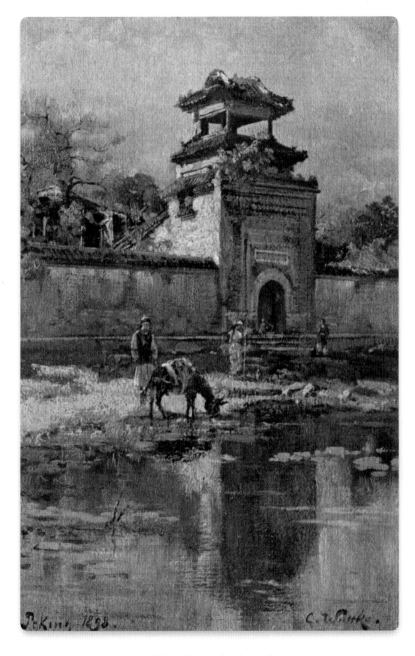

Gate to mosque built by Qianlong for his Muslim concubine. Carl
Wuttke, oil painting, 1898. R 312

Römler & Jonas, Dresden

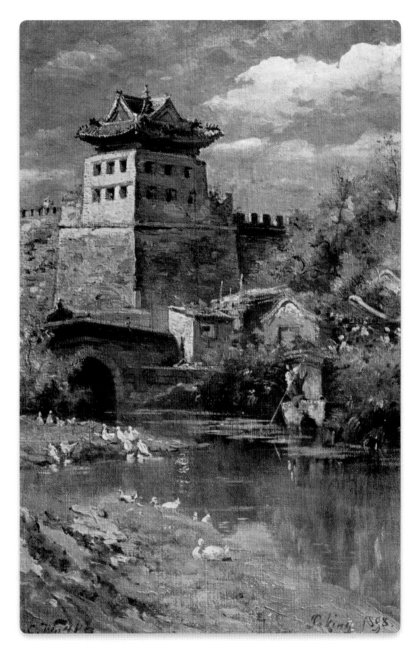

Corner tower and creek. Carl Wuttke, oil painting, 1898. R 302

Römler & Jonas, Dresden

25
The Great Wall,
Beijing's Protectress

THE NANKOU PASS,
THE GATE TO THE
NETHERWORLD AND
THE FORMIDABLE
BADALING TUNNEL

Last but not least, a few final dramatic postcards depict the Great Wall, one of the greatest architectural feats in the world, which passes just thirty miles north of Beijing. So immense and extensive is the wall that it is said to be one of the only human-wrought objects that could be seen from the Moon by the Apollo astronauts. The Great Wall is said to have been originally the achievement of the first emperor, Qin Shihuang, who unified China, burned its books, and tied already existing sections of wall together in order to keep the northern barbarians—the nomadic tribes of the north—out of China. His grave site, studded with a "Terracotta Army" of thousands of clay warriors, was discovered near Xi'an in recent years. Employing a million laborers, his wall was completed in twenty years' time, it is said. The present wall was built by during the Ming dynasty, however.

The Great Wall runs from the province of Gansu in the west to Shanhaiguan on the east coast of China. It climbs up to mountaintops and down valleys and canyons. It was first constructed of mud and grass, and later it was made of brick. Hefty observation towers were placed in stages and manned by archers for the country's defense. The horse-mounted barbarians who lived on the periphery—the bow-and-arrow carrying Khitans, Tobas, Jurchen, and Mongols—sometimes spilled over into China's agricultural land. They sought food and pastureland. Sometimes Chinese emperors sent bags of gold to the nomad chieftains to pacify them, so the Chinese could breed horses for their own cavalry. The men who constructed or renovated the wall lived in simple huts with their families at the bottom of the thirty-foot-high structure, moving their temporary domicile as the wall progressed. Their sons took over when the fathers died, so that the work was an ongoing generational enterprise. The wall terminates at the Bohai Sea. It was through this opening that the Manchu horsemen poured into China in 1644 and sped to the Forbidden City.

Near Beijing, the Great Wall passes through a canyon called the Nankou Pass, which was the capital's northern gateway to the outside world. In 1905, the Qing government approved a railroad link between Beijing and Zhangjiakou, an important commercial city in Manchuria. This rail line would have to traverse the pass. Jeme Tien Yow, a Chinese native who had received a bachelor's degree in civil engineering in the United States and trained in his homeland, was appointed to head the project and solve the difficult engineering challenge. Jeme Tien Yow defied skepticism, overcoming the steep approach by means of switchbacks. To expedite construction of the tunnel, he used a vertical shaft method rather than dig from the two ends only. The Badaling Tunnel was the longest tunnel in China at the time, and Jeme Tien Yow succeeded in completing it in only two years' time—a remarkable feat and a triumph for his country.

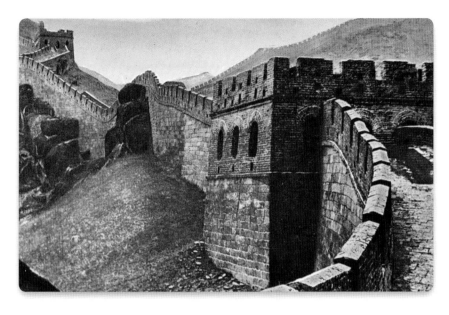

Great Wall and watchtower
Japanese publisher 1920–1930

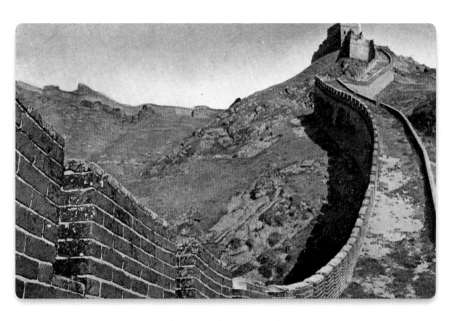

Great Wall on a card from the Republican era
no publisher 1920–1930

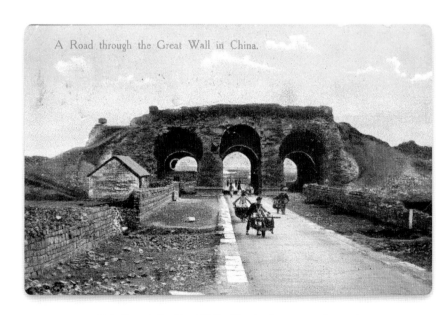

Gate through the Great Wall, with wheelbarrows on the road
Peking-Kalgan Railway, publisher back hand-dated 1915

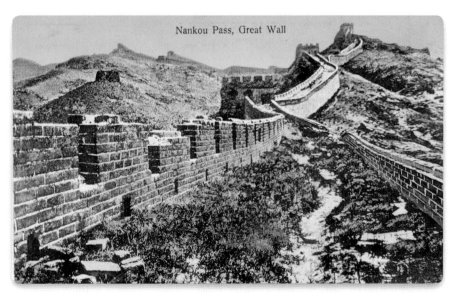

The Great Wall at Nankou Pass
no publisher 1920s

Nankou Pass—Gateway to the Outer World

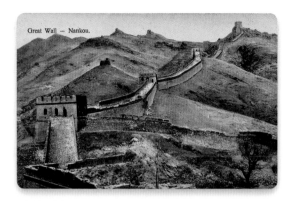

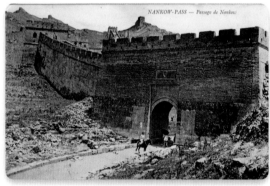

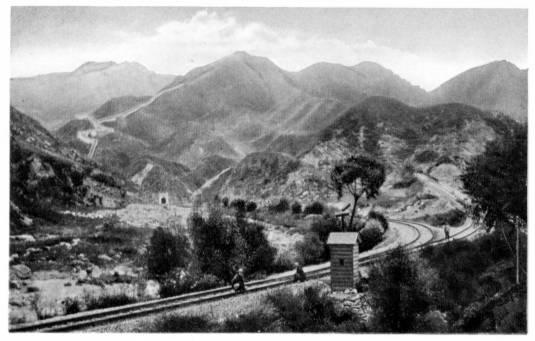

Top Great Wall at Nankou Pass
no publisher 1910–1920

Above Nankou Pass gate and rider on horse
I. Wannieck 1920s

Railway tracks to the Badaling Tunnel bored into the mountain shown at the middle left of card
Ministry of Communications card of the Peking-Kalgan Railway 1920–1930

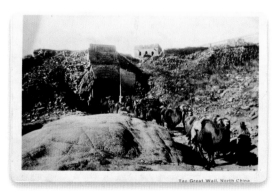

Nankou Pass gate and camel train
I. Wannieck, Peking 1910–1920

Verso of card opposite top: "Engineer who built the P. S.
[Peking-Shenyang] Railway—going to the Great Wall"

Statue of Jeme Tien Yow, celebrated engineer
of the Badaling Tunnel at the Nankou Pass
no publisher Real Photo postcard, ca. 1920

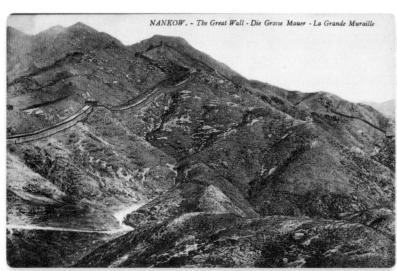

NANKOW. - *The Great Wall - Die Grosse Mauer - La Grande Muraille*

Rugged mountain terrain at Nankou Pass
I. Wannieck 1910–1920

Railroad tracks passing through narrow valley
no publisher 1910–1920

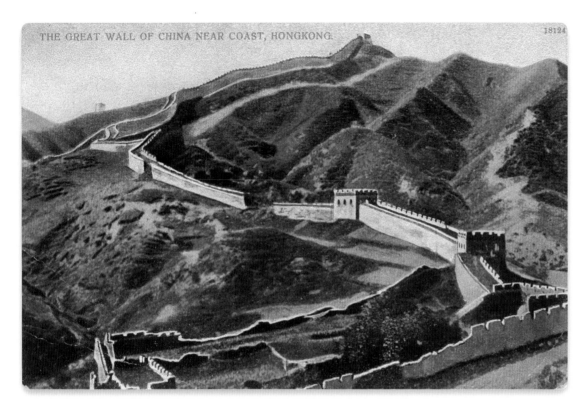

THE GREAT WALL OF CHINA NEAR COAST, HONGKONG.

Last stretch of Great Wall on way to the coast
Lao King Kee 1910–1920

City Gate at Shanhaiguan, where the
Great Wall meets the sea
Kingshill (Qing dragon flag) 1910–1920

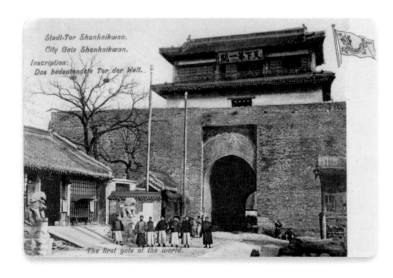

POSTSCRIPT

Postcards have preserved a glimpse of the splendor from which the emperors ruled a vast empire. These rulers—and the dynasties before them—left after them a unique architectural style, a lunar calendar, an observatory, palaces in walled compounds and beside lakes, pavilions and bridges, religious monuments and temples, uncountable worldly and religious art objects, paper, gunpowder, the compass, the first humanist philosopher in Confucius, and a great classical literature and translucent poetry—all of which are an immense contribution to mankind's cultural heritage and ongoing endeavors here on earth.

An age-old society has been transformed today. Change had to come. The colonial powers brought it to China in their quest for profit and their own advantage, while missionaries introduced schools, orphanages, hospitals, universities, and reform—such as freeing Chinese women of their bound feet. The Chinese Nationalists made a start at this transformation, wiring the country with telegraph and telephone, building more railroads, introducing airplanes and airports, transforming the spoken language into a new literature, and starting a modern infrastructure. An atheistic Western-born Communist-Marxist ideology took over in 1949. The new leadership marshaled the people, remodeling the ancient society into communes, leaving few individual freedoms, until Deng Xiaoping opened the country to trade and free markets in the 1970s. This opening generated the finances for the building of skyscrapers and high-rises of a futuristic design that would house the vast population, which over the years had increased exponentially. This now is the contemporary Chinese habitat. Gulps of Western technology have been introduced in order to further modernize every aspect of life, a goal that is being pursued at a galloping pace. With its heritage now in museums—whither China next?

Bibliography

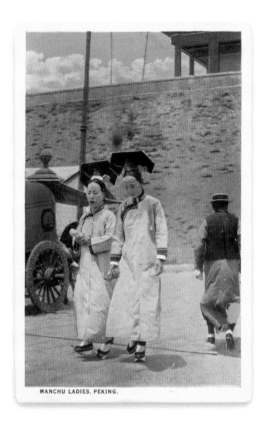

Two Manchu ladies walking in the street in their platform shoes
Camera Craft hand-colored card, 1910–1920

Arlington, L. C., and William Lewisohn. *In Search of Old Peking*. Peking: Henri Vetch, 1935.

Bredon, Juliet. *Peking*. Shanghai: Kelly and Walsh Limited, 1920.

Bushell, S. W. *Chinese Art*, vol. I. London: Wyman and Sons, Ltd., 1904.

Carl, Katharine A. *With the Empress Dowager of China*. New York: Century Company, 1906.

Cody, Jeffrey W., and Frances Terpak. *Brush and Shutter: Early Photography in China*. Los Angeles: Getty Research Institute, May 1, 2011.

Conger, Sarah Pike. *Letters from China*. Chicago: A. C. McClurg & Company. 1909.

Cumming, C. F. Gordon. *Wanderings in China*. Edinburgh and London: William Blackwood, 1889.

Der Ling, Princess. *Two Years in the Forbidden City*. New York: Dodd Mead & Company, 1925.

Eberhard, Wolfram. *A History of China*. Berkeley: University of California Press, 1948.

Fernal, Helen. *Chinese Court Costumes*. Toronto: Royal Ontario Museum of Archaeology, 1946.

Franke, Wolfgang. *China und das Abendland*. Göttingen: Vandenhoeck & Ruprecht, 1960.

Hacker, Arthur. *China Illustrated: Western Views of the Middle Kingdom*. Rutland, Vt.: Tuttle Publishing, 2004.

Harrison, John A. *The Chinese Empire*. New York: Harcourt Brace Jovanovich, 1972.

Headland, Isaac Taylor. *Court Life in China*. New York: Flemming H. Revell Company, 1909.

Heyking, Elisabeth von. *Tagebuecher aus vier Welten, 1886–1904*. Leipzig: Koehler & Amerling, 1926.

Li, Lillian M., et al. *Beijing: From Imperial Capital to Olympic City*. New York: Palgrave Macmillan, 2007.

Montel, Gösta. *Unter Göttern und Menschen*. Leipzig: F. A. Brockhjaus, 1948.

Parker, E. H. *China Past and Present*. New York: E. P. Dutton, 1923.

Reed, Marcia, and Paola Demattè, eds. *China on Paper: European and Chinese Works from the Late Sixteenth to the Early Nineteenth Century*. Los Angeles: Getty Research Institute, 2007.

Reischauer, Edwin O., and John. K. Fairbank. *China: Tradition and Transformation*. Boston: Houghton Mifflin Company, 1989.

Scidmore, Eliza Ruhama. *China—The Long-Lived Empire*. New York: Century Company, 1900.

Siren, Osvald. *The Imperial Palaces of Peking*. Paris and Brussels: G. van Oest, 1926.

Smith, D. Howard. *Chinese Religions from 1000 B.C. to the Present Day*. New York: Holt Rinehart and Winston, 1968.

Spence, Jonathan. *The Search for Modern China*. New York: W. W. Norton, 1990.

Vetch, Henri. *The Peking Bookstore*. Peking: Henri Vetch, 1935.

Appendix

POSTCARD VERSOS

After the invention of photography in 1838, cameras soon came to China with the Westerners. Photography shops were opened in all treaty ports by both Westerners and Chinese. Between 1870 and 1889, the first image cards appeared in Europe. The postcard became a quick and inexpensive means of communication, and, as souvenirs, postcards became hugely popular almost immediately. People wrote cards to each other and started to collect them and fill albums, to such an extent that the period from 1898 to 1919 is referred to as the Golden Age of Postcards. The earliest postcards of China date back to the beginning of this period, 1898.

The Weltpostverein, German for "Universal Postal Union"—"Union Postale Universelle" in French—was founded in 1874 in Bern, Switzerland, to coordinate the delivery of mail between member states. Twenty-two countries joined immediately, and the mailing of postcards was backed by the union. The names of member states appear in different languages in the upper left hand corner of the back of a card on a number of Beijing cards, Russia using its own script, for instance.

UNDIVIDED AND DIVIDED BACKS, WITH OR WITHOUT PUBLISHERS' NAMES —STAMPS AND CANCELLATIONS

The so-called "undivided back" postcard has three lines on the verso of the card for the address and no space for a message. This type of card prevailed before 1907. Senders wishing to add a personal message had to scribble something on the image side of the card by default. A category of cards with a white border for a message at the bottom of the image side did exist during this early postcard era, and England permitted the "divided back" card as early as in 1902, with France following in 1904, Germany in 1905, and the United States Postal Service in 1907. The year 1907 has become the standard date for divided back postcards and is thus an important date for dating postcards. The first cards after 1907 were divided unevenly, favoring the address portion. Some postcards have the publisher, the printer, or the photography shop name on the back. In the early period of the postcard, most cards in China were printed by the British or were printed overseas in Germany, where printing techniques were highly developed.

Stamps on postcards tell the era they belong to, while cancellations can tell their own story. For example, a letter sent from China by a British national bore a Hong Kong stamp with the letters B.P.O.., which stood for "British Post Office." Other nationals in China built their own post offices in the treaty ports or mailed their letters from their embassy or consulate with stamps from their own countries, some stamps being overprinted. "Peking" on the cancellation was used during the imperial era until the Chinese nationalists proclaimed a national government in 1911, moving the capital to Nanjing and renaming the city "Peiping" (Beiping), as can be seen on cancellations. A general Chinese post office was created in the 1920s.

Postcards document political and social change. They are themselves history.

Peking view card, undivided back. Imperial Post Office stamp with dragon (engraved in London). Cancellation illegible, passed through Shanghai B.P.O. (British Post Office).
Postal Union member's listing: O. Ludwig, Peking

Peking view card, early divided back. Hongkong 4¢ stamp used by B.P.O. (British post offices in China). Card mailed from Tianjin (cancellation), passed through Shanghai B.P.O.
Postal Union member's listing: C.H. 592 copyright

Beijing view card, "Rice Sower" stamp, Republic Post Office. Cancellation "Peiping"—as Peking was renamed when the Republican capital moved to Nanjing—dated 1920. *Camera Craft. Peking card made in U.S.A.*

Card of Puyi, emperor of China; divided back. Russian stamp with overprint "Kitai" (China) in Cyrillic. "Peking" cancellation in Cyrillic dated 7.5.10. *Registered O. Ludwig, Peking, 1908*

View card of Great Wall, divided back. Card published by Lau Ping Kou in Hongkong (see notation in English at left side of back.)
Union Postale Unverselle

Peking view card. Republic Post Office. German-language message. Cancellation "Peking "; hand-dated 12.6.2. Note: "via Siberia" postal route to Europe, 3-cent "junk" stamp

About the Author

Felicitas Titus was born and raised in Hankou, China, a former treaty port on the mid-Yangtze River. She grew up in a traditional foreign businessman's *hong* in the midst of her family and many Chinese, and as a girl and young woman she was able to observe the old Chinese culture firsthand. Felicitas's father was a leading German businessman in Hankou. His company exported tea, silk, silk cocoons, animal skins, vegetable talc, and tung oil. He served as the president of the Chamber of Commerce and on the board of the International Hospital for many years. Her mother was on the board of the Anglican Blind School in Wuchang. Soon after World War II, her parents were granted a special immigration visa to the United States and left China for America. Her brother, Wolfgang, a medical student, moved to Hong Kong, and Felicitas moved to Taiwan after the Chinese People's Republic was proclaimed in 1949. Miss Titus studied the Chinese language, literature, and history for two and a half years at the College of Chinese Studies in Beijing at the end of World War II. She traveled extensively, including to the Tibetan Lamasery Kumbum and the Caves of the Thousand Buddhas in West China. After emigrating to the United States, Felicitas received a Master of Arts degree in German Studies and French Studies from the University of California at Berkeley in 1956. She taught at universities and colleges. She began to collect antique China postcards, amassing this unique collection, illustrating the life of the Chinese, the Manchus, and Westerners in China. In Berkeley, she became interested in preservation and served as a board member of the Landmark Heritage Foundation, supporting the magnificent and architecturally superb Berkeley City Club building. She considers her Beijing postcard collection another form of preservation. Miss Titus pursues art and writing projects.

Foreword Author

Susan Naquin is professor of History and East Asian Studies at Princeton University. She is the author of *Millenarian Rebellion in China*, *Shantung Rebellion*, and *Peking: Temples and City Life, 1400–1900*. She is also coauthor with Evelyn Rawski of *Chinese Society in the Eighteenth Century* and coeditor of *Pilgrims and Sacred Sites in China*. She lives in Lawrenceville, N.J.

Acknowledgments

M. B., past president and initiator of the Landmark Heritage Foundation for the preservation of the Julia Morgan Berkeley City Club building in Berkeley; Dr. Susan Naquin, professor of History and East Asian Studies, Princeton; Dr. Frances Terpak, Curator of Photographs, Getty Research Institute, Los Angeles; Dr. Sarah Gill, professor emeritus, Art History; Ann-Catrin Schultz, PhD, architectural historian; Dr. Patricia Berger, Chinese Art, University of California, Berkeley; Dr. Deborah Rudolph, East Asian Library, University of California, Berkeley; Cao Hongxing, assistant professor, International Business School, Beijing Foreign Studies University, Beijing, China; Lewis Baer, postcard historian, editor of the San Francisco Bay Area Postcard Club; Alistair Johnston, printer and print historian, Berkeley; Mark W., imaging expert, Photolab, Berkeley; Calvert Barksdale, Tuttle Publishing; Doe Library, University of California; archivists, Bancroft Library, University of California, Berkeley; librarians, East Asian Library, University of California, Berkeley

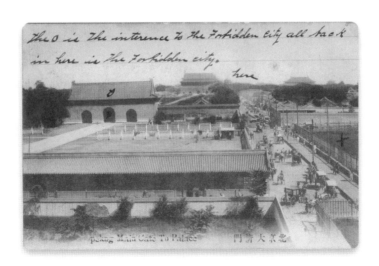

First Gate leading toward the Wumen and into the Imperial Palace,
horse carriages in street
Japanese publisher ca. 1910

"In this remarkable volume, Felicitas Titus has assembled a stunning array of postcards that she has collected over many years of dedicated searching. Ephemeral, small, and unassuming, postcards are often overlooked for the major role they played in influencing public opinion. Filled with primary information on China, its people and culture, these postcards will be of interest to both the general reader curious about China and the specialist seeking to understand the Western perception of China in the first decades of the twentieth century."

—*Frances Terpak, author and editor of*
Brush & Shutter: Early Photography in China